ALEXANDER THE GREAT
TREASURES FROM AN EPIC ERA OF HELLENISM

ALEXANDER THE GREAT

TREASURES FROM AN EPIC ERA OF HELLENISM

Dimitrios Pandermalis

ALEXANDER S. ONASSIS PUBLIC BENEFIT FOUNDATION (USA)

Published by the Alexander S. Onassis Public Benefit Foundation (USA)

Copyright © 2004 by the Alexander S. Onassis Public Benefit Foundation (USA), New York, N.Y. 10022

ONASSIS CULTURAL CENTER, 645 Fifth Avenue, New York, N.Y. 10022
December 10, 2004–April 16, 2005

CONTRIBUTORS TO THE EXHIBITION

Curator
Dimitrios Pandermalis

Coordination in Greece
Niki Dollis

Research Assistants
Frederick Lauritzen
Korinna Vastelli
Naya Charmalia

Design
Daniel B. Kershaw

Graphics
Sophia Geronimus

Lighting
Anita Jorgensen

Installation
David Latouche

Conservator
Leslie Gat

CONTRIBUTORS TO THE CATALOGUE

Authors
Dimitrios Pandermalis
Polyxeni Adam-Veleni
Frank L. Holt
Angeliki Kottaridi
Maria Lilibaki-Akamati
Eleni Trakosopoulou
Maria Tsimbidou-Avloniti

Authors of the Entries
Dimitrios Pandermalis
Polyxeni Adam-Veleni
Manthos Bessios
Frank L. Holt
Angeliki Kottaridi
Maria Lilibaki-Akamati
Stella Miller-Collett
Eleni Trakosopoulou

Translation of essays written by
A. Kottaridi, M. Lilibaki-Akamati, E. Trakosopoulou,
M. Tsimbidou-Avloniti, and M. Bessios
Alexandra Doumas

Editor
Pamela Barr

Design
Sophia Geronimus, Linda Florio

Photographs of exhibits in Greece
Yorgos Poupis
Telemachos Souvlakis

Printing
Randem Printing, Inc.

FRONT COVER: *Portrait of Alexander the Great.* 340–330 B.C. Pentelic marble. Height 0.35 m.
Found near the Erectheion, Acropolis of Athens, 1886. Acropolis, Athens (Ακρ. 1331)

CONTENTS

PREFACE

Alexander the Great, a pupil of Aristotle, schooled in military science, mathematics, art, literature, and theater, lived his short but glorious life according to the legend of the Homeric hero Achilles.

Alexander's military campaigns to Asia had as a target, not only the defense of Europe but also the dissemination in the East of Hellenic Culture as an ecumenical civilization of human values. He led his army of Hellenes to the farthermost reaches of his world, expanding the boundaries of civilization and knowledge, and changing the course of history.

His personality and unparalleled achievements have been shrouded in myth, but his incalculable impact on civilization reverberates over millennia.

The Alexander S. Onassis Public Benefit Foundation (USA) is proud to present to the American public this great Greek king who was so much larger than life yet so real. The magnificent rare portraits and ancient exhibits, of which the exhibition is comprised, speak eloquently about Alexander and his age, an epic era in the history of Hellenic civilization and the world's political, military, scientific, and cultural evolution.

In engaging in the difficult task of organizing this exhibition on such an ambitious theme, the Alexander S. Onassis Public Benefit Foundation (USA) enjoyed the precious scholarship of the Curator of the exhibition Professor Dimitrios Pandermalis; the collaboration of the Hellenic Ministry of Culture; and the cooperation of major Greek, American, Italian, and French museums and institutions which contributed to the exhibition. To all of them we express our deepest gratitude and appreciation.

Stelio Papadimitriou
President
Alexander S. Onassis Public Benefit Foundation

LENDERS TO THE EXHIBITION

We warmly thank the Hellenic Ministry of Culture, the Archaeological Museum of Thessaloniki, and the 16th, 17th, and 27th Ephorates of Prehistoric and Classical Antiquities for their cooperation.

GREECE
The Acropolis Museum, Athens
Archaeological Museum of Dion
Archaeological Museum of Kilkis
Archaeological Museum of Pella
Archaeological Museum of Polygyros
Archaeological Museum of Thessaloniki
Excavations of Ancient Pydna
The Royal Tombs at Aigai: A Museum on the Site

EUROPE
Museo Archeologico Nazionale di Napoli
Bibliothèque nationale de France

UNITED STATES
The American Numismatic Society, New York
Arthur M. Sackler Museum, Harvard University Art Museums
Brooklyn Museum of Art
Indiana University Art Museum
Iris & B. Gerald Cantor Center for Visual Arts, Stanford University
The Metropolitan Museum of Art, New York
Museum of Fine Arts, Boston
The Museum of Fine Arts, Houston
Princeton University Art Museum
Saint Louis Art Museum
The Walters Art Museum, Baltimore

FOREWORD

In his second treatise on kingship, Dio Chrysostom, a Greek orator and popular philosopher of the first century A.D., portrays Alexander the Great as a defender and supporter of the Homeric ideal of kingship. He writes of an imaginary dialogue between Philip and Alexander conducted at the foothills of Mount Olympus. Alexander speaks of his preference for Homer above all the Greek authors because only Homer described the true profile of an actual king and ruler. Chysostom's fabricated conversation does, however, draw on historical evidence. During breaks from battle, Alexander would read a special edited manuscript of the Homeric *Iliad* (Plutarch, *Alexander* 8). Other sources indicate that he did not hesitate to publicly demonstrate his admiration of the Homeric world, as, for example, in 334 B.C., when he visited the famous Temple of Athena in Troy, where the weapons from the epic war were stored. There, he dedicated his own weapons to the goddess Athena and, in a symbolic gesture, took those of the epic era and used them as his own in his campaign battles. The weapons from the temple were usually paraded ahead of Alexander in battle, showing Alexander's own association with, and projection of himself as, an epic hero (Arrian, *Anabasis* 1, 11, 7).

It is significant that in the portraits that Alexander commissioned, he always sought to have himself presented youthfully, with leonine hair, eyes looking upward to the heavens; as Plutarch is quoted: "This statue seems to look at Zeus and say: 'Keep thou Olympos; me let earth obey!'" (*Moralia* 335 A–B, ca. A.D. 80). No doubt the philosopher and biographer Plutarch idealizes Alexander and inflates his capacities. In spite of this, portrait heads of Alexander surviving from antiquity and especially from the fourth century B.C. and the early Hellenistic period do provide a sense of a dynamic young hero, strong in contrast to the portraits of previous leaders, with their tradition of the more mature, bearded statesman with calculating gaze. In the Onassis Foundation exhibition "Alexander the Great: Treasures from an Epic Era of Hellenism," two fine samples of Alexander's portraits—the head from the Athenian Acropolis and that from Pella—exemplify the flavor of the prototypes of the fourth century B.C. and the Early Hellenistic period. They provide reliable sources of the style in which Alexander was portrayed both in the north and south of Greece.

Archaeological materials from recent excavations in northern Greece enrich the available written sources on the military equipment of Alexander's period. Helmets, a Macedonian shield, greaves, spears, daggers, swords, javelins, arrows, slings, and above all, the bronze elements of the sarissa—the most effective weapon in the battlefield—are presented and provide a sense of Alexander's military machine.

The famous Macedonian symposia were almost epic in style. As host of these events, both during peacetime and war, Alexander used them as forums for relaxation and socialization with royal friends, the officers of his army, and foreign ambassadors. Extensive descriptive accounts of these symposia both before and during the campaign are preserved. The degree of organization of these events, with performances by poets, actors, musicians, and dancers, is impressive as are the special arrangements and decorations of the banquet halls in which they were conducted. Excavations at the Royal Tombs of Aigai (Vergina) have revealed precious pieces of the expensive tableware that was used. Contemporary bronze drinking sets from Pydna also testify to the practice of the symposia among the middle classes of the same period.

The royal women at Pella's court played an important role in public life, not only on social occasions but also in state affairs. Alexander's mother, Olympias, achieved a significant political role, especially after Alexander's departure from Macedonia. The special role of powerful women continued after Alexander's death, making the transition from royal women to ruling queens.

The lifestyle of the palace had a direct influence on the dress and fashion of the women of the capital city of Pella. Terracotta female figurines manufactured in Pella in the fourth century B.C. and the Hellenistic period indicate the rich and colorful range of female attire at the time. The accuracy of these figurines is attested to by a gold necklace in the exhibition that is also worn and represented on the protome of a woman.

Through Macedonian control of the Pangaion mining area, large amounts of gold were abundantly available to the Macedonians, creating the explosion of jewelry production that accompanied the period of Philip and Alexander. Macedonian women wore jewelry to make themselves more attractive and to indicate their social status. Some excellent examples of the more elaborate and richly decorated pieces are on view.

The Onassis Foundation exhibition dares to include some authentic finds of a period some one hundred and fifty years before Alexander's birth, when the state of Macedonia is first cited in the records of ancient historians. King Alexander I traced his family through Herakles back to Zeus and was the first Macedonian king to participate in the Olympic games. Archaeological evidence from this period is scant, making the unexpected and rich find of a noble woman's burial in 1998 particularly welcome. Many gold ribbons and rosettes covered the now-lost fabric of her dress. She wore gold shoes and a diadem-like gold band on her head and many pieces of precious jewelry that allow us to reconstruct the appearance of a royal lady of the old capital of the Macedonian state. In this early time, gold came to kings' treasuries from the gold contained in the waters of the River Echedoros, close to today's Thessaloniki.

Alexander's achievements and powerful character overwhelmed his contemporaries. Even those who participated in his campaign and wrote of his history, such as Callisthenes, Ptolemy, and Aristobulus, are often apologetic, encomiastic, or adulating of their king. Later authors used "exempla" of Alexander's campaign, isolated from their context to create philosophical and rhetorical treatises. In contrast, archaeological evidence presented in the exhibition provides primary data and allows the viewer the firsthand experience of seeing objects from Alexander's era and the Hellenistic period, many of which have never been seen before by the public.

I would like to thank all the participating museums for their willing support of this exhibition. In particular I wish to thank the Prime Minister and Minister for Culture, Kostas Karamanlis; the Alternate Minister for Culture, Fani Palli-Petralia; the Deputy Minister for Culture, Petros Tatoulis; and the General Secretary for Culture, Christos Zachopoulos for their generosity in approving the release of so many objects from recent Greek excavations.

The Alexander S. Onassis Public Benefit Foundation and its president, Stelio Papadimitriou, embraced this endeavor and enabled its successful realization, supporting every stage of its development. The Executive Director of the Onassis Foundation, New York, Ambassador Tsilas, and the Foundation's Director of Cultural Events, Amalia Cosmetatou, provided invaluable assistance, ideas, and problem-solving in the course of the exhibitions preparations.

My colleagues collaborated enthusiastically in the realization of the exhibition and this catalogue. I would like to thank Dr. Adam-Veleni, Mr. Manthos Bessios, Professor Frank L. Holt, Dr. Angeliki Kottaridi, Dr. Maria Lilibaki-Akamati, Professor Stella Miller-Collett, Ms. Eleni Trakosopoulou, and Dr. Maria Tsimbidou-Avloniti.

I am delighted to once again have had the pleasure of a productive collaboration with Dan Kershaw, the exhibition designer; Alexandra Doumas, the translator; Sophia Geronimus, the graphic designer; and Pamela Barr, the editor. My thanks also to Frederick Lauritzen for his research assistance in New York.

Finally, the daily efforts of my associates Niki Dollis, Korinna Vastelli, and Naya Charmalia made my task in preparing this exhibition much easier.

Dimitrios Pandermalis
Professor of Classical Archaeology
Aristotle University of Thessaloniki

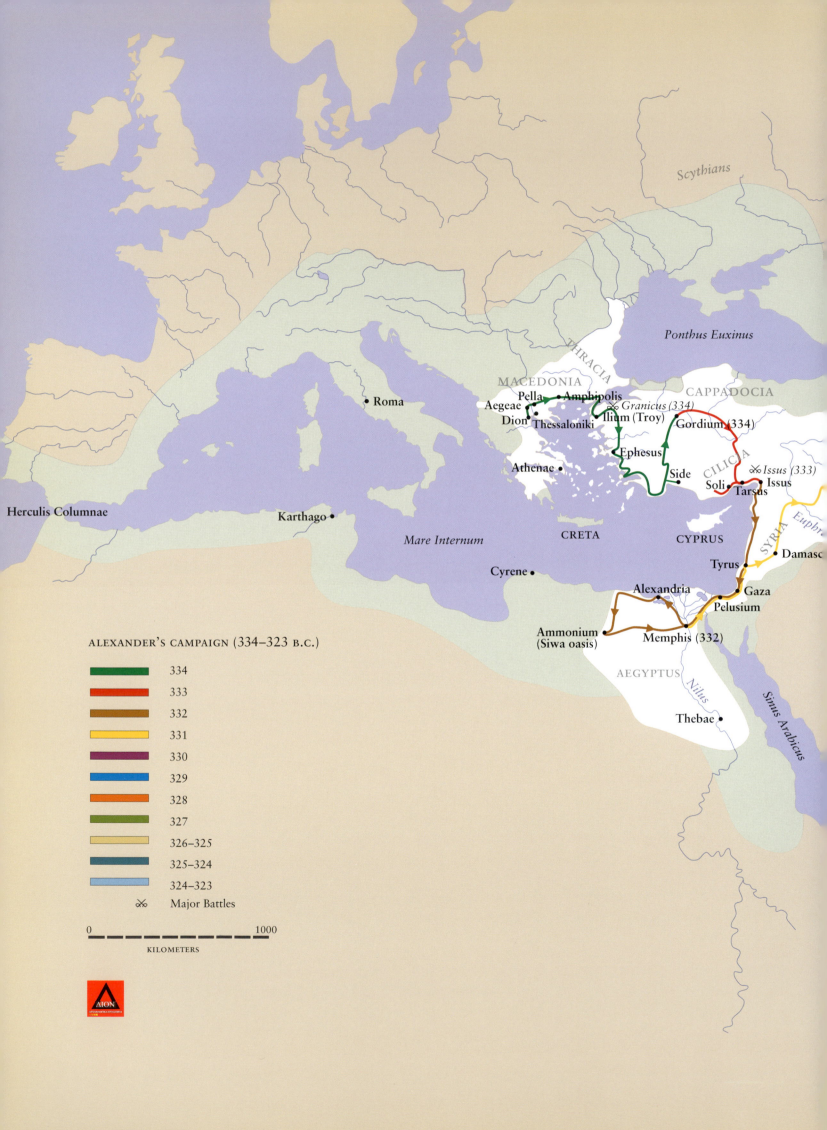

Scythians

Ponthus Euxinus

THRACIA

MACEDONIA
CAPPADOCIA

Pella • Amphipolis
Aegeae
Dion • Thessaloniki
Ilium (Troy)
⚔ *Granicus (334)*
Gordium (334)

Roma

Ephesus
CILICIA
⚔ *Issus (333)*

Athenae
Side
Soli Issus
Tarsus

Herculis Columnae

Karthago

Mare Internum
CRETA
CYPRUS
SYRIA
Euphr.

Damasc

Tyrus

Cyrene
Alexandria
Gaza
Pelusium

Ammonium
(Siwa oasis)
Memphis (332)

AEGYPTUS
Nilus
Sinus Arabicus

Thebae

ALEXANDER'S CAMPAIGN (334–323 B.C.)

🟩	334
🟥	333
🟫	332
🟨	331
🟪	330
🟦	329
🟧	328
🟩	327
🟨	326–325
🟦	325–324
🟦	324–323
⚔	Major Battles

0 — — — — — — — — 1000

KILOMETERS

ΔΙΟΝ

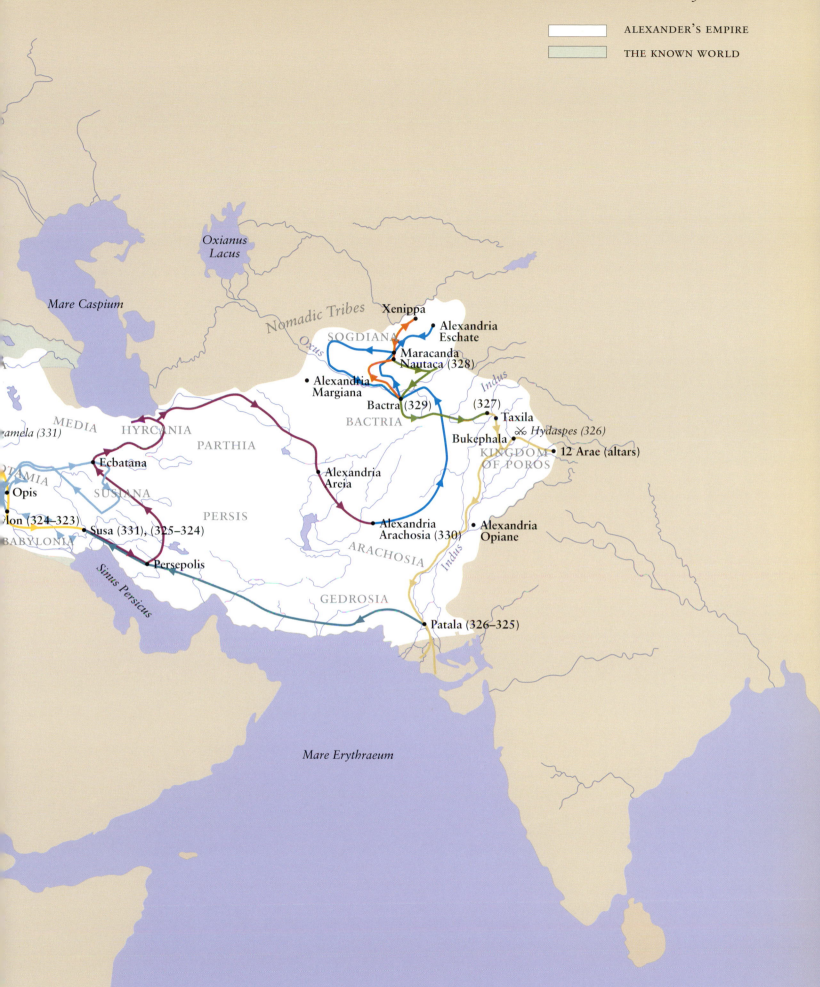

ALEXANDER'S EMPIRE

THE KNOWN WORLD

Oxianus Lacus

Mare Caspium

Xenippa

Alexandria
Eschate

Nomadic Tribes

SOGDIANA

Oxus

Maracanda
Nautaca (328)

Indus

Alexandria
Margiana

Bactra (329)

(327)

MEDIA

HYRCANIA

BACTRIA

Taxila

Hydaspes (326)

...mela (331)

PARTHIA

Bukephala

KINGDOM
OF POROS

12 Arae (altars)

Ecbatana

...OTAMIA

Opis

SUSIANA

Alexandria
Areia

PERSIS

Alexandria
Arachosia (330)

Alexandria
Opiane

...lon (324–323)

Susa (331), (325–324)

ARACHOSIA

Indus

BABYLONIA

Persepolis

Sinus Persicus

GEDROSIA

Patala (326–325)

Mare Erythraeum

THE PORTRAITS OF ALEXANDER

Dimitrios Pandermalis

In 338 B.C. Philip II commissioned a gallery of portraits of his royal family to be placed in Olympia in the sanctuary of the Olympic Zeus—the most famous in the ancient world for its pan-Hellenic character—in order to underline his status as leader of the Greeks and his primacy over the Persians. The youngest member of the family to be immortalized in these chryselephantine portraits was Alexander the Great, just sixteen years of age. We know the sculptor of this portrait to be the artist Leochares, who was famous for his statue of the gods. Pausanias (*Description of Greece* 5, 20, 9–10) tells us that the statue was made of gold and ivory—a precious chryselephantine. A few years later, another famous sculptor of bronze statues, Lysippos, who was from the northern Peloponnesos and who had worked in the court of Pella for Philip, created *Alexander with a Lance*, described by Plutarch in *De Alexandri Fortuna* (2.2). In this statue Lysippos incorporated the tilt of Alexander's neck, a physical peculiarity that caused Alexander's head to have a slightly upward angle, but gave the impression that Alexander was in fact addressing Zeus, the father of the gods. Lysippos also gave Alexander a sharp and penetrating look, unlike portraits that emphasize the glistening (υγρότης) eyes that he is said to have had. Known to have been a man of small dimensions, Alexander was depicted with a regal presence suitable to his role as leader, and the renderings of his full mass of hair and well-known cowlick portray the king as virile and leonine. Unfortunately, no sculpture survives, so the ancient descriptions of *Alexander with a Lance* cannot be verified. The type can be recognized in some bronzes statuettes, namely the Fouquet from Egypt (Musée du Louvre, Paris), dating to approximately 330 B.C. and thought to be the closest to Lysippos' work, and two variations, one Hellenistic (Stanford University, Stanford, Calif.) and one Roman (Harvard University, Cambridge) found in Macedonia.

A second famous statue made by Lysippos was *Alexander on Horseback*, taken from a composition of twenty-five equestrians who fell in the battle of Granikos in May 334 B.C. The original monumental sculpture was at Dion, in the great sanctuary of the Olympic Zeus at the foothills of Mount Olympus, whence Alexander started his campaign after making his ceremonial sacrifice. The Roman general Q. Caecilius Metellus transported this monumental composition of Alexander with his Macedonians to Rome in 146 B.C. The *Statuette of Herculaneum* (Museo Archeologico Nazionale, Naples) echoes this masterpiece.

In antiquity it was said that Alexander issued an edict that only Lysippos should cast his image in bronze, that only Apelles should paint him, and that only Pyrgoteles should engrave his image on gems (Pliny, *Naturalis Historia* 7, 125). In Apelles' most famous painting of Alexander, Alexander is said to have been portrayed bearing a thunderbolt in his hand like Zeus. The painting was in the temple of Artemis at Ephesos, the most celebrated sanctuary in Asia Minor. The ancients admired this painting, saying that Philip's Alexander was invincible but that Apelles' Alexander was inimitable (Plutarch, *De Alexandri Fortuna* 2, 2). A painting in the House of the Vetti in Pompeii provides some idea of the prototype. There are no surviving works by Pyrgoteles. It is possible that the obverse of three medallions from Abu Qir, Egypt, with frontal portraits of Alexander, reflect the original creations of the king's engraver.

There are many portraits preserved from Antiquity that have been identified with Alexander the Great. A great number of these are in fact unrelated, as proved by detailed research, and the majority are copies of the Roman period. Only a few are originals from the Hellenistic period, among them the bust of Alexander from Priene and the Alexander from

Magnesia-by-Sipylos (second century B.C.). The portrait from the Athenian Acropolis (340–330 B.C.) and the portrait from Pella (early third century B.C.) include some of the well-established features of Alexander known from ancient sources but bring freshness to the king's image.

The latest presentation of Alexander the Great in the Hellenistic style is the one on silver tetradrachms issued in the early first century B.C. by Aesillas, the Roman quaestor of Macedonia. The coins were produced as a means of raising the morale and bolstering the resolve of the Macedonian army against foreign enemies in the area.

Later in the first century B.C. the Roman general Pompey became a great admirer of Alexander. He issued portraits showing himself with a small cowlick and melting eyes in order to be likened to Alexander. Julius Caesar adopted a statue of Alexander the Great, changing its head to his own, and Augustus sealed his official documents with a stamp that bore Alexander's image. The greatest revival of interest in Alexander the Great, however, came in the third century A.D. Most of the emperors—including Caracalla (r. A.D. 211–17), Severus Alexander (r. A.D. 222–35), Gordian III (r. A.D. 242–43), and Philip the Arab (r. A.D. 244–49)—encouraged the growth of the cult of Alexander as God, promoted the construction of statues of Alexander, and in various ways drew direct political comparisons between the king's life and their own. Caracalla was perhaps the most obsessed, using weapons in battle and drinking cups in the symposia that were said to have belonged to Alexander. He also outfitted the Macedonian phalanx of sixteen thousand soldiers with weapons and equipment much like Alexander's Macedonian army. Caracalla even boasted that he was the incarnation of Alexander the Great.

The impact of this revival of Alexander was obvious in Macedonia. Beroea organized illustrious games called the Alexandreia-Olympia to honor the glorious king of the past. Three official announcements inscribed on marble slabs have been found from the games, dated A.D. 229, 240, and 252, respectively. The victors of the games were given gold medallions (the νικητήρια), most of which bore portraits of Alexander on the obverse. Twenty of these precious pieces—three with the portrait of Emperor Caracalla—were found in Abu Qir in 1902. Another three medallions—among them a multiple gold coin (X8) of the emperor Severus Alexander—were found in Tarsus, an ancient city in south Asia Minor. A third medallion from the Abu Qir finds bears the inscription ΟΛΥΜΠΙΑ, indicating the games, and the year ΔΟC (A.D. 242–43). In general, the medallions from Tarsus date from about A.D. 230 and those from Abu Qir from A.D. 230 to 250. The obverse of the medallions with the image of Alexander the Great seems to follow the monumental iconographical tradition, whereas the reverse derives from the miniatures in the illustrated edition of the *Alexander Romance*, which was widely disseminated in the third century A.D.

Ioannes Chrysostomos, a distinguished father of the Christian church in the late fourth century A.D., provides interesting insight into the significance of Alexander's portrait in that late period of Antiquity: common people are said to have used the coins bearing Alexander's likeness as amulets, binding them around their heads and ankles in expectation of being protected by the Greek king's image.

BIBLIOGRAPHY

Alexander the Great, Reality and Myth. Analecta romana instituti danici, suppl. 20 (1993).

Bieber, M. *Alexander the Great in Greek and Roman Art.* Chicago, 1964.

Grammenos, D., ed. *Ρωμαϊκή Θεσσαλονίκη.* Thessaloniki, 2003.

Hölscher, T. *Ideal und Wirklichkeit in den Bildnissen Alexanders des Grossen.* Heidelberg, 1971.

Kiilerich, B. "Physiognomics and the Iconography of Alexander the Great." *Symbolae Osloenses* 53 (1988), pp. 51–56.

Papisca, M. *Immagini della imitatio Alexandri in eta Severiana.* Ancient Macedonia, VI International Symposium. Thessaloniki, 1999, pp. 859–71.

Richter, G. H. A. *The Portraits of the Greeks III.* London, 1965, pp. 255–57.

Rizakis, A., and I. Touratsoglou. *Λατρείες στην Ανω Μακεδονία.* Ancient Macedonia, VI International Symposium. Thessaloniki, 1999, pp. 949–64.

Schreiber, T. *Studien über das Bildnis Alexanders des Grossen.* Leipzig, 1903.

Smith, R. R. R. *Hellenistic Royal Portraiture.* Oxford, 1989.

Stewart, A. *Faces of Power.* Berkeley, 1993.

Touratsoglou, I. *The Alexander of the Coins.* Lectures on the History of Coinage 2 (The Bank of Cyprus). Nicosia, 2000.

Toynbee, J. M. C. "Greek Imperial Medallions." *Journal of Roman Studies* 34 (1944), pp. 65–73.

Voutiras, E. *Οι απεικονίσεις του Μεγάλου Αλεξάνδρου στην Αρχαία Τέχνη.* Exhib. cat. Thessaloniki, 1997, pp. 18–23.

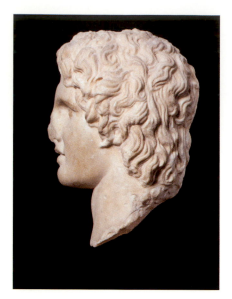 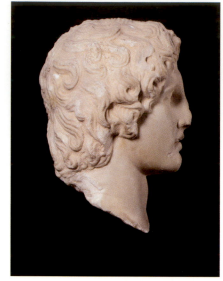

1. PORTRAIT OF ALEXANDER
340–330 B.C.
Pentelic marble
Height 0.35 m
Found near the Erectheion,
Acropolis of Athens, 1886
Acropolis Museum, Athens
(Aκρ. 1331)

The head turns to the right, as indicated by the assymetries of the face and the slight torsion of the neck. The long, thick locks of hair are unusual for the period and careful examination reveals many traces of red coloring, apparently the base for golden-colored hair. (Aelian, *Varia historia* 12.14). These characteristics combine to emphasize the leonine appearance of Alexander, frequently referred to in ancient texts. Looking at the head from behind, the tapering of the hair midhead indicates the earlier presence of a wreath or band. Above the right eye the strands of hair create the famous cowlick, also present in the portraits of the Roman general Pompey, who believed a cowlick would give him a likeness to Alexander the Great (Plutarch, *Life of Pompeius* 2). The youthful portrait shows the deep-set eyes typical of portraits of Alexander the Great. The prominent brow further shadows the hollows of the eyes, intensifying the king's expression.

The identification of the portrait of the Acropolis Alexander was made on the basis of the essential similarities with the marble Herm of Azara (Musée du Louvre, Paris), which bears the inscription "Alexander [son] of Philip, Macedon." While there is no doubt about the identity of the portrait from the Acropolis, there is some disagreement about whether it dates from the fourth century B.C. A typical replica of the Acropolis Alexander is that of the Erbach Alexander, which is Hadrianic in manner. Comparison however of the Acropolis Alexander with heads of young people from Attic grave stones of the late fourth century B.C. strengthens its dating to that time.

M. Brouskari, *Musée de l'Acropole* (1974), p. 184; A. Stewart, *Faces of Power* (Berkeley, 1993), pp. 106–13; E. Harrison, "Macedonian Identities in Two Samothracian Coffers," in *Αγαλμα* [*Festschrift für Giorgios Despinis*] (2001), pp. 285–90.

D.P.

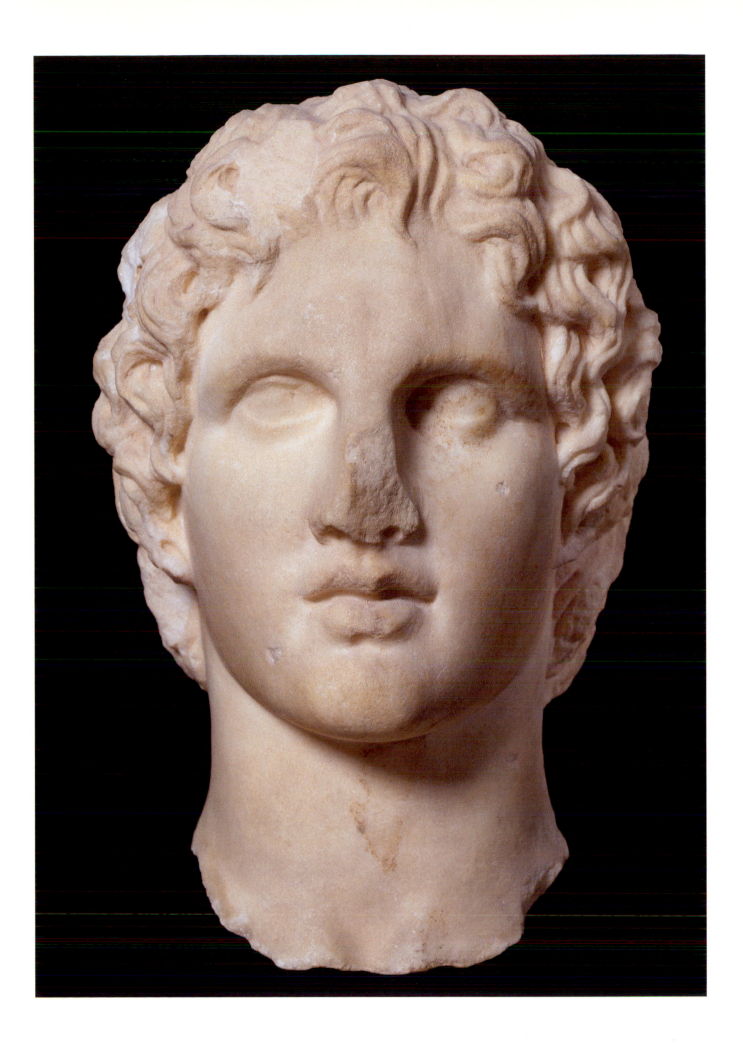

2. MARBLE HEAD OF ALEXANDER
Early 3rd century B.C.
Marble
Height 0.32 m
Found approx. 6 km west of Pella,
in the area of Yanitsa, Greece
Archaeological Museum of Pella
(ΓΛ 15)

This portrait, which possesses an expressionistic dynamic, is characterized by the outstanding mass of hair and the distinctive turn and inclination of the head. Long locks of hair frame Alexander's smooth fresh face and strengthen his leonine appearance. Some of the king's successors adopted this kind of hair mass as a symbol of their royal status. The shadowed, deep-set eyes and the slightly open mouth add an unusual pathos to the portrait. The presence of the cowlick confirms the portrait as a likeness of Alexander. The clear treatment of the surface and the dry style of the sculptor's work, characteristic of the early third century B.C., are replete with the charismatic features that demonstrate Alexander's royal distinction and youthful energy.

M. Siganidou, in *The Search for Alexander*, exhib. cat. (Boston, 1980), p. 181, no. 155, fig. p. 180, and color pl. 25; A. Stewart, *Faces of Power* (Berkeley, 1993), pp. 284–86, fig. 97.

D.P.

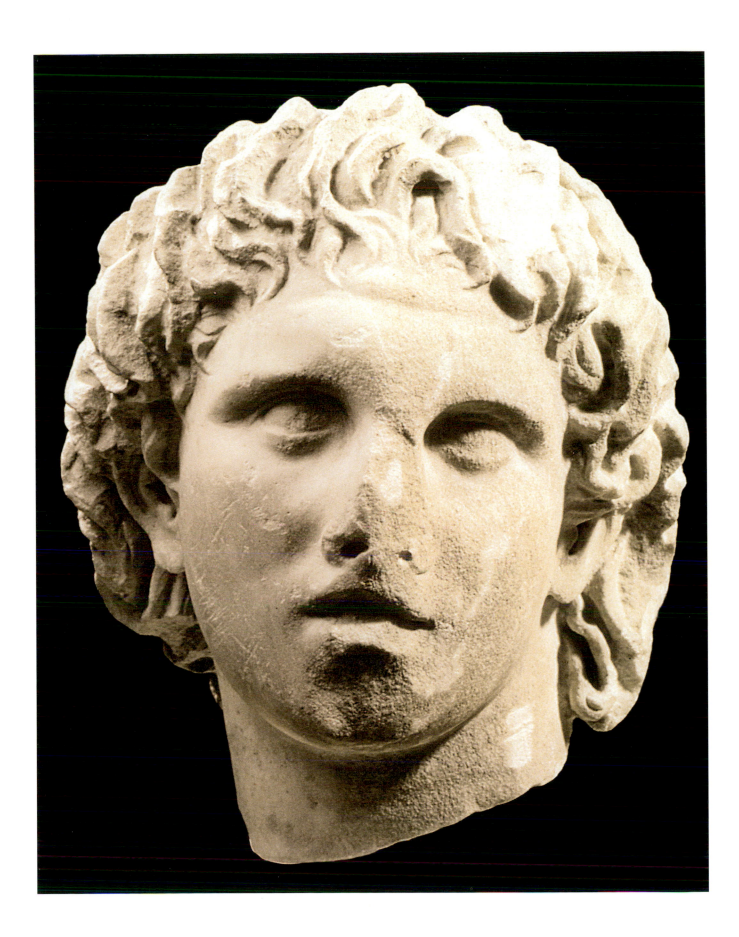

3. STATUETTE OF PAN-ALEXANDER
Early 3rd century B.C.
Marble
Height 0.375 m
From a residential quarter of Pella
Archaeological Museum of Pella
(ΓΛ 4)

The statuette is identified as the god Pan because of the pointed ears, the stump of a tail, the posture of the body, and the presence of the two small horns. Some basic facial characteristics are reminiscent of portraits of Alexander the Great, however, and the presence of the band-diadem on the head allows the hypothesis that the statuette is a Pan-Alexander. Athenians believed that Pan was involved in the battle of Marathon in 490 B.C., generating panic among the enemy. Similarly, King Antigonas Gonatas believed that Pan helped him win the war against the Celts in the decisive battle of Lysimacheia in 277 B.C. To commemorate the victory, the king produced a series of silver tetradrachms on which he placed his own portrait, presented with two small horns to honor the god of fear and a band-diadem to indicate his own royal status.

M. Siganidou, in *The Search for Alexander*, exhib. cat. (Boston, 1980), p. 179, no. 153, color pl. 25; A. Stewart, *Faces of Power* (Berkeley, 1993), pp. 284–86, fig. 97.

D.P.

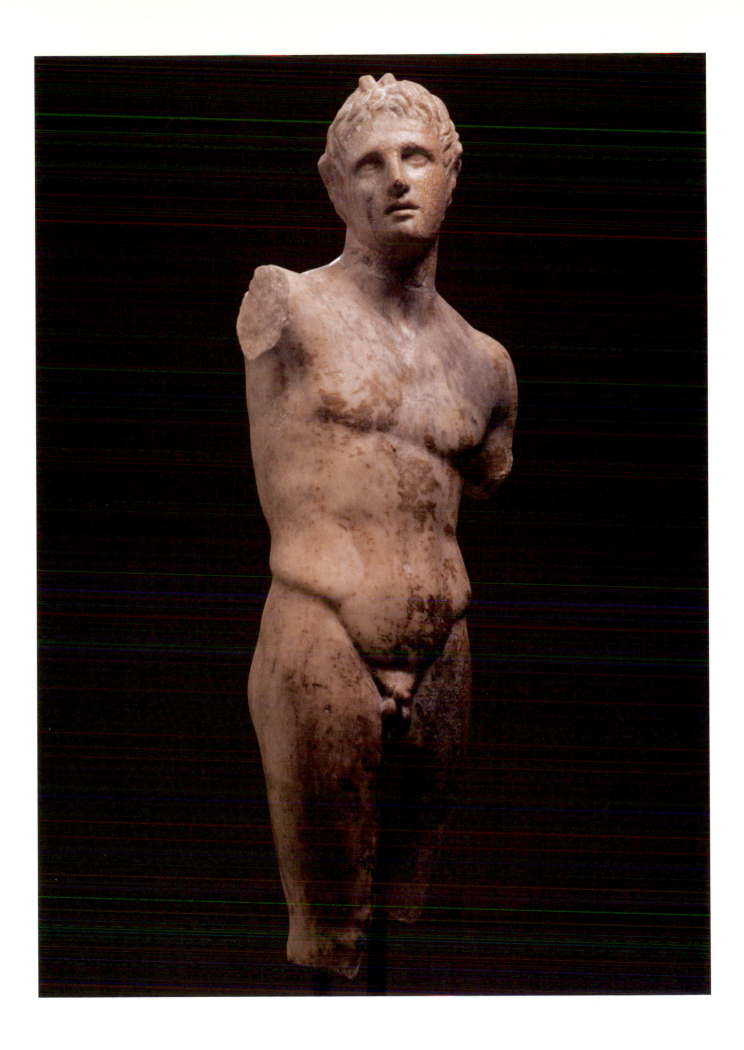

4. EQUESTRIAN ALEXANDER

1st century B.C.
Bronze
Height 0.51 m
Found at Herculaneum in 1761
Museo Archeologico Nazionale,
Naples (4996)

Found at Herculaneum with a similarly made riderless horse, this statuette of Alexander—his status denoted by the diadem he wears—dates from the first century B.C. The king is preparing to deliver a fatal blow with his sword. The work is daring and full of dynamism, and shows exceptional attention to detail. The diadem is flat and the full mass of hair is that of Alexander, but the piece shows influences of contemporary Roman art. Undoubtedly, it was inspired by a bronze masterpiece. Many consider the piece to be a copy of a work by Lysippos, and some have suggested that it is linked to the group of bronze statues he created for Alexander and placed at Dion, depicting the elite horsemen who fell at the battle of Granikos.

G. Calcani, *Cavalieri di bronzo: La torma di Alessandro opera di Lisippo* (1989); A. Stewart, *Faces of Power* (Berkeley, 1993), pp. 123–24, 127–28, fig. 21.

D.P.

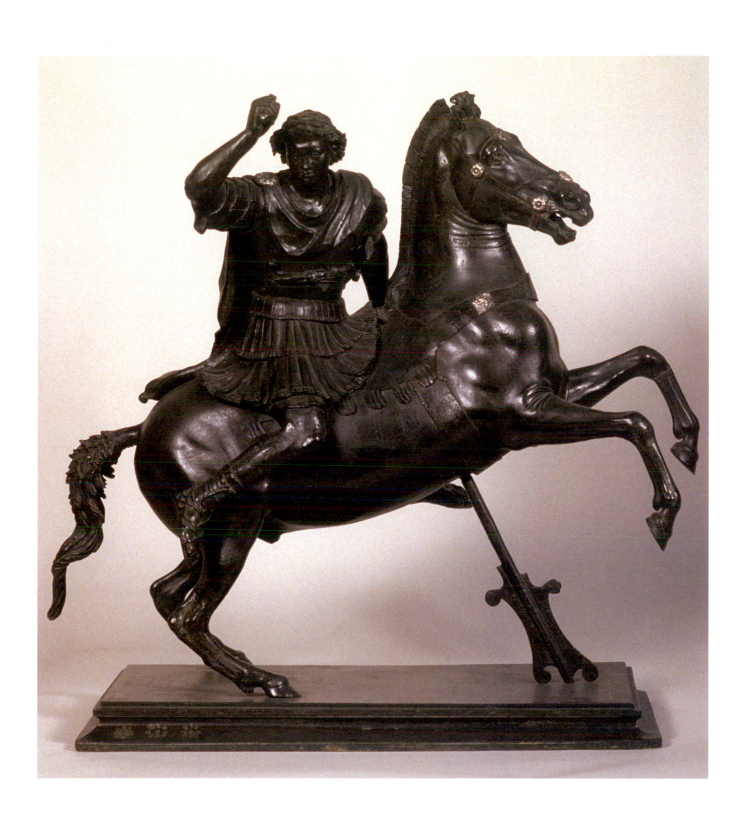

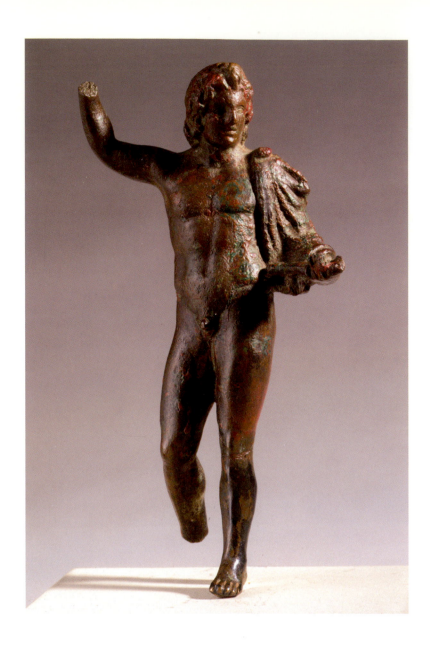

5. ALEXANDER THE GREAT
 Hellenistic
 Bronze
 Height 0.105 m
 Iris & B. Gerald Cantor Center for Visual Arts,
 at Stanford University, Hazel Hansen Fund
 (1975.47)

This statuette of hollow cast bronze shows
Alexander naked but for his cloak, which falls
from his shoulder toward his left hand in which
he carries a sheathed sword. His other upraised
hand would have held a spear. There are nine replicas
of this type of statue, which is associated with the
sculptor Lysippos. The posture of the body, the way
in which the eyes have been set deep into the sockets,
and the abundance of hair suggest that the statue
dates from the Hellenistic period.

M. Bieber, *Alexander the Great in Greek and
Roman Art* (Chicago, 1964), p. 65, fig. 72;
A. Stewart, *Faces of Power* (Berkeley, 1993),
pp. 163–71, fig. 39.

D.P.

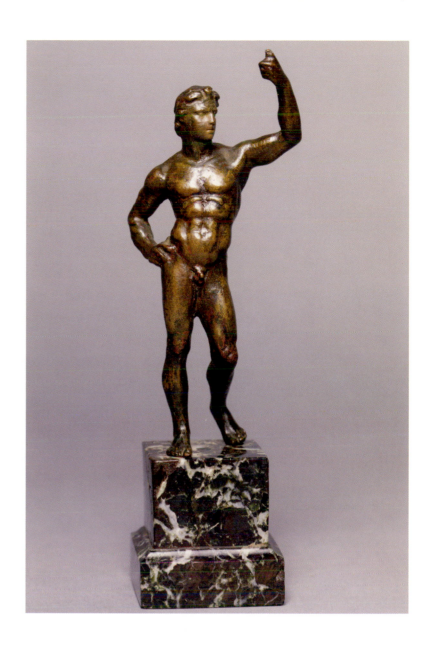

6. ALEXANDER WITH A LANCE

Roman, early 3rd century A.D.
Bronze
Height 0.12 m
From Macedonia, by way of the Istanbul bazaar
Courtesy of the Arthur M. Sackler Museum,
Harvard University Art Museums,
Gift of Mr. C. Ruxton Love, Jr. (1956.20)
Photograph: Michael A. Nedzweski
© 2004 President and Fellows of Harvard College

Plutarch (*De Iside et Osiride* 24) described a famous work by Lysippos in which Alexander is presented as a warrior with a lance. This bronze statuette represents Alexander with his left hand raised and holding a lance, as Lysippos would have portrayed him. The relaxed pose, with the right hand resting on the hip, and the summary rendering of details indicate a date in the Roman period, probably in the first half of the third century A.D., when interest in Alexander was rekindled.

L. Pollak, *Klassisch-Antike Goldschmiedearbeiten im Besitze Sr. Excellenz A. J. von Nelidow* (1903), pp. 3 (front), 139 (back), 184 (profile to right), 198 (text); *Ancient Art in American Private Collections,* exhib. cat., Fogg Art Museum (1954), pp. 31–32, no. 220, pl. 62; D. Buitron, "The Alexander Neilidow: A Renaissance Bronze?" *Art Bulletin* 55, no. 3 (1973), pp. 393–400; A. Stewart, *Faces of Power* (Berkeley, 1993), pp. 163–71, fig. 35.

D.P.

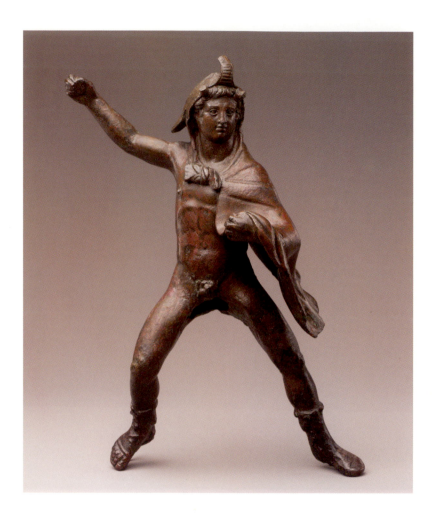

7. RIDER WEARING AN ELEPHANT SKIN
 Late Hellenistic
 Bronze
 Height 0.248 m
 From Athribis in the Nile Delta
 The Metropolitan Museum of Art, New York,
 Edith Perry Chapman Fund, 1955 (55.11.11)
 Photograph © 2003 The Metropolitan Museum
 of Art

This bronze figure from Egypt represents a mounted warrior who once held a weapon, now lost, in his raised right hand and uses an elephant skin as a helmet and cuirass. As Alexander is represented with a similar elephant skin on the silver tetradrachms that were minted by Ptolemy I of Egypt, this statuette may represent Alexander as ruler of Egypt. The rendering of the facial features is simplified.

For related figures with elephant skin, see H. Sauer, in *Festschrift E. von Mercklin* (1964), pp. 152ff.; on the Metropolitan statuette, see ibid., pp. 156ff., pl. 54. See also M. Bieber, *Alexander the Great in Greek and Roman Art* (Chicago, 1964), figs. 40–42, for coin portraits with elephant skin; and G. M. A. Richter, *The Portraits of the Greeks* (London, 1965), vol. 3, fig. 1972. For comparison, see A. Stewart, *Faces of Power* (Berkeley, 1993), pp. 172–73, fig. 52.

D.P.

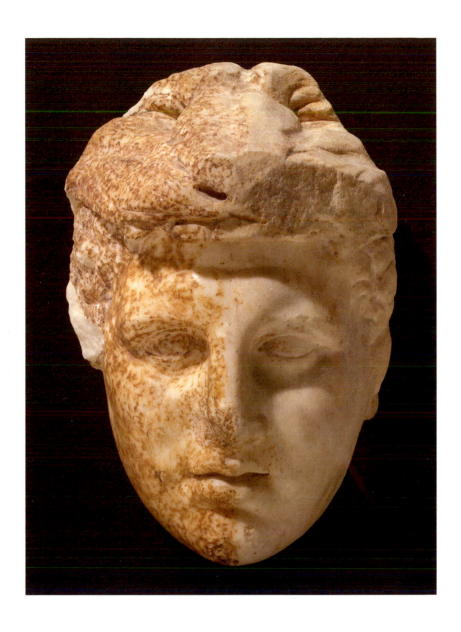

8. HEAD OF ALEXANDER-HERAKLES
Probably late 4th century B.C.
Marble
Height 0.24 m
Said to have been found at Sparta
Museum of Fine Arts, Boston,
Otis Norcross Fund (52.1741)
Photograph © 2004 Museum of Fine Arts, Boston

It is almost impossible to reconstruct the figure from which this head came and it is uncertain whether it is a representation of Alexander or Herakles. Other heads exist with a lion skin helmet—for example, the head from Ilissos formerly at the Museum of the Acropolis and now at the 1st Ephorate of Prehistoric and Classical Antiquities—and some have been identified as Alexander, others as Herakles. The Boston head shares many characteristics with the mounted Alexander at the Sarcophagus of Abdalonymus in Constantinople.

M. Bieber, *Alexander the Great in the Greek and Roman Art* (Chicago, 1964), p. 52, figs. 39A, B; M. Comstock and C. Vermeule, *Sculpture in Stone* (1976), no. 127 (with full citation of earlier literature); C. Vermeule, in *The Search for Alexander*, exhib. cat. (Boston, 1980), pp. 100–101, cat. no. 5. For the head in the Acropolis Museum found in Ilissos, see M. Bieber, *op. cit.*, fig. 38. See also A. Stewart, *Faces of Power* (Berkeley, 1993), p. 282, fig. 77.

D.P.

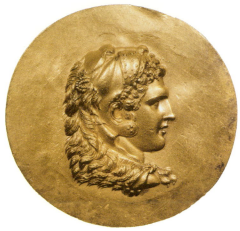 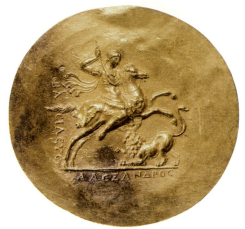

9. MEDALLION:
ALEXANDER THE GREAT
Ca. A.D. 230
Gold
Diameter 0.067 m, weight 98.7 g
From Tarsus
Bibliothèque nationale de France,
Cabinet des Médailles et Antiques,
Paris (F 1671)
Photograph © Bibliothèque nationale
de France

Obverse: Bust of Alexander the Great (r.)
The famous silver tetradrachm of Alexander
the Great depicts young Herakles with
a lion skin. After Alexander's death, the
figure of Herakles represented on the
coins of his successors became Alexander.
There is no question that it is Alexander
the Great that is represented on the gold
medallions of the third century A.D.

Reverse: Alexander on Horseback,
Spearing a Lion
The identification is based on the
inscription, *ΒΑCΙΛΕΥC ΑΛΕΞΑΝΔΡΟC*.
The lion hunt was one of the most popular
interests of the royal court of Alexander,
and ancient texts refer to the monuments
that commemorate them. The style of
the scene on this medallion indicates a
prototype of the Roman Imperial period,
perhaps from the illuminated edition
of the *Alexander Romance*.

H. Dressel, *Fünf Goldmedallions aus dem
Funde von Abukir*. Abhandlungen der
preussischer Akademie der Wissenschaft
zu Berlin, Klasse für Sprachen, Literatur,
und Kunst, no. 2 (Berlin, 1906); J. M. C.
Toynbee, "Greek Imperial Medallions,"
Journal of Roman Studies 34 (1944),
pp. 65–73; J. Gage, "Alexandre Le Grand
en Macédoine dans la 1ère moitié du IIIe
siècle après J.-C.," *Historia* 24 (1975),
pp. 1–16; M. Papisca, *Immagini della
imitatio Alexandri in eta severiana*,
Ancient Macedonia, VI International
Symposium (Thessaloniki, 1999), pp.
859–71; I. Touratsoglou, *The Alexander
of the Coins*. Lectures on the History
of Coinage 2 (The Bank of Cyprus)
(Nicosia, 2000).

D.P.

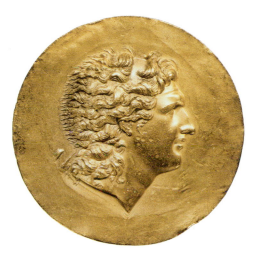 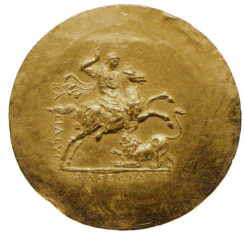

10. MEDALLION:
ALEXANDER THE GREAT
Ca. A.D. 230
Gold
Diameter 0.07 m, weight
110.31 g
From Tarsus
Bibliothèque nationale de
France, Cabinet des Médailles
et Antiques, Paris (F 1672)
Photograph © Bibliothèque
nationale de France

Obverse: Head of Alexander with
a Diadem (r.)
The windswept hair gives expression
to the king's temperament. He looks up
with his face turned toward the heavens,
a reference to the official statue made
by Lysippos in which Alexander looks
upward to Zeus. A variation of this
portrait appears on three medallions
from Abu Qir that depict Alexander
wearing the horns of Amonn-Zeus, his
father, indicating his legendary origins.

Reverse: Alexander on Horseback,
Spearing a Lion

H. Dressel, *Fünf Goldmedallions aus dem
Funde von Abukir*. Abhandlungen der
preussischer Akademie der Wissenschaft
zu Berlin, Klasse für Sprachen, Literatur,
und Kunst, no. 2 (Berlin, 1906); J. M. C.
Toynbee, "Greek Imperial Medallions,"
Journal of Roman Studies 34 (1944),
pp. 65–73; J. Gage, "Alexandre Le Grand
en Macédoine dans la l[ère] moitié du IIIe
siècle après J.-C.," *Historia* 24 (1975),
pp. 1–16; M. Papisca, *Immagini della
imitatio Alexandri in eta severiana*,
Ancient Macedonia, VI International
Symposium (Thessaloniki, 1999), pp.
859–71; I. Touratsoglou, *The Alexander
of the Coins*. Lectures on the History
of Coinage 2 (The Bank of Cyprus).
(Nicosia, 2000).

D.P.

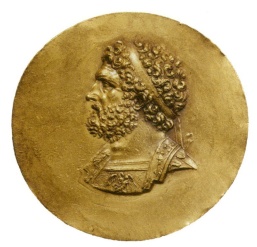
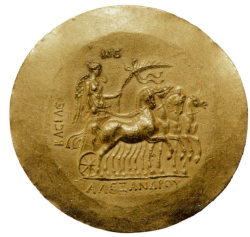

11. MEDALLION:
PHILIP II OF MACEDON
A.D. 230
Gold
Diameter 0.067 m, weight 98.83 g
From Tarsus
Bibliothèque nationale de France,
Cabinet des Médailles et Antiques,
Paris (F 1673)
Photograph © Bibliothèque
nationale de France

Obverse: Bust of Philip II of Macedon (r.)
Philip II wears a king's diadem in his
curly hair and a ceremonial cuirass
depicting both the Rape of Ganymede
by Zeus in the Form of an Eagle and, on
the shoulder straps, figures of Nike and
thunderbolts. The portrait represents a
bearded mature man, and, though modi-
fied in the style of the Roman Imperial
period, is likely based on an original of
the fourth century B.C. The three-quarter
turn of the bust toward the front recalls
the theatrical portrait poses of Caracalla.

Reverse: Nike Driving a Ceremonial
Quadriga (r.)
The winged goddess commands a quadriga
(a chariot drawn by four horses abreast)
while holding a long palm branch with a
headband for the victor. The inscription,
ΒΑCΙΛΕΩC ΑΛΕΞΑΝΔΡΟΥ, shows the
presentation relates to Alexander the
Great.

H. Dressel, *Fünf Goldmedallions aus dem
Funde von Abukir.* Abhandlungen der
preussischer Akademie der Wissenschaft
zu Berlin, Klasse für Sprachen, Literatur,
und Kunst, no. 2 (Berlin, 1906); J. M. C.
Toynbee, "Greek Imperial Medallions,"
Journal of Roman Studies 34 (1944),
pp. 65–73; J. Gage, "Alexandre Le Grand
en Macédoine dans la 1ère moitié du IIIe
siècle après J.-C.," *Historia* 24 (1975),
pp. 1–16; M. Papisca, *Immagini della
imitatio Alexandri in eta severiana,*
Ancient Macedonia, VI International
Symposium (Thessaloniki, 1999), pp.
859–71; I. Touratsoglou, *The Alexander
of the Coins.* Lectures on the History of
Coinage 2 (The Bank of Cyprus).
(Nicosia, 2000).

D.P.

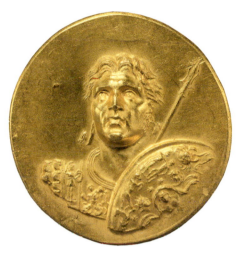
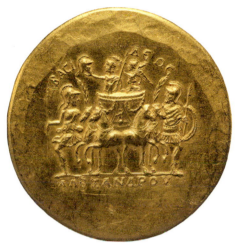

12. MEDALLION:
ALEXANDER THE GREAT
A.D. 230–50
Gold
Diameter 0.054 m, weight 95 g
From Abu Qir
The Walters Art Museum, Baltimore,
Maryland (59.1)

Obverse: Bust of Alexander Gazing
Upward
This portrait of Alexander shows him
with his hair drawn back (την μεν γαρ
κομην αναaεσυρθαι αυτω . . . (Aelian, *Varia
historia* 12.14). He wears a decorated
cuirass with a figure of Athena on the
shoulder strap and, on the chest, a scene
from the Gigantomachy (War of the
Giants)—a giant preparing to hurl a rock.
Alexander holds a spear and a shield. At
its middle, the shield has a representation
of a female figure holding up her himation,
which forms an arch. She symbolizes Gaia
(Earth), and, above her, the sun, the moon,
and six stars represent the heavens. Five
symbols of the zodiac—Aries, Taurus,
Gemini, Cancer, and Leo—are also visible.
This is a representation of the universe,
which, according to the legends of Late
Antiquity, Alexander wanted to dominate.

Reverse: A Quadriga Bearing Alexander
and Nike
The king, who wears a cuirass, carries a
spear in his left hand and a helmet in his
outstretched right hand. From behind,
the winged goddess bestows him with
a crown. At the front of the quadriga
(a chariot drawn by four horses abreast)
are two larger figures who lead the way.

On the left is a female in a short chiton with
her right breast exposed, wearing a helmet
and holding a spear—a personification of
Roma or Virtus. The figure on the right,
an armed cuirassier, is probably the god
of war, Ares or Mars. The inscription,
ΒΑCΙΛΕΩC ΑΛΕΞΑΝΔΡΟΥ, confirms
that the reference is to Alexander, and
the subject, of course, is the coronation
of a triumphant general.

H. Dressel, *Fünf Goldmedallions aus dem
Funde von Abukir.* Abhandlungen der
preussischer Akademie der Wissenschaft
zu Berlin, Klasse für Sprachen, Literatur,
und Kunst, no. 2 (Berlin, 1906); J. M. C.
Toynbee, "Greek Imperial Medallions,"
Journal of Roman Studies 34 (1944),
pp. 65–73; J. Gage, "Alexandre Le Grand
en Macédoine dans la 1ère moitié du IIIe
siècle après J.-C.," *Historia* 24 (1975),
pp. 1–16; M. Papisca, *Immagini della
imitatio Alexandri in eta severiana,*
Ancient Macedonia, VI International
Symposium (Thessaloniki, 1999), pp.
859–71; I. Touratsoglou, *The Alexander
of the Coins.* Lectures on the History of
Coinage 2 (The Bank of Cyprus).
(Nicosia, 2000).

D.P.

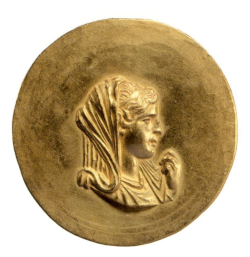
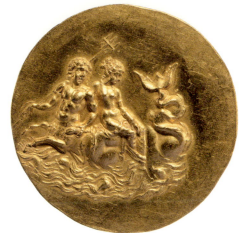

13. MEDALLION: OLYMPIAS
 A.D. 230–50
 Gold
 Diameter 0.054 m, weight 62 g
 From Abu Qir
 The Walters Art Museum, Baltimore,
 Maryland (59.2)

Obverse: Veiled Bust of Olympias (r.)
Another medallion with the same type
of portrait shows Olympias holding a
scepter in the right hand.

Reverse: A Sea Centaur Carrying a
Nereid on His Back
In his right hand the centaur holds a
trident and in his left a fish. Alexander's
mother, Olympias, descended from a noble
family from Epirus that claimed to derive
from Thetis, who was from the world of
the sea and whose companions were the
Nereids. This imagery vividly depicts
the mythological environment to which
Thetis belonged.

H. Dressel, *Fünf Goldmedallions aus dem
Funde von Abukir*. Abhandlungen der
preussischer Akademie der Wissenschaft
zu Berlin, Klasse für Sprachen, Literatur,
und Kunst, no. 2 (Berlin, 1906); J. M. C.
Toynbee, "Greek Imperial Medallions,"
Journal of Roman Studies 34 (1944),
pp. 65–73; J. Gage, "Alexandre Le Grand
en Macédoine dans la 1ère moitié du IIIe
siècle après J.-C.," *Historia* 24 (1975),
pp. 1–16; M. Papisca, *Immagini della
imitatio Alexandri in eta severiana*,
Ancient Macedonia, VI International
Symposium (Thessaloniki, 1999), pp.
859–71; I. Touratsoglou, *The Alexander
of the Coins*. Lectures on the History
of Coinage 2 (The Bank of Cyprus).
(Nicosia, 2000).

D.P.

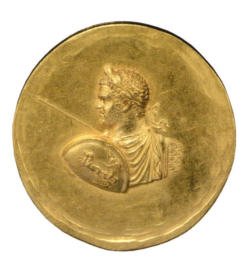
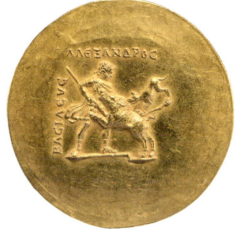

14. MEDALLION:
 ROMAN EMPEROR CARACALLA
 A.D. 230–50
 Gold
 Diameter 0.057 m, weight 70 g
 From Abu Qir
 The Walters Art Museum, Baltimore,
 Maryland (59.3)

Obverse: Bust of the Roman Emperor Caracalla
In this portrait of Caracalla, viewed from behind, the emperor wears his cuirass and emperor's paludamentum (cloak). He is bearded and has a wreath of laurel on his head. In his left hand he holds a shield on which is depicted Nike driving a biga (chariot drawn by two horses). In his right hand he holds his spear; the spike of the butt end is visible. This pose is characteristic of the emperor, far from the battlefield. Alexander's representation on the reverse is in keeping with Caracalla's promotion of himself as the Roman Alexander.

Reverse: Alexander Hunting Boar with His Hound
This scene shows Alexander in a short chiton and chlamys (cloak). He is participating in a royal hunt, confirmed by the inscription, *BACIΛEYC AΛEΞANΔPOC.* A similar scene is depicted on another

medallion from Abu Qir (see J. N. Svoronos, in *Journal Numismatique* 13 [1907], pls. 9, 2), one with a tree and an additional hound.

H. Dressel, *Fünf Goldmedallions aus dem Funde von Abukir.* Abhandlungen der preussischer Akademie der Wissenschaft zu Berlin, Klasse für Sprachen, Literatur, und Kunst, no. 2 (Berlin, 1906); J. M. C. Toynbee, "Greek Imperial Medallions," *Journal of Roman Studies* 34 (1944), pp. 65–73; J. Gage, "Alexandre Le Grand en Macedoine dans la Ière moitié du IIIe siècle après J.-C.," *Historia* 24 (1975), pp. 1–16; M. Papisca, *Immagini della imitatio Alexandri in eta severiana,* Ancient Macedonia, VI International Symposium (Thessaloniki, 1999), pp. 859–71; I. Touratsoglou, *The Alexander of the Coins.* Lectures on the History of Coinage 2 (The Bank of Cyprus). (Nicosia, 2000).

D.P.

PORTRAITS IN PRECIOUS METALS:
ALEXANDER THE GREAT AND NUMISMATIC ART

Frank L. Holt

> For good ye are and bad, and like to coins,
> Some true, some light, but every one of you
> Stamp'd with the image of the King.
> —Tennyson, *The Holy Grail* 1.25 (1869)

Behind these lines of Lord Tennyson labors one of the great legacies of Alexander. The almost universal notion that royal coinage should bear the ruler's image arose in direct response to Alexander's extraordinary place in Western history. His predecessors did not put their own portraits on money; his successors did so almost to a man—and woman. The obverse (appropriately called the heads of a coin), previously reserved for the gods and goddesses of the Greeks, thereafter showed the new face of history, as Athena, Apollo, and Zeus gave way to Ptolemy, Seleucus, and Arsinoe. This profusion of royal portraits included many Hellenized foreigners, such as the rulers of Parthia, Characene, and Pontus. The practice of displaying portraits on coins naturally influenced the Caesars as well, as one of their subjects famously pointed out when he called for a so-called Tribute Penny and asked, "Whose is this image and superscription?" By the time of Jesus, people from Iberia to India understood that their currencies belonged to and honored the kings and emperors who minted them. The Greeks had made this abundantly clear by inscribing the ruler's name in the genitive (possessive) case: "King Alexander's" or "Queen Cleopatra's" for example, to show whose money it really was. One therefore rendered to Caesar what already belonged to Caesar, as his face and name insisted even among a people offended by the graven image. Later, the legendary King Arthur, the poet assumes, also must have stamped his portrait on the coin of his realm—had there been any. Today, the legacy continues on the tiny metallic canvases of Europe's remaining royal mintages. They form part of a vast numismatic portrait gallery in which Alexander's image was the first to be exhibited some twenty-three centuries ago.

Ambitious and inquisitive, young Alexander came to the throne of Macedonia with a profound sense of the past. He walked in the footsteps of Achilles and looked upon himself as another link in a royal Argead lineage that stretched back to the first Alexander and beyond to the god-hero Herakles. He would not have understood our skepticism on such matters, for Herakles was as real and as much a relative to him as were the Amyntases and Perdiccases whose royal coins he could hold in his hands. On those coins, Alexander could trace the typical progression of Greek numismatic art. The earliest examples of Alexander I (ca. 498–454 B.C.) and Perdiccas II (ca. 454–413 B.C.) often depicted armed warriors or hunters on horseback (coins 1 and 2); this obverse served as a symbolic representation of horse-wild Macedonia, just as other contemporary states chose a shield (Thebes), an athlete (Kos), a cow (Eretria), or a griffin (Abdera). In time, the Macedonian kings joined with other Greeks in selecting the heads of various deities to adorn their currency. Apollo, borrowed from the neighboring Chalcidian League, often appeared on Macedonian money, as did the ancestral Herakles and his father, Zeus (coins 3–9). The names of the kings remained on the coins' reverses, usually accompanied by some variation of the horse motif displaced from the former obverse designs. Alexander's father, King Philip II (359–336 B.C.), whose name means "lover of horses," modified the design to celebrate his equestrian victories at the Olympic Games (coins 8 and 9). So numerous and

desirable were the coins of Philip that they achieved international fame, and in Italy centuries later the plays of the Roman Plautus were filled with references to these "Philippi."

There is some evidence that during the first years of his reign, Alexander (336–323 B.C.) continued to mint his father's coinage in a practical, and perhaps also respectful, acknowledgement of his own place in a great dynasty not yet overshadowed by his deeds. When he struck coins patently his own, Alexander portrayed the image of Athena wearing a crested Corinthian helmet on his gold issues (coins 12 and 13); she may have embodied the Pan-Hellenic theme of the Eastern expedition. The Nike reverse suggests victory at sea, which formed a key element in the king's grand strategy against Persia along the Asia Minor coast and at Tyre. For the silver (coins 10 and 11), Alexander favored on the reverse a depiction of Zeus seated on his throne, holding an eagle in one hand and his scepter in the other. Like several of his forebears, Alexander chose Herakles—-wearing the scalp of the slain Nemean lion—-for the obverse. We might be tempted to recognize Alexander's own features in this youthful face of Herakles, as did Constantine VII Porphyrogennetus (tenth century A.D.) when he wrote: "The kings of Macedonia identified themselves as descendants of Herakles. . . . For this reason, they would actually wear the lion scalp . . . as is proven by the coinage of Alexander, which is adorned with this very image." Of course, Alexander may have intended his money to suggest his close familial resemblance to Herakles without actually depicting himself *in place of* his ancestor; thus, it would be unwise to call this particular image the first numismatic portrait of a living king. We are, however, getting close.

Different numismatic and religious conventions outside Greece made it possible for some Persian satraps and dependencies to place their portraits on the obverses of regional issues. The great king of kings himself was portrayed as a rather stylized figure, running in a crouched posture and carrying a bow, Persia's characteristic weapon (coin 14). This image can scarcely be called a royal portrait since it lacks detail and individuality, but it served a useful purpose not lost on Alexander. After the fall of Persia, Alexander did allow himself to be shown in a fighting pose on the obverse of the large silver elephant medallions that commemorated his victory at the Hydaspes River (326 B.C.). The dramatic scene evokes the Macedonian's awesome powers as he wields a sarissa, Macedonia's national weapon, and pursues the retreating elephant of Rajah Porus. The reverse confirms the conqueror's invincibility, as he stands in full battle array, clutching a thunderbolt in godlike fashion while Nike crowns him. Here, Alexander assumes outright the attributes of divinity on a special medallion. A squint of our eyes can almost reveal a tiny portrait on the medallion but the effect falls short. The same is true for the figures on the obverse and on the smaller tetradrachms of this series depicting archers and other Indian soldiers (coins 15 and 16). Meanwhile, Alexander's coinage per se remained faithful to Greek artistic traditions until his untimely death in 323 B.C. In his last years, Alexander added the royal title to his coins but never an obverse portrait of himself. Nonetheless, Alexander's conquests had created a new world in which his transcendent achievements and personality warranted special recognition by his successors.

At first, Alexander's coins continued to be minted virtually unchanged, and these posthumous "Alexanders" dominated the economies of the Hellenistic East as the "Philips" did the West. In time, however, the former generals of the king bolstered their own reputations by placing Alexander's portrait on their coinage. Lysimachus in Thrace produced the most famous numismatic image of Alexander, sporting the ram's horns of Zeus-Ammon (coins 17 and 18). Thus the portrait of the deified Alexander could properly occupy the obverses of Greek coins, where only deities normally resided. Ptolemy in Egypt featured Alexander wearing an elephant scalp and aegis (coin 19), while Seleucus showed the king in an elaborate helmet adorned with a bull's horns and ears (coin 21). These *diadochoi* (successors) launched their careers by exploiting their ties to Alexander, but eventually some dared to put their own portraits in place of his. Ptolemy, for

example, moved his former sovereign to the reverse and placed himself, dressed in the divine aegis, where only the gods and Alexander had once been (coin 20).

This extraordinary mix of politics and religion personalized history. Ironically, as powerful men and women proclaimed themselves less human and more divine, they immortalized themselves on coins as real persons, warts and all. The die was set for centuries to come, as Hellenistic rulers as far east as Afghanistan and Hellenistic imitators as far west as Rome assumed their stations on the obverses of their coins. These rulers promoted themselves with a growing sense of the dramatic, anxious to send the message of the hour through the medium of the day. They advertised their youthfulness and energy, their animalistic potency, their prowess in war, and their enormous wealth. We therefore see them variously dressed in regal splendor (aegis, diadem), armed for combat (helmet, spear), adorned with the horns of totem creatures (bulls, rams, goats), and posed on valuable denominations of silver and gold (tetradrachms, staters, decadrachms). They often added to their coins such cult titles as Theos (God), Nicator (Conqueror), Soter (Savior), and Euergetes (Benefactor). By the middle of the second century B.C., coins announced the existence in Bactria (modern Afghanistan) of a Greek king Eucratides, who called himself Megas (The Great) and appeared in a heroic pose hurling his spear (coin 24).

Alexander inspired a revolution in numismatic portraiture. Roman engravers of the third century A.D. continued this homage by representing Alexander and his family on gold medallions. Even Alexander's mother, Olympias, was commemorated in this way. As he had in so many other fields, her son marked a turning point in the progress of art and numismatics that would become all too evident. We need only look to the teachings of Jesus, the idylls of Tennyson, or the treasures assembled for this stunning exhibition.

BIBLIOGRAPHY

Bellinger, Alfred. *Essays on the Coinage of Alexander the Great*. New York: American Numismatic Society, 1963.

Davis, Norman and Colin Kraay. *The Hellenistic Kingdoms: Portrait Coins and History*. London: Thames and Hudson, 1973.

Holt, Frank. *Alexander the Great and the Mystery of the Elephant Medallions*. Berkeley: University of California Press, 2003.

Kroll, John. "The Emergence of Ruler Portraiture on Early Hellenistic Coinage: The Importance of Being Divine." In Ralf von den Hoff and Peter Schultz, eds. *Early Hellenistic Portraiture: Image, Style, Content* (forthcoming).

Mørkholm, Otto. *Early Hellenistic Coinage*. Cambridge: Cambridge University Press, 1991.

Price, Martin. *The Coinage in the Name of Alexander the Great and Philip Arrhidaeus*. 2 vols. London: British Museum Press, 1991.

Smith, R. R. R. *Hellenistic Royal Portraits*. Oxford: Oxford University Press, 1989.

Stewart, Andrew. *Faces of Power: Alexander's Image and Hellenistic Politics*. Berkeley: University of California Press, 1993.

1. SILVER OCTADRACHM OF ALEXANDER I
(ca. 498–454 B.C.)
Mint: Macedonian
Weight: 27.84 g
Obverse: mounted warrior riding r.,
holding two spears
Reverse: quadrate incuse square containing
royal name
American Numismatic Society, New York
(1967.152.190)

2. SILVER TETROBOL OF PERDICCAS II
(ca. 454–413 B.C.)
Mint: Macedonian
Weight: 2.26 g
Die axis: 9.00
Obverse: mounted warrior riding r.,
holding two spears
Reverse: forepart of lion in incuse square
American Numismatic Society, New York
(1963.268.47)

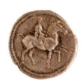

3. SILVER DIDRACHM OF ARCHELAUS I
(413–399 B.C.)
Mint: Macedonian
Weight: 10.54 g
Die axis: 10:00
Obverse: head of Apollo(?) r.
Reverse: incuse square containing horse r.
and royal name
American Numismatic Society, New York
(1963.268.50)

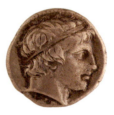
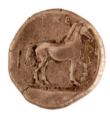

4. SILVER DIDRACHM OF AEROPUS II
(398–395 B.C.)
Mint: Macedonian
Weight: 10.59 g
Die axis: 4:00
Obverse: head of Apollo(?) r.
Reverse: incuse square containing horse r.
and royal name
American Numismatic Society, New York
(1970.94.2)

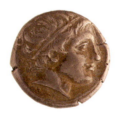
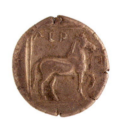

5. SILVER DIDRACHM OF AMYNTAS II
(395–394 B.C.)
Mint: Macedonian
Weight: 10.95 g
Die axis: 3:00
Obverse: head of Apollo(?) r.
Reverse: incuse square containing horse r.
and royal name
American Numismatic Society, New York
(1963.268.53)

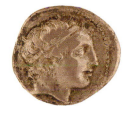
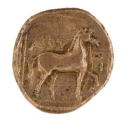

6. SILVER DIDRACHM OF AMYNTAS III
(393–370 B.C.)
Mint: Macedonian
Weight: 8.18 g
Die axis: 2:00
Obverse: head of bearded Herakles r.,
wearing lion skin
Reverse: incuse square containing horse r.
and royal name
American Numismatic Society, New York
(1944.100.12165)

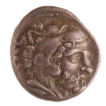
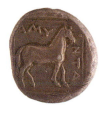

7. SILVER DIDRACHM OF PERDICCAS III
(365–359 B.C.)
Mint: Macedonian
Weight: 10.22 g
Die axis: 11:00
Obverse: head of beardless Herakles r.,
wearing lion skin
Reverse: horse prancing r.; royal name
Symbols: club and monogram
American Numismatic Society, New York
(1963.268.54)

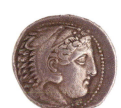
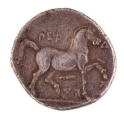

8. GOLD STATER OF PHILIP II
(359–336 B.C.)
Mint: Pella
Weight: 8.6 g
Die axis: 12:00
Obverse: head of laureate Apollo r.
Reverse: two-horse chariot racing r.;
royal name in exergue
Symbol: thunderbolt
American Numismatic Society, New York
(1963.268.25)

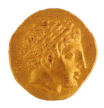
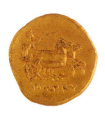

9. SILVER TETRADRACHM OF PHILIP II
(359–336 B.C.)
Mint: Pella
Weight: 14.32 g
Die axis: 3:00
Obverse: head of laureate Zeus l.
Reverse: horse and young jockey r.,
holding palm branch; royal name
Symbol: bee
American Numismatic Society, New York
(1964.42.22)

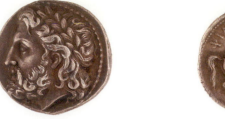
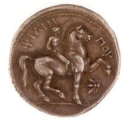

10. SILVER TETRADRACHM OF ALEXANDER III
(336–323 B.C.)
Mint: Memphis
Weight: 17.04 g
Die axis: 12:00
Obverse: head of beardless Herakles r.,
wearing lion skin
Reverse: Zeus seated on throne l., holding
eagle and scepter; royal name
Symbols: khnum and monogram
American Numismatic Society, New York
(1947.98.327)

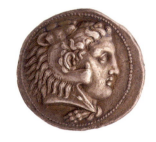
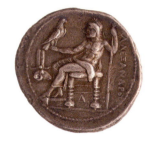

11. SILVER TETRADRACHM OF ALEXANDER III
(336–323 B.C.)
Mint: Memphis
Weight: 17.24 g
Die axis: 1:00
Obverse: head of beardless Herakles r.,
wearing lion skin
Reverse: Zeus seated on throne l., holding
eagle and scepter; royal name
Symbols: khnum and monogram
American Numismatic Society, New York
(1947.98.326)

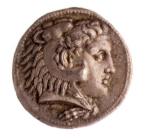
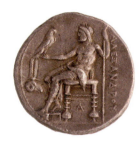

12. GOLD STATER OF ALEXANDER III
(336–323 B.C.)
Mint: Babylon
Weight: 8.56 g
Die axis: 1:00
Obverse: head of Athena r., wearing crested
Corinthian helmet
Reverse: Nike standing to l., holding wreath and
stylis; royal title and name
Symbols: head of satyr and monogram
American Numismatic Society, New York
(1944.100.35514)

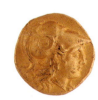
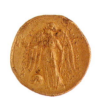

13. GOLD STATER OF ALEXANDER III
(336–323 B.C.)
Mint: Babylon
Weight: 8.53 g
Die axis: 6:00
Obverse: head of Athena r., wearing crested
Corinthian helmet
Reverse: Nike standing to l., holding wreath and
stylis; royal title and name
Symbol: monogram
American Numismatic Society, New York
(1944.100.35517)

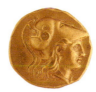
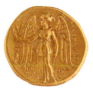

14. GOLD DOUBLE-DARIC, REIGN OF ALEXANDER III
(336–323 B.C.)
Mint: Persia
Weight: 16.63 g
Obverse: crouching bearded king running r. with
bow and scepter
Reverse: striations
Symbol: monogram
American Numismatic Society, New York
(1977.158.1290)

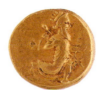
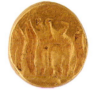

15. SILVER TETRADRACHM OF ALEXANDER III
(336–323 B.C.)
Mint: traveling in East(?)
Weight: 16.20 g
Die axis: 12:00
Obverse: elephant striding r. with two riders,
banner overhead
Reverse: four-horse chariot charging r. with
driver and archer
American Numismatic Society, New York
(1990.1.1)

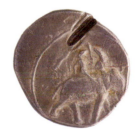
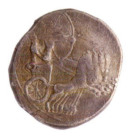

16. SILVER TETRADRACHM OF ALEXANDER III
(336–323 B.C.)
Mint: traveling in East(?)
Weight: 16.71 g
Die axis: 9:00
Obverse: Indian elephant walking r.
Reverse: standing Indian archer, firing r.
Symbol: monogram
American Numismatic Society, New York
(1995.51.68)

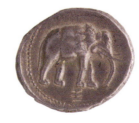
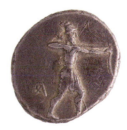

17. SILVER TETRADRACHM OF LYSIMACHUS
(305–281 B.C.)
Mint: Alexandria Troas
Weight: 17.13 g
Die axis: 12:00
Obverse: head of Alexander r., wearing diadem,
with horn of Ammon
Reverse: Athena seated l. with shield,
holding Nike; royal title and name
Symbols: wreath and monogram
American Numismatic Society, New York
(1966.75.115)

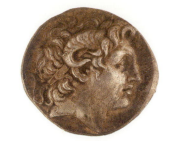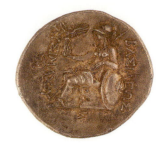

18. GOLD STATER OF LYSIMACHUS
(305–281 B.C.)
Mint: Byzantium
Weight: 8.38 g
Die axis: 11:00
Obverse: head of Alexander r., wearing diadem,
with horn of Ammon
Reverse: Athena seated l. with shield,
holding Nike; royal title and name
Symbol: monogram
American Numismatic Society, New York
(1944.100.81446)

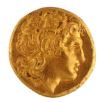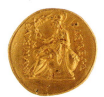

19. SILVER TETRADRACHM OF PTOLEMY I
(305–283 B.C.)
Mint: Alexandria, Egypt
Weight: 16.78 g
Die axis: 12:00
Obverse: head of Alexander r., wearing
elephant scalp and aegis
Reverse: Athena Alkidemos standing r. with
shield, hurling spear; eagle with thunderbolt;
royal name
Symbol: monogram
American Numismatic Society, New York
(1944.100.75471)

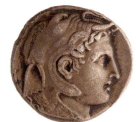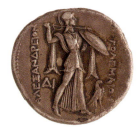

20. GOLD STATER OF PTOLEMY I
(305–283 B.C.)
Mint: Alexandria, Egypt
Weight: 7.1 g
Die axis: 12:00
Obverse: head of Ptolemy r., diademed,
wearing aegis
Reverse: elephant quadriga l., Alexander
as charioteer holding thunderbolt and scepter;
royal title and name
Symbol: monogram
American Numismatic Society, New York
(1967.152.621)

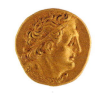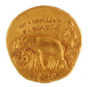

21. SILVER TETRADRACHM OF SELEUCUS I
(312–281 B.C.)
Mint: Susa
Weight: 16.89 g
Die axis: 2:00
Obverse: head of Alexander r., wearing
horned helmet covered with panther skin
Reverse: Nike standing r., crowning
trophy of arms; royal title and name
Symbol: monogram
American Numismatic Society, New York
(1944.100.74108)

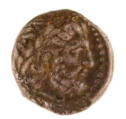
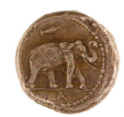

22. SILVER STATER OF SELEUCUS I
(312–281 B.C.)
Mint: Susa
Weight: 16.76 g
Die axis: 4:00
Obverse: laureate head of Zeus r.
Reverse: Indian elephant walking r.
Symbols: spearhead and monogram
American Numismatic Society, New York
(1944.100.73359)

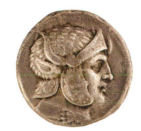
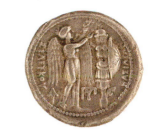

23. SILVER TETRADRACHM OF SELEUCUS I
(312–281 B.C.)
Mint: Pergamum
Weight: 16.75 g
Die axis: 11:00
Obverse: head of horned horse r., wearing bridle
Reverse: Indian elephant walking r.;
royal title and name
Symbols: bee and anchor
American Numismatic Society, New York
(1967.152.675)

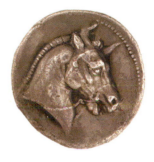
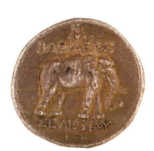

24. SILVER TETRADRACHM OF EUCRATIDES I
(ca. 171–147 B.C.)
Mint: Bactrian
Weight: 16.53 g
Die axis: 12:00
Obverse: bust of diademed and helmeted
Eucratides l., shown from behind, hurling javelin
Reverse: Dioscuri riding r., holding palms and
spears; royal title and name
Symbol: monogram
American Numismatic Society, New York
(1995.51.78)

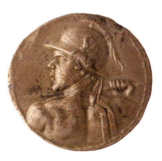
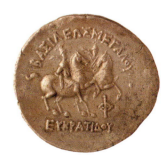

ARMS AND WARFARE TECHNIQUES OF THE MACEDONIANS

Polyxeni Adam-Veleni

At a time when prevailing in battle depended solely on an army's warfare skills and on the soldiers' motivation to fight bravely, hand-to-hand, the Greeks managed to develop arms, armament systems, methods, tactics, and strategy that allowed them to advance warfare to the state of the art. Warfare was seen as the supreme good, the utmost virtue, through which every brave citizen willingly honored his country with his life and in return was rewarded with the highest honors for his sacrifice.

The main occupation of all fit, adult men in ancient Greek cities, the political and social structures of which had a military basis, was developing the art of warfare. From a young age men started to exercise and practice warfare techniques, either through daily training or hunting, in order to be ready for battle at all times. The dispersion of the Greek population into autonomous city-states contributed greatly to the development of sophisticated arms from early on and thus their defensive and offensive battle systems were far superior to those of the non-Greeks.

As a result, the many opportunities for battle provided throughout Antiquity by wars against common national enemies, as well as other city-states, contributed to the gradual but steady improvement of the Greeks' warfare methods. The wars against the Persians, the Peloponnesian War, the wars of Philip II, Alexander the Great's campaign, the wars among the Diadochi (successors to Alexander's empire), and the three Macedonian wars against the Romans helped the Greeks develop superior arms, armament systems and equipment, and to maximize their effectiveness.

King Philip's Innovative Organization and Deployment Methods of the Macedonian Army

The superiority of Alexander the Great's army and its undisputed prevalence over the battle-hardened nations of the East is undoubtedly the result of the major changes brought upon the Macedonian army by Alexander's father, King Philip II. Alexander the Great, in turn, initiated many additional improvements and enforced strenuous training drills among the already seamlessly organized Macedonian army.

Our knowledge of King Philip II, the great reformer of the Macedonian kingdom, comes mainly from accounts provided by his enemies. They describe Philip as a barbarian whose success was the result not of his genius but of the mistakes and disloyalty of his opponents. The truth, however, must be far from this portrayal. Through a series of ingenious multifaceted activities, King Philip II managed within a short time not only to assume power (after the death of his brother, Perdikas III, in a battle against the Illyrians in the summer of 360 B.C.) but also to reorganize the political, economic, and military structure of his kingdom, making it the dominant force in Greece and, as a result, elevating it to unsurpassed prestige and glory.

One of the few known incidents from Philip's younger years is when he was held hostage in Thebes. There, according to an account by Diodoros, at the court of Epaminondas, a Pythagorean philosopher taught him the basic principles of Greek philosophy. At the same time, the young prince was given access to the organizational secrets of the exceptionally trained, perfectly armed, and ingeniously deployed army of Epaminondas, a great general who devised and implemented groundbreaking warfare methods. Epaminondas' phalanx of *hoplites* (heavily armed foot soldiers) was the best in Greece.

Convinced of the superiority of Epaminondas' military formations and methods, Philip tried to apply them to his own troops when he returned to Macedonia, where he unexpectedly found himself in power. Although special emphasis was given to the organization of the Macedonian army, historical evidence from the time is meager and it is only through indirect references during the reign of Alexander the Great and his successors that we find information on the arms, strategies, and general military organization of the Macedonian kingdom.

Important additional evidence derives from archaeological finds, especially the excavation of tombs, mostly in Macedonia, in the last decades of the twentieth century. Analysis of those finds remains preliminary, however, and a multidisciplinary study is needed in order to understand the significance of all the new information uncovered.

Although we have not yet pinpointed the period in which these forward-looking changes took place in the Macedonian army, we presume that it must have been around the time of King Philip's first victories against the Illyrians and the Thracians. Certainly the experience that the visionary leader gained from those first battles proved instrumental to his subsequent supremacy. The way the Macedonian phalanx was deployed was so brilliant that not only was each soldier well protected by his shield and the shield of his partner—the man to his right—but his spear-pike simultaneously threatened the upper body of the enemy soldiers.

The phalanx moved sidelong in a very dense formation that ultimately broke the resistance of the opponent and was quickly transformed from an indestructible defensive formation into a highly effective offensive one. The king equipped his soldiers with a much longer pike, the *sarissa*, which made the phalanx arrangement a nearly impenetrable wall of fully raised and half-raised spears.

The gradual extension of the sarissa and the way it was handled by the soldiers was the most groundbreaking aspect of the Macedonian infantry. The soldiers in the front row of the formation held shorter sarissas and those in the back rows held longer ones—the farther back, the longer the sarissa. In spite of the dense formation, this phalanx of *pezetairoi* (Macedonian heavy infantry) was much more maneuverable than the classic phalanx of the hoplites because the pezetairoi were deployed only eight rows deep and in much thinner formation, leaving a distance of one meter between them during offense and reducing it to half a meter during defense. Furthermore, they were trained to break up into squads and units, if necessary, in order to fight independently.

In contrast to earlier Greek hoplites, the Macedonian heavy infantry did not wear a heavy breastplate, did not carry the traditional short spear, and used a much smaller shield than was customary. The only large weapon they carried was the sarissa (see cat. no. 10), its length determined by the soldier's position in the phalanx. In the fourth century B.C. the length of the sarissa ranged between 4.50 and 5.50 meters, according to Theophrastos (*History of Plants* 3, 12.2). Theophrastos reports that the Macedonians preferred to make the sarissa's long shaft from the wood of the cornel tree because it was more durable. By the middle of the second century B.C., at the time of Polybius, the length of the sarissa had reached almost seven meters.

When it was time to assume battle positions, the regiments of the Macedonian army were deployed in various formations: in straight lines; in sidelong, crescent formations; or at obtuse angles. In order to achieve these formations the phalanx had to move in conjunction with the divisions located at the center of the attack—forward, backward, or sideways. Evidence shows, however, that every battle required its own tactics and formations. At the battle of Issus, for example, the phalanx was only eight men deep.

The soldiers in the last four rows swung their sarissas to their right and up so that they could deflect the track of the arrows arched by the enemy.

The unique weapons of the pezetairoi and the great flexibility in battle formation were not the only improvements Philip brought to the warfare capabilities of his troops. He initiated a series of changes that resulted in the establishment of a powerful army and a respectable naval force. In addition to the hoplites divisions, which were for the most part composed of ordinary Macedonian citizens, Philip put together an infantry division made up of distinguished citizens from the upper classes of Macedonian society. They were called the *hypaspists*, foot soldiers armed with modern weapons who comprised the personal guard of the king and fought by his side at every battle. These corps of hypaspists, which in subsequent Hellenistic years were distinguished by their shields—"copper-shielders," "white-shielders," and "silver-shielders"—enjoyed the king's favor in all his battles for the unification of Greece and also became Alexander the Great's special forces during his campaign in Asia.

The rest of the infantry, made up of enlisted soldiers of various races, origins, and professions, was organized through training and arms into a homogeneous body of soldiers that constituted the pezetairoi, the heavy infantry. Philip also created light cavalry squadrons, archer and peltast squadrons (see cat. nos. 11–14), and special squads that worked the siege towers and other siege devices.

Over time the hypaspists became especially important, since certain chosen soldiers among them were assigned the paramount duty of guarding the king himself. Arriano often refers to them as the "shield-bearing guard," a division Philip created—three battalions, each one thousand men strong—from his first royal guard. Hence, the royal army had eight cavalry divisions of pezetairoi, one of which was the Royal Mounted Guard, and three battalions of hypaspists, one of which was the Royal Infantry Guard.

Together with the changes in the infantry, Philip tended to the increase and improvement of his cavalry divisions, creating light cavalry divisions along with the traditional ones. These mounted divisions fought alongside the king and were armed with the *xiston* (a pikelike weapon), a spear, and a sword. According to Thucydides in 429 B.C., the cavalrymen were protected by a short metallic or leather breastplate with shoulder straps and moving parts at the height of their thighs in order to facilitate easier movement, as well as a helmet without a crest, which allowed better visibility. The horses were protected with armor and had metal headstalls and mouthpieces so they could be handled more easily by the riders.

The Macedonians had a long tradition of breeding and training horses. Their horses were small in size—slightly bigger than a pony—and could be mounted without using stirrups; riders simply put their hands on the horse's back and leaped on, riding bareback. Despite the fact that the Macedonian riders were well trained and often deployed in full-scale attacks or used to harrass the enemy, more often the cavalry acted as scout and support for the infantry, guarding the divisions' flanks and rear and escorting the king in military operations. The light-cavalry divisions created by Philip and used widely by Alexander were armed with a sarissa shorter than the one held by the pezetairoi but longer than the xiston of the cavalry, which is why sometimes they were called *sarissophoroi* (sarissa-bearers).

There is no evidence suggesting the use of chariots in battle during the reigns of King Philip and Alexander. In addition to the four-wheel carts that were most certainly drawn by horses or mules and used mainly for transporting supplies, we assume there must have been luxury carriages of some sort, used in parades and other formal events by the king and high-ranking army officers. These chariots, probably with two wheels, were lavishly decorated in order to impress the king's subjects, as suggested by a

bronze medal depicting the goddess Athena (cat. no. 17) and the heads of four animals—two dogs (cat. no. 18) and two panthers (cat. no. 19)—that were uncovered during excavations at Thessaloniki, in Hellenistic levels, in a luxurious building that probably was used by the king and the princes when staying in the city.

The prudent King Philip also concerned himself with the creation of a strong fleet, since the kingdom of Macedonia, which had never had a naval force, had always been inferior in this regard to the sea-ruling Athenians, their main rivals.

The Arms of the Macedonian Army

In addition to the sarissa, the Macedonian soldier was armed with a saber (see, for example, cat. no. 9) and a small round shield. The shield was about sixty-five centimeters, was only slightly curved, and, according to Askleipiodotos (*Art of Tactics* 5, 1), was fastened to the soldier's body by a leather strap, placed obliquely so that the bearer was able to move his hands freely and use a sword or a dagger or both.

The Macedonian shield, especially that of the hypaspist, was decorated with a twelve-ray sun at the center and elliptical trails on the perimeter, representing the solar system and, in a sense, the universal supremacy of the king. The name of the king was inscribed between the central and perimeter decorations. Until recently we knew these shields only from depictions on coins, from the well-known mural at Pompeii, and from the first-class, highly artistic frescoes of the tomb of Lissonas and Kalliklis at Lefkadia. Such a shield was found among the votive offerings of the Dodoni sanctuary, however, and two recent archaeological findings—one in western Macedonia (Vegora) and one in Dion (cat. no. 5)—have enriched our knowledge regarding such shields.

Apparently, the leaders and probably the high-ranking officers as well had a more formal, fully decorated shield for use in parades and ceremonies, much like the one found in the Royal Tombs in Aigai. The formal (dress) shield was of impressive dimensions and bore representational and geometric decorations, crafted from ivory, on a fine leather surface. The central theme of the Amazon that falls victim to the warrior was depicted on the perimeter with fine, delicate patterns. On the inside, the shield had a bronze frame with two handgrips, also decorated with floral motifs and geometric patterns.

The swords of the Macedonians, as they are known from excavation finds in the last decades, were usually made of iron and often had a hilt and sheath clad with wood—or, in more luxurious versions, with ivory—and were kept in a leather scabbard decorated with plant motifs or sometimes inlaid with gold ornaments. The daggers were made of bronze, but during the fourth century B.C. they gradually fell into disuse as the iron sword became the weapon of choice (see, for example, cat. nos. 1, 8).

The body armor of the Macedonians included a light breastplate, greaves (shin plates), and helmet. The breastplate had shoulder flaps and usually was made of leather. More rarely it was made of iron or even bronze, lined inside with leather and fabric. It is conceivable that the lining material used distinguished officers from plain soldiers. (A characteristic example of an iron breastplate decorated with gold stripes was found at the tomb of Philip II at Aigai.) For further protection of the upper body and the neck, the Macedonians wore an iron collar, also decorated with gold floral ornaments. Representative samples of these were found in many Macedonian tombs at Aigai, Sindos, and Pydna.

The greaves, a key and indispensable part of the armor, were usually made of bronze (cat. nos. 2, 6). Following the anatomy of the shin for an easier and better fit, they covered the leg from the top of the knee to the tarsus. They were open at the back and lined inside with leather or fabric.

The helmet, as it is known mainly from depictions on coins, differed from period to period and from king to king. During the fifth and fourth centuries b.c., Illyrian-type helmets (cat. no. 4) were worn; later on soldiers wore Thracian-type helmets, and by about the middle of the fourth century b.c. we see the Chalkidian type (cat. no. 3). The successors of Alexander the Great are depicted with an Attic-type helmet, with a tall crest and cheek flaps. In some coin depictions from the fourth century b.c. the depicted leader is on horseback and is wearing the well-known Macedonian kausia, a type of broad-brimmed hat made of leather. Few helmets from the time of Philip and Alexander the Great have been uncovered in excavations, but an important and representative example is the one found in a warrior's tomb in Pydna, Pieria.

The Strategies of Philip and Alexander the Great

King Philip II placed great significance on the comprehensive training of his soldiers and maintaining high morale among his troops, as did his son Alexander the Great. Philip believed that a good army should not have the mentality of mercenaries and saw to it that their persistent and disciplined training infused them with a national consciousness. He managed to create a cohesive army with a strong national spirit that could prevail over its opponents in warfare and arms as well as in morale.

The six rows of the Macedonian phalanx constituted a national guard. Bound by their common language and their homeland, they were devoted to their king, the guardian of the state. Philip recruited large numbers of soldiers from the nations he conquered or took in as allies. Taking advantage of the experience of the Thessalian horsemen, he incorporated a regiment in his army; for the light-infantry divisions he recruited Thracians, Paiones, and Odrysses.

The Thessalian cavalry was a heavy division and worked together with the Macedonian pezetairoi soldiers. The Paionic cavalry was a lighter division, used primarily for reconnaissance missions. All divisions, however—heavy and light cavalry, infantry, pezetairoi and hypaspists, archers and peltasts—cooperated closely and were rotated on a steady basis so that they could develop a strong sense of solidarity and collaboration. Their arms, their training, and their battle formations were offensive rather than defensive.

In the famous manual of Asklepiodotos we see the compositions of the perfect phalanx, its formation, and the training it underwent. The Macedonian phalanx comprised sixty-two regiments, each with 256 men and a commanding officer. Each regiment had sixteen rows, with sixteen soldiers in each row. If the phalanx had to form in eight rows, then the men in the second section slipped in the rows of the first and third section and so forth. Two pairs of rows were led by a tetrarchis and four pairs of rows were led by a brigadier. When facing the enemy, they assembled behind the lines so that their elbows touched. Thirty-two battalions formed a flank of 8,200 men, as many as an entire infantry brigade. Two flanks constituted a full Macedonian phalanx, which trained daily under the direction and orders of its general.

In addition to the cavalry, the infantry, and the navy, the Macedonian war machine had another original feature, the "siege trains." These innovative weapons came in all sizes and types, and were operated and maintained by specially trained men. The early engineering corps who used them played a major role in the conquest of walled cities or the destruction of the enemy troops from a safe distance. They became part of the Macedonian army during the time of Philip and were used widely by Alexander the Great, who hired the best engineers and mechanics of the time to perfect and develop siege trains during his campaign. These specialists accompanied the troops in battle and gave their support.

The siege trains were not used exclusively in offensive operations but also during supportive missions, such as crossing rivers, rehabilitating roads, and climbing steep areas. Nevertheless, we do not know much about these siege trains since they were usually made of wood and naturally could not be maintained for long. The siege train included siege towers, battering rams, torsion catapults, and hangars that were either transported to the battlefield ready for action or were constructed on site so that they could be adapted to the particular terrain. The siege gear was carried on special transport carts drawn by animals, while other four-wheel carts carried the necessary supplies for the troops.

Together with all the aforementioned army divisions, Alexander the Great also enlisted specialists from all fields of study. He believed that it was a great opportunity for all these "scientists" to see new places, flora, and fauna and to take advantage of new resources, products, and alternative energy sources. Doctors, geographers, naturalists, mathematicians, merchants, and technicians of all trades followed his army together with the support units that were responsible for the maintenance of weapons and the daily care of the soldiers and officers—their food, sleep, clothing, shoes, and supplies. This huge mass of people must have included many women and children.

Alexander the Great's campaign no doubt involved 100,000 persons, as estimated by experts. Half of these people were occupied exclusively in battle operations while the other half performed support services for the soldiers. The factor that made the expedition to Asia different from any other expedition in history and made Alexander the Great an unsurpassed army commander and the greatest leader of all times was the way he culturally infiltrated and influenced the nations he had conquered. At the same time, Alexander himself and many of his high-ranking officers accepted or selectively adopted their cultural characteristics. Alexander the Great founded new cities and settled Macedonians in them; he had large numbers of his soldiers marry women from the conquered areas, following his own example; he had married an Asian princess Roxanne. He spread the cultural achievements of Greek civilization and at the same time showed great respect for the civilization of the defeated, not hesitating to adopt certain practices from them in his daily life, a forward-looking position considered unthinkable by the vain conquerors of modern times, especially of the last two centuries.

BIBLIOGRAPHY

Despotopoulos, A. "Η πολεμική τέχνη των Ελλήνων κατά την περίοδο 1100–336 π.Χ." *I.E.E.*, Γ2, pp. 192–235.

Faure, P. *La Vie quotidienne à l'époque d'Alexandre le Grand*. Paris, 1982. Greek ed. *Η καθημερινή ζωή την εποχή του Μ. Αλεξάνδρου*, trans. G. Aggelou. Athens, 1991.

Fuller, J. F. C. *The Generalship of Alexander the Great*. Greek ed. *Η ιδιοφυής στρατηγική του Μεγάλου Αλεξάνδρου*, ed. Z. Kotoula, trans. K. Koliopoulos. Athens, 2004.

Sakellariou, M. *Μακεδονία, 4.000 χρόνια*. Athens, 1982.

Snodgrass, M. *Arms and Armor of the Greeks*. London, 1967. Greek ed. *Τα επιθετικά και αμυντικά όπλα των Ελλήνων*, ed. P. Faklaris, trans. B. Stamatopoulou. Thessaloniki, 2003.

Steinhauer, G. *Ο πόλεμος στην Αρχαία Ελλάδα*. Athens, 2000.

The Weapons of Philip II

In the time of Alexander the Great, weapons were to men what jewelry was to women. Expensive possessions, companions in war, they became symbols of a man's status in the world and followed him—warrior and hunter—to the grave. The Macedonians of Aigai were in the habit of providing their dead with two spears or javelins; on rare occasions they provided a sword, and, more rarely—and only for the wealthy and prominent—a helmet.

In burying his father, the greatest general of his day, Alexander surpassed all precedent, offering to the dead at least four panoplies, works by master armorers who incorporated all the innovative achievements in metallurgy of the time. Of the three panoplies placed in the tomb, two were richly ornamented with gold. The cuirass in one of these, which is reinforced with iron, closely resembles that worn by Alexander in the well-known depiction in the famous Naples mosaic of his battle with Darius. The masterful ivory-and-gold shield from the same set of armor is the most impressive and certainly the most precious weapon known from the ancient world. At least one more panoply was offered on the funeral pyre that consumed the dead king's body; among the remains were found fragments of a shield, three spearheads, a neckpiece, and two swords plus parts of the hilt of a third.

A.K.

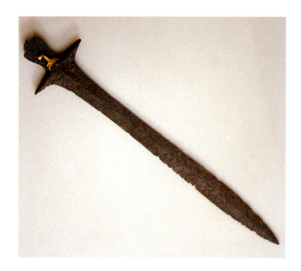

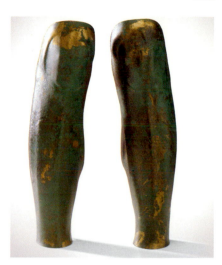

1. **GOLD-EMBELLISHED SWORD**
336 B.C.
Iron, gold, wood
Estimated length 0.544 m, max.
width of hand guard 0.109 m
From the Royal Tombs of Aigai
Museum of the Royal Tombs of Aigai,
Vergina (BM 1713)

This sword was found in the remnants of the funeral pyre of Philip II, which, in accordance with custom, had been strewn upon the vault of his tomb. Both an offensive and a defensive weapon, it was used primarily in close combat, as its relatively short length indicates, and belongs to the most common type of Classical times. Similar swords are frequently depicted in scenes of battle; they are rarely found in the tombs of dignitaries.

Because this sword was cast into the flames of the funeral pyre, its wooden scabbard and the investment of its hilt, which must also have been of wood, were lost. However, the fire proved beneficial for the iron blade, which was "steeled" and is preserved in very good condition. Noteworthy is the way in which the

thickness of the blade was increased down the middle, reinforcing its long axis so that the sword did not bend. The strengthening with iron strips of the "guards," the horizontal arms of the hilt that protected the warrior's hand, bear witness to the maker's concern for the weapon's flawless function.

The upper part of the hilt broke and is lost, but because this sword closely resembles those found in the burial chamber of the tomb, its shape can be restored: there would have been a pommel, a cylindrical or slightly conical head veneered with wood, like the rest of the hilt, the edge of which was strengthened by the elliptical ring of iron, found together with the sword.

Particularly unusual is the discreet yet precious decoration of the hilt: a heavy, solid, cast-gold ornament, attached to the wooden investment by two gold nails imitating acanthus leaves, rendered with remarkable vitality and verisimilitude.

M. Andronikos, *Vergina: The Royal Tombs and the Ancient City* (Athens, 1984), p. 145.

A.K.

2. **PAIR OF GREAVES**
336 B.C.
Bronze
Height 0.414 m, width 0.417 m
From the Royal Tombs of Aigai
Museum of the Royal Tombs of Aigai,
Vergina (BM 2587)

These plain and sturdy greaves, made of strong bronze sheets with the anatomy of the leg summarily rendered, originally were lined with leather. They completed one of the two sets of armor that had been placed in Philip II's burial chamber. However, since the king fought on horseback, it is likely that he preferred the much more comfortable—and probably just as effective—high Macedonian boots.

M. Andronikos, *Vergina: The Royal Tombs and the Ancient City* (Athens, 1984), p. 145.

A.K.

3. "CHALKIDIAN" HELMET

Second half of the 4th century B.C.
Bronze
Height 0.32 m, max. length 0.23 m,
max. width 0.16 m
From Kitros, locality "Louloudies," new railway
line, tomb 98
Cist grave in the form of a *theke*
Archaeological Museum of Thessaloniki,
Pydna excavation (Πυ 10.808)

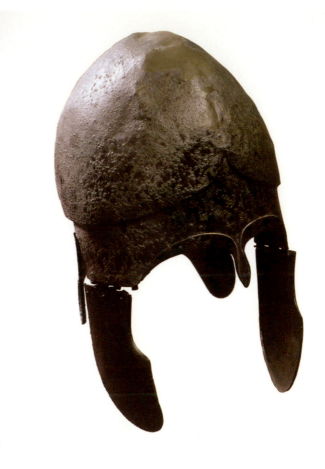

This helmet, with its movable cheek-pieces, modeled
eyebrows, and cranial vault, is "Chalkidian" in style,
a rarity for this period. The closest example is the
helmet from Arzos by the River Evros (ancient Hebrus);
another adorns the large sword from the Tomb of
Philip II. A basic accessory in warrior armor, it is
here used as an ossuary.

For the helmet from Arzos, see Kate Ninou, ed.,
Treasures of Ancient Macedonia, exhib. cat.
(Thessaloniki, 1979), no. 458. For the sword from
the tomb of Philip, see M. Andronikos, *Vergina:
The Royal Tombs and the Ancient City* (Athens, 1984),
pp. 142ff., pl. 101.

M.B.

4. "ILLYRIAN" HELMET

4th century B.C.
Bronze
Height 0.28 m
From the Kilkis area
Archaeological Museum of Kilkis (MK 504)

The helmet is made of a single hammered plate that
protects most of the face, leaving only a rectangular
opening at the center. The brim at the back of the neck
turns outward. This type of helmet originates from
the Peloponnese and is often found in Macedonia.

P.A.-V.

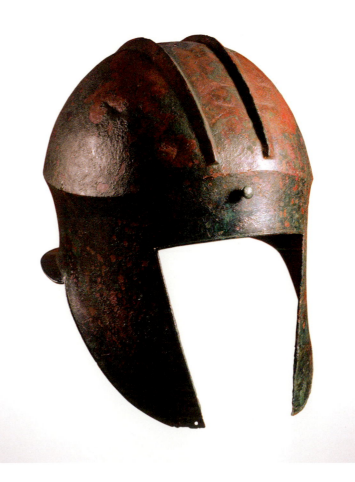

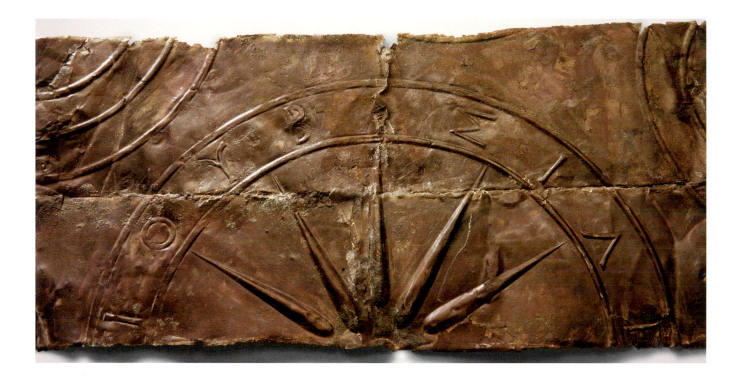

5. PART OF A MACEDONIAN SHIELD
Early 3rd century B.C.
Bronze
Diameter 0.74 m
From the Sanctuary of Olympian Zeus, Dion
Archaeological Museum of Dion (MΔ 7479)

The three pieces of the exterior shield covering provide a secure base for its reconstruction. The sun, from which twelve rays emanate, is represented at the center, around which the words *ΒΑΣΙΛ[ΕΩΣ ΔΗΜΗΤΡ]ΙΟΥ* ([The Shield] of King Demetrios) are written. On the remaining main body of the shield are seven small stars, representing planets and their orbits, a common pattern on Macedonian shields in Antiquity. Evidently the inscription refers to Demetrios Poliorketes, who visited Dion in 294 B.C. to dine with King Alexander, son of Cassander. This meeting was the beginning of his adventurous rise to the throne of Macedonia. The shield of Demetrios was a royal votive to the Sanctuary of Olympian Zeus at Dion.

D. Pandermalis, *ΒΑΣΙΛΕΩΣ ΔΗΜΗΤΡΙΟΥ, Myrtos* (Thessaloniki, 2000), pp. 18–22.

D.P.

6. PAIR OF GREAVES
Second half of the 4th century B.C.
Bronze
Height 0.42 m, width 0.12 m
From Korinos, locality "Toumbes," tumulus B,
Macedonian tomb
Archaeological Museum of Thessaloniki,
Pydna excavation (Πυ 10.807)

This part of a warrior's armor was made to protect
the leg below the knee and follows those general
anatomical lines. Similar greaves were found in the
"Great Tumulus" at Vergina (four pairs in the
tomb of Philip, one in the tomb of the prince), in the
tombs at Derveni (one intact and parts of a second
in tomb A, and one intact in tomb B), as well as in
tomb 3 in the Toumba Pappa at Sevasti in Pieria.

Μ. Μπέσιος and Μ. Παππά, *Πύδνα* (Thessaloniki,
1995), p. 92, pl. Γ; Μ. Μπέσιος, *"Ανασκαφικές
έρευνες στην βόρεια Πιερία,"* *Το Αρχαιολογικὸ Ἔργο
στη Μακεδονὶα και Θρὰκη* 5 (1991), p. 177, n. 18.

M.B.

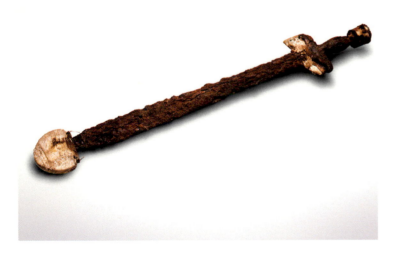

7. SWORD
Second half of the 4th century B.C.
Iron, wood, ivory
Length 0 .75 m, max. width 0.12m
From Makryyalos, field no. 951, tomb 187,
north cemetery of Pydna
Archaeological Museum of Thessaloniki,
Pydna excavation (Πυ 7848)

This iron sword with integral hilt and hand guards
was placed in the tomb along with its wooden
scabbard, traces of which are preserved on the blade.
The scabbard's ivory decoration is in relatively good
condition at both ends. Excavations in Macedonia
have yielded a considerable number of these offensive
weapons, the most spectacular of them, in terms of
opulence, being the sword from the tomb of Philip II.

See M. Andronikos, *Vergina: The Royal Tombs
and the Ancient City* (Athens, 1984), pp. 142–44;
Treasures of Ancient Macedonia, exhib. cat.
(Athens, 1979), nos. 43 (sword from Kozani) and
68 (sword from Veroia [ancient Beroea]).

M.B.

8. KOPIS (SABER) WITH SCABBARD

Last third of the 4th century B.C.
Iron, wood, ivory
Length 0.515 m
From the Cemetery of Aigai
Museum of the Royal Tombs of Aigai,
Vergina (BM 2398)

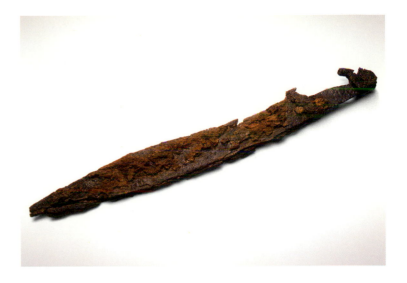

The *kopis* is a type of sword with a slightly curved blade and only one cutting edge. Normally it was used by warriors fighting on horseback, which is why it was a favorite weapon of the Macedonians, who were well known for their equestrian tradition.

The example here, which belonged to a Macedonian cavalryman from Aigai, a contemporary of Philip II and Alexander the Great, is preserved in sufficiently good condition for us to identify several of its features. Its scabbard, considerable traces of which remain, was of wood, the upper part decorated with ivory. Particularly elaborate is the peculiar bird-shaped hilt, which is one of the distinctive features of these weapons. Its iron core, in fact the continuation of the blade, is clad on both sides with wood and reinforced with additional iron strips, then bound completely with textile, perhaps to ensure a firm grip. These multiple revetments were held together by rivets, two of which are in situ.

In the lower part of the hilt is the hand guard, a small horizontal bar that extends toward the cutting edge of the blade. In contrast to most other swords with a cruciform hilt, which were intended for hand-to-hand combat and have a double guard to protect the hand on both sides, horsemen who struck their opponents with a saber from the height of their mount exposed only the lower part of the hand and hence had only one protective guard for that vulnerable area. The curved beak of the bird also protected the warrior's hand from behind. It is clear, then, that the decision to use this particular decorative figure was not merely ornamental, but derived from specific functional needs.

A.K.

9. SABER

4th century B.C.
Iron
Length 0.43 m
From the Chalkidike area
Archaeological Museum of Polygyros (I.166.82)

This was an auxiliary weapon, having only one cutting edge and an anatomic handle for better grip.

Unpublished.

P.A.-V.

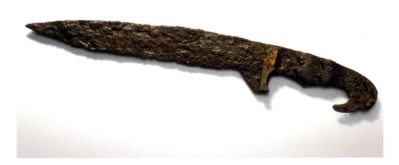

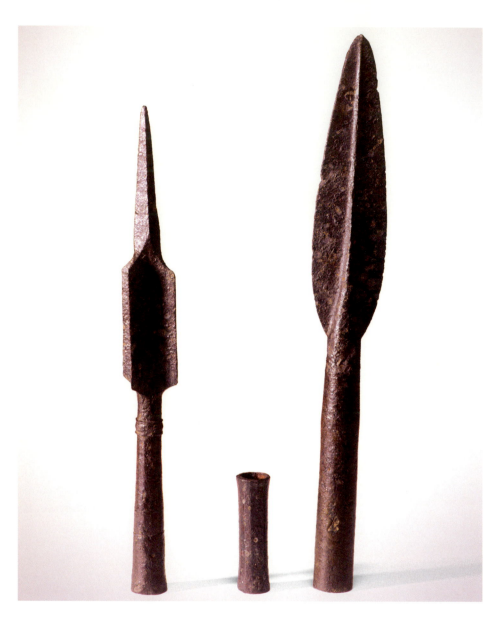

10. POINT, SAUROTER, AND CONNECTING SOCKET OF A SARISSA

Last quarter of the 4th century B.C.
Iron
Length (of point) 0.51 m, (of sauroter) 0.446 m,
(of connecting socket) 0.107 m
From the grave of a Macedonian warrior in
the Cemetery of Aigai
Museum of the Royal Tombs of Aigai, Vergina
(BM 3014–16)

The length of the heavy, leaf-shaped point with the low midrib and of the sauroter with the pyramidal spike and the massive flanges—which together exceed three feet—as well as the presence of the iron connecting socket, attest that these items are sections of the sarissa, the terrible Macedonian pike whose invention had a decisive effect on the art of warfare of the age. Since the total length of the sarissa in the fourth century B.C. was, according to ancient sources, about 5.5 meters, the length of the wooden shaft must have been over 4.5 meters. If made as one piece, a shaft of this length would have bent and had a greater probability of breaking. It is likely, therefore, that it was made of two poles of wood that were joined together with the help of an iron connecting socket, such as the one here, which still preserves traces of a pole inside. Such a socket would have been a useful reinforcement at the most vulnerable point.

M. Andronikos, "Sarissa," *Bulletin de Correspondance Hellenique* 94 (1975), pp. 91–107.

A.K.

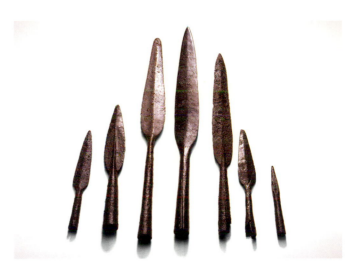

II. LARGE POINT
Second half of the 4th century B.C.
Iron
Length 0.49 m
From the Cemetery of Aigai
Museum of the Royal Tombs of Aigai,
Vergina (BM 3010)

This point, found in the grave of a warrior
at Aigai, displays some noteworthy
peculiarities: it is very large and heavy but
lacks a midrib to reinforce it; it also has
a rather narrow socket, which indicates a
quite thin shaft. It cannot have belonged
to a sarissa, as that would have required
a much sturdier wooden shaft and rein-
forcement. However, it is difficult to
imagine it on an ordinary spear, since
without the midrib it would easily bend
or break in battle and could prove fatal
for its bearer. It is possible, then, that it
is from a short spear or, more likely, from
a cavalryman's sarissa that was shorter
than normal but which, given the impetus
of the horse, could be just as effective,
provided it was well balanced.

Perhaps its owner was one of the
renowned pike-bearing cavalrymen of
Alexander the Great, who returned home
with the veterans to die in the land of
his forefathers.

A.K.

THREE SPEARHEADS
4th century B.C.
Iron
Length (BM 3011) 0.467m,
(BM 1763) 0.427 m, (BM 3012) 0.275 m
From the Cemetery of Aigai
Museum of the Royal Tombs of Aigai,
Vergina (BM 3011, BM 1763, BM 3012)

The offensive weapon par excellence of
the ancient Greek infantrymen (*hoplites*)
and cavalrymen (*hippeis*) was the spear.
Approximately 2.20 to 2.40 meters (7 to
8 feet) in length, it was essentially a plain
wooden shaft with a metal point affixed
to the proximal end and a sauroter (a type
of spike made of iron or bronze with
which the spear was stuck in the ground)
to the distal end. These three foliate
spearheads, characteristic examples of the
highly advanced Macedonian weaponry
of the fourth century B.C., are forged
from a strong sheet that in the lower
part was shaped as a tubular socket into
which the wooden shaft was inserted.
A nail, which passed through the two
diametrically opposite holes at the bottom
of the socket, held the missile point in
place. A strong midrib—which in the best
cases (for example the point with a relief
ring on the lower part of the socket) is
enhanced as a decorative element of the
spare form—prevented the spearhead from
bending and, by increasing its weight,
reinforced its efficiency at the moment
of impact.

A.K.

TWO JAVELIN POINTS
4th century B.C.
Iron
Length (BM 1760) 0.211 m,
(BM3009) 0.227 m
From the Cemetery of Aigai
Museum of the Royal Tombs of Aigai,
Vergina (BM 1760, BM 3009)

The javelin, 1.35 to 1.80 meters in
length, was in reality simply a smaller
and slightly lighter spear—always with-
out a sauroter—which the warrior hurled
at his opponent (or prey, if hunting)
from a distance, as opposed to using it
in pitched battle. These two iron javelin
points, though similar to spearheads, are
distinguished as such because they are
smaller and lighter. The end of the socket
does show holes from nailing it to the
wooden shaft, but there is no lengthwise
midrib, since the impact of the throw
from a distance obviates the need for
reinforcement. When such reinforcement
does exist on javelin points, it is for
decoration more than function.

A.K.

POINT
4th century B.C.
Iron
Length 0.14 m
From the Cemetery of Aigai
Museum of the Royal Tomb of Aigai,
Vergina (BM 3013)

This small, solid, peculiar point, with
a long socket and of pyramidal shape,
probably should be correlated with the
use of siege machines such as catapults,
common in the military operations of
Philip II and Alexander.

A.K.

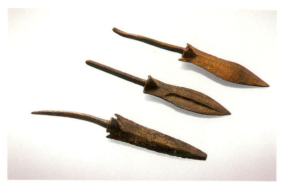

12. THREE SPEARHEADS

4th century B.C.

Bronze

Length (OL 31.145) 0.098 m, (OL 31.298) 0.089 m,

(OL 31.32) 0.104 m

From the Chalkidike area

Archaeological Museum of Polygyros (OL 31.145, OL 31.298,

OL 31.32)

Unpublished.

P.A.-V.

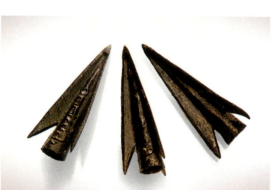

13. THREE ARROWHEADS

4th century B.C.

Bronze

Length (OL 31.75) 0.07 m, (OL 34.146) 0.068 m, (OL 34.147) 0.07 m

From the Chalkidike area

Archaeological Museum of Polygyros (OL 31.75, OL 34.146, .147)

These three bronze arrowheads, one of which bears the inscription
ΦΙΛΙΠΠΟΥ (of Philip) belonged to the archers of Philip II, who besieged
and conquered many cities in the Chalkidike. The inscription of the name
of the king indicates that these arrowheads were made at a workshop
under state control.

Unpublished.

P.A.-V.

14. FOUR INSCRIBED SLING SHELLS

4th century B.C.

Lead

Length 0.03 m, 0.015 m

From the Chalkidike area

Archaeological Museum of Polygyros (OL 38ms114, OL 38ms125,
OL 38ms63, OL 34.255 (0490)

Sling shells were basic gear of the light infantry units in Philip II's army.
The initials inscribed on them are probably the initials of their commanding
officer, or perhaps the town from which the slingers (hurlers) came.
Experienced hurlers could throw a shot as far as four hundred meters.

Unpublished.

P.A.-V.

15. TWO INSCRIBED SLING SHELLS

4th century B.C.

Lead

Length (Ποτ.214) 0.027 m, (Ποτ.230) 0.031 m

From the Chalkidike area

Archaeological Museum of Polygyros (Ποτ.214, .230)

This pair of sling shells was found in the city of Potidaia, which was
besieged and conquered by Philip II.

Unpublished.

P.A.-V.

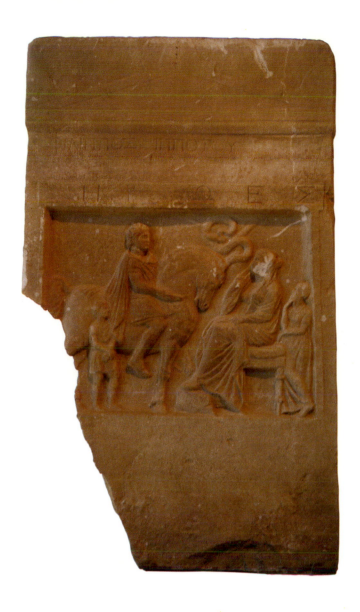

16. GRAVE STELE OF PHILIP,
SON OF HIPPOTES
Second half of the 2nd century B.C.
Marble
Height 0.84 m
From near the village of Kolindros
(Pieria, northern Greece)
Archaeological Museum of Dion (MΔ 8166)

A horseman with his groom and a lady seated
on a stool with her companion are depicted on this
framed panel. In the background is a snake in a tree.
At the top there is the inscription *HPΩEΣ* (heroes);
below the incised pediment is the inscription
ΦΙΛΙΠΠΟΣ ΙΠΠΟΤΟΥ (Philip son of Hippotes).
The rider wears a short chiton, cuirass, and chlamys,
reminiscent of the Macedonian horse riders shown
in the war scene on the sarcophagus of Alexander
the Great, and in the representation of the battle of
Pydna on the frieze from the monument of Aemilius
Paullus at Delphi. By the inscription and the presence
of the snake of the hero-cult, Philip, the deceased,
is elevated to the realm of heroes.

W. Fuchs, *Die Skulptur der Griechen*
(Munich, 1978), fig. 542; V. von Graeve,
Der Alexander Sarkophag und seine Werkstatt
(Berlin, 1970), p. 85, pls. 27, 31; E. Trakosopoulou,
"Sepulchral Stele from Kolindros-Pieria,"
Μακεδονικά 23 (1984), pp. 154–67, fig. 1.

D.P.

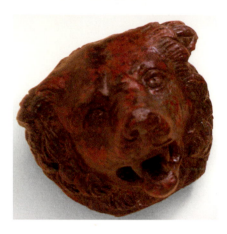

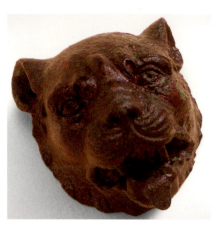

17. MEDAL WITH AN EMBOSSED
 BUST OF ATHENA
 First half of the 2nd century B.C.
 Bronze
 Diameter 0.272 m
 Found at the landfill site of an
 Early Hellenistic luxury building,
 possibly royal quarters, in Kiprion,
 Agoniston Square, Thessaloniki
 Archaeological Museum of
 Thessaloniki (MΘ 17540)

This medal was part of the decoration
for a formal chariot used in parades.
It depicts Athena, though only three-
quarters of the goddess survives. With
her right arm raised like a warrior, she
bears an aegis with scales that terminate
in snake heads. She is wearing a peplos
and a helmet, the front of which forms
a gorgoneion. The piece, probably
from Delos, is unique.

P. A.-Veleni, *Bronze Medal with Goddess
Athena and Four Animal Heads from
Thessaloniki, Myrtos* (Thessaloniki, 2000),
pp. 141–57.

P.A.-V.

18. TWO DOG HEADS
 First half of the 2nd century B.C.
 Bronze
 Length 0.077 m, width 0.074 m
 (MΘ 17536); 0.077 m,
 width 0.073 m (MΘ 17537)
 Found at the site of a Hellenistic
 building in Kiprion, Agoniston
 Square, Thessaloniki
 Archaeological Museum of
 Thessaloniki (MΘ 17536, 17537)

These dog heads were used as chariot
decorations. They are cast (though they
were made in different molds) and have
an internal casing for attaching them.

P. A.-Veleni, *Bronze Medal with Goddess
Athena and Four Animal Heads from
Thessaloniki, Myrtos* (Thessaloniki, 2000),
pp. 141–57.

P.A.-V.

19. TWO PANTHER HEADS
 First half of the 2nd century B.C.
 Bronze
 Length 0.052 m, width 0.061 m
 (MΘ 17538); 0.054 m,
 width 0.062 m (MΘ 17539)
 Found at the site of a Hellenistic
 building in Kiprion, Agoniston
 Square, Thessaloniki
 Archaeological Museum of
 Thessaloniki (MΘ 17538, 17539)

These heads, like the goddess Athena
medal (cat. no. 17) and the two dog heads
(cat. no. 18), decorated parade chariots.
The two heads were cast in different
molds and have an internal casing for
attaching them to a wooden pole.

P.A.-V.

P. A.-Veleni, *Bronze Medal with Goddess
Athena and Four Animal Heads from
Thessaloniki, Myrtos* (Thessaloniki, 2000),
pp. 141–57.

P.A.-V.

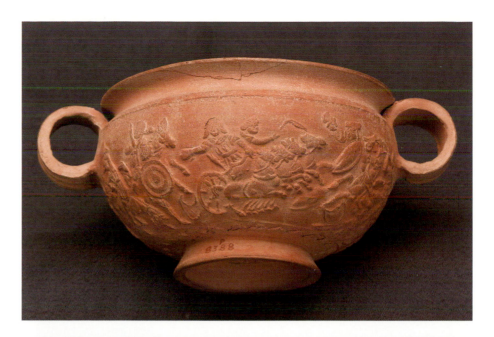

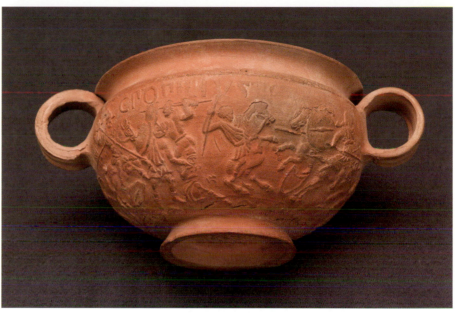

20. BOWL WITH RELIEF SCENE
110–80 B.C.
Ceramic
Height 0.073 m, diameter 0.116 m
Provenance unknown
Museum of Fine Arts, Boston
Henry Lillie Pierce Fund (99.542)
Photograph © 2004 Museum of Fine Arts, Boston

This Italian bowl, made in the style of the Italo-Megarian cups, bears the maker signature of C. Popilius. On its exterior there is a relief scene of Alexander fighting Darius at the Battle of Issus. It is clear that the relief, in which sixteen figures are depicted, was influenced by the famous mosaic of Alexander at Pompeii.

G. Hartwig, in *Ein Tongefaess des G. Popilius mit Szenen der Alexanderschlacht, Roemische Mitteilungen* 13 (1898), pp. 399ff., pl. 11; E. Künzl and G. Koeppel, *Souvenirs und Devotionalien* (Mainz am Rhein, 2002), pp. 62–63, fig. 114; D. Grassinger, *Die Mythologischen Sarkophage* (Berlin, 1975), vol. 1, p. 143, n. 115, p. 268, n. 186. A. Herrmann in *The Search for Alexander* (Boston, 1980) pp. 122–23, cat. no. 45; P. Puppo, *Le coppe megaresi in Italia* (Rome, 1995) pp. 50–51, no. 11, fig. 3.

P.A.-V.

THE SYMPOSIUM

Angeliki Kottaridi

Since the very beginning of civilization, participation in the communal eating of the meat of sacrificed animals and drinking of holy beverages has been a virtually inextricable part of every ritual. This essentially "magical" process, which strengthens the bonds between the members of a group and renews their relationship with the divine, is the ground from which the concept of the feast or festival sprung. An indispensable component of every public or private feast or festival and of every convivial assembly was the symposium, the banquet that, as a rule, followed the communal meal and was for the Greeks, from the time of Homer until the end of Antiquity, the essence of social life, irrespective of sociopolitical developments and differences.

The heroes of the Homeric epics take their bath, are rubbed with aromatic oils, put on clean clothes, and sit down together to delight in the pleasures of food and drink. While the cups are kept filled with watered wine, a bard sings of the adventures and feats of men and gods. On special occasions, the entertainment may be varied with the performances of dancers. Outstanding women—queens like Arete and Helen, goddesses such as Circe—may be present at the symposia of men and take an active part in the conversation and discussion. Nevertheless, the fair sex is, as a rule, confined to a servile role.

In the aristocratic societies of the Archaic period, the symposium, which had developed into an arena of critical philosophical as well as political ferment, that would lead to unprecedented changes for the world, acquired its "classic" form: when the evening meal is over, the diners wash and perfume themselves, put on a wreath, and recline, usually in pairs, on couches in order to enjoy imbibing wine, which is always diluted with water in the proportions ordered by the master of the banquet (*symposiarch*) so as to control the time and degree of inebriation.

The symposium always started with libations to the gods and was prolonged for as long as the participants held out. Usually there were desserts—dried fruits and nuts, cheeses, honey cakes, and other sweetmeats—that accompanied the consumption of wine; for a successful symposium, music and, of course, discussion and good company were almost as essential as the wine.

Suitable space for a symposium was the most spacious and presentable room (or rooms for the wealthy) in the house, the andron, and, of course, the areas of assembly in sanctuaries, clubs (*leschai*), and monumental halls. On fine days, of which there are many in Greece, the symposium could be held in the courtyard or a nearby grove, while it appears that men were not adverse to feasts in the countryside, which is why in vase-paintings symposiasts are depicted reveling under vines and trees.

The philosopher Xenophanes (who dies at a ripe old age, ca. 470 B.C.), a restless and pioneering spirit who lived through all the world-shattering changes that led to the consolidation of the democracy, the regime that is the expression par excellence of rational discourse, has left us an eloquent description of the procedure of the symposium:

> For now the floor is clean, and the hands of all
> and the cups are clean, and a slave crowns them with intertwined wreaths
> and another gives them sweet-smelling myrrh from a bowl.
> And the krater has been put in place, full of mirth.
> And more wine has been prepared, which promises never to betray,
> dark red wine in pitchers, which is fragrant as flowers.
> In the middle, incense sends its pure perfume,
> and the water is cool, delicious, clean.
> And beside are spread fair breads, and a table nobly laid,

heavy with cheeses and thick honey,
And the altar, in the middle, bedecked with flowers,
and song and dance fill the house.
The happy men must first hymn the god
with congratulatory myths and chaste words.
And later they must pour libations and pray to always act justly
(that is the easiest of what they must do).
It is no hubris to drink as much as you can take
and to go home propped up by a slave, unless you are an old man.
Praise the man who, even though he has drunk, speaks well,
as long as his memory helps him, and discusses with passion and virtue.
—Xenophanes, *Fragment 1* (Athenaios 462e, free rendering)

Moderation and virtue were the philosopher's requisites for the ideal symposium, but the reality was often quite different; drunken revelers who sometimes had to vomit in order to relieve themselves, naked girls and boys playing music and dancing in order to put the participants in a good mood, and amorous advances that quite often turned into true orgies appear again and again in vase-paintings on the subject of the symposium. Such representations, which are particularly abundant during the sixth and fifth centuries B.C., offer an exceptionally vivid, direct, and genuine picture of ancient life. Furthermore, the textual sources have no qualms about mentioning, describing, deriding, and even traducing similar phenomena that are attributed preferably "to others," without, of course, meaning that they did not happen to "themselves" as well.

In the democratic city the symposium was, together with the agora, the paramount venue for generating politics and ideology. Here, free male citizens met with friends and fellows of like mind and enjoyed themselves while discussing issues, exchanging opinions and forming views. Here, intrigues were hatched and conspiracies plotted, and it is by no means fortuitous that crucial and definitive acts, such as the assassination of the tyrants (tyrannicide), the mutilation of the herms, the attack on Megara, and many others are said to have been decided upon during a symposium. Then, too, were conceived the ideas that on the morrow would become laws and decrees, hymns and tragedies, statues, monuments, and philosophies.

Plato's pen eloquently immortalized the ideal symposium of Classical Athens, which is said to have been held in the house of the tragic poet Agathon on the day after the celebrations of his first victory in the competition organized as part of the Dionysia festival: the symposiasts are a choice few, among whom the comeliest of all Athenians is Alcibiades and the wisest is Socrates, who politely dismisses the female flautist since the topic of this gathering is "sober drunkenness." The wine is light and drunk in moderation, and the highest pleasure to which the participants aspire is the pure knowledge that emerges from the dialectical exploration of the essence of love.

Although at the critical climax of the Platonic Symposium Socrates himself makes the sage priestess Diotima an imaginary participant in the discussion, ascribing to her the maternity of the words he himself will defend; free women in the democratic city—the wives, mothers, daughters and sisters of the citizens—had no place at the male feast; the female sex was represented only by slave girls, flute players, and dancers—"good-time girls" whose role was to serve and to satisfy all manner of the symposiasts' desires. The only exception to this rule were the courtesans (*hetairai*), who not only participated in but could also be amphitryones and hostesses of the party.

At once an institution and an obligation, participation in the symposium was, together with war, hunting, and politics, a vital element of a man's social identity. Indeed, this is the

reason why in Dorian societies the gift that accompanied the rite of passage from adolescence to manhood was a wine cup.

A central subject of life, the symposium also left its mark on death: together with his strictly personal paraphernalia, weapons, jewelry, and the unguentaria necessary for the funerary rites, the wine cup was included as part of the essential equipment of the dead on his journey of no return, often together with a jug or pitcher; in exceptional cases, a full set of symposium vessels was placed in the tomb. While those initiated into mystic cults expected eternal life beyond death, the symposium—the most common entertainment in life on earth—became the ultimate promise of the delights of posthumous existence: rid of cares and troubles, the devotees of Bacchus and of Orpheus, cognizant of the secret path to salvation, were not lost in the darkness of Hades but continued to live happily in the eternal symposium of the Blessed, in the jubilant light of the Elysian Fields. And it is not fortuitous that the central figure of the Bacchic and the Orphic mysteries, the dying and the reborn god whose fate presaged that of his devotees, was Dionysos, the god who gave men the gift of wine, the god of intoxication and of ecstasy.

These beliefs, combined with Platonic instruction, were to acquire fervent followers in fourth-century b.c. Macedonia, where the king and his family as well as the noble companions (*hetairoi*) became initiates of Bacchus and had expectations of the eternal bliss of heroes. Since in such a context there were no sumptuary laws restricting the expenses of the funeral, as in the democratic cities, and indeed after the campaign to the East, when money flowed in abundantly, the heroized dead were very often accompanied in the tomb by all of the necessary tableware, which, in addition to the symposium vessels, some more precious than others, even included the compulsory couch.

Even more profound than the role of the symposium in the formation of metaphysics and ideology was the influence that this essential and frequently repeated social event exercised on the formation of the tangible reality that is characterized as material culture. Truly the most extroverted activity of private life, the symposium was the best platform for the conspicuous display of the host's social status, wealth, and power: that is why only the best, the largest, and the most sumptuous room, the andron, was reserved for it as well as the most expensive and luxurious furniture and vessels in the household. (The need for the andron decisively influenced the overall design and organization of spaces throughout the entire house.)

The literary sources, the numerous representations on vases, wall paintings, and reliefs, as well as excavation finds—which, in the region of Macedonia are, for reasons mentioned above, particularly rich—give us a rather complete picture of the spaces and the equipment essential for the symposium.

Sine qua non were the couches (*anaklintra*): large, quite high, and made of wood, these were a cross between a bed and a settee. They were placed one next to the other along the walls of the room, the size of which was determined by the number of couches it accommodated. The least number was three; frequently there were five, seven and sometimes nine or eleven, while even more have been found in the houses of the very wealthy, the palaces, and the banqueting halls of sanctuaries (*hestiatoria*). The width of the couches, which were intended for two reclining symposiasts, was three feet (in ancient measure) while their length was usually seven feet (in ancient measure). On one, or even two, sides there were, as a rule, raised "pillows," and mattresses and cushions with loom-woven and embroidered covers made them more comfortable. The wooden couches were decorated with paintings, reliefs, inlays of materials such as precious woods, ivory, glass, gold, or silver, or even appliqué metal fittings, usually of bronze.

Depending on the form of their legs, the couches are classed in different categories: the most impressive and monumental are those with rectangular legs and volute capitals; along with the similar thrones, these are the Greeks' most important contribution to furniture making. Particularly light and elegant are the couches with lathe-turned legs. In the fourth century b.c.

these acquired an arched "cushion," the lateral support of which, the so-called fulcrum, was often made of bronze and lavishly decorated with reliefs. These couches, of wood or bronze, became particularly popular during the ensuing centuries and were to constitute the most characteristic item of symposium furniture in Hellenistic and Roman times. (See the bronze fulcrum from Pella [cat. no. 27] and the bronze couch fittings from Dion [cat. nos. 23–26]). Placed in front of the couches were small portable tables, usually low and tripod, on which the symposiasts put their cups and the trays of sweetmeats and appetizers.

Set up in the symposium venue was the krater, a large wide-mouthed vase indispensable for the procedure of wine drinking, since wine and water were mixed in it. Made off clay, rarely of bronze, and in exceptional cases of silver, the kraters, which at first resembled cauldrons, acquired elaborate, elegant, and extravagant forms over the years.

The wine was carried in sealed pitchers (*amphorae*). The water, which had to be cool and fresh, was carried in hydrias (see the bronze hydria [cat. no. 9]). Jugs of various shapes (see the silver oinochoe from the tomb of Philip II [cat. no. 1], the bronze oinochoe from Pydna [cat. no. 14], the bronze trefoil amphora [cat. no. 7], and the bronze lagynos [cat. no. 8]) were used to ladle the diluted wine from the krater and to serve it in the participants' cups, which were simple bowls (*skyphoi*) with or without handles (see the glass skyphos from Pydna [cat. no. 20]); kylikes, relatively large cups with shallow body, horizontal handles, and high or low foot (see the silver kylix from the tomb of Philip II [cat. no. 2]); or *kantharoi*, deep cups with impressive handles and characteristic bases (see the silver kantharos [cat. no. 22] and the bronze kantharos from Pydna [cat. no. 18]). The wine was kept cool in *psykters*, vessels filled with ice or snow brought from the mountains.

The symposium set also included jugs and basins for hot water, for the washing of the symposiasts' hands, perfume flasks (see the bronze lekythos from Pydna ["Women in Macedonia," cat. no. 28]), trays for the sweetmeats and appetizers, lamps (single or multiple) and their stands, as well as wine jugs (see the bronze oinochoe from Pydna [cat. no. 13]), bossed bowls, and pateras, large shallow bowls with a long handle, reminiscent of frying pans, that were used for the essential libations to the gods at the start of the symposium (see the bronze patera from Pydna [cat. no. 15]).

If to the items above we add the strident colors of textiles, the heady scent of incense, the fragrance of the aromatic oils and the floral wreaths, the delicious tastes of the sweetmeats and appetizers, and the dulcet strains of the lyre and the flute, we can perhaps come close to appreciating the vibrant and exuberant atmosphere of the symposium.

In the democratic cities, where citizens ought to be—and, above all, to appear—equal, excessive waste aimed at personal promotion was considered dangerously deviant. This applied principally to symposia given in the homes of private citizens as well as of officeholders, who had to be careful not to affront public feeling on equality, either with the luxury of their house or their household goods or with the abundance of drink and delicacies.

Symposia with a large number of participants were held only on the occasion of public festivals and celebrations, while it was not unusual for guests to appear at private gatherings carrying their little basket of tidbits, so that they contributed, very democratically, their share of the expenses. Characteristic of the austerity of the Greek symposia is the surprise expressed by the Spartan King Pausanias at the sumptuousness and luxury of the symposium vessel in the tent of Mardonius.

Even so, if moderation, austerity, and the avoidance of distinction and display were for democratic citizens the highest virtues even in merry-making (with the result that any divergence from this norm was considered not only provocative and morally offensive but also "barbaric"), after the collapse of Athens and of the ideals that this city expressed, as birthplace of democracy, the center of gravity began to shift slowly but surely from the public to the private domain, and the climate had already begun to change by the end of the fifth century B.C.

Despite the complaints of the moralists, comfort and opulence became fashionable and this fashion was followed by whoever was willing and able. So we hear of symposia "on couches with ivory legs and mattresses of purple-dyed cloth."

In the frontier land of Macedonia, which remained outside sociopolitical developments in southern Greece and where the structures of the societies of the Homeric epics continued to exist until the reign of Philip II, over and above his subjects, the Temenid ruler was for them the tangible manifestation of the power and stability of the state, and this image had to be projected to all foreigners, friends and enemies. A symbolic persona, the monarch himself was essentially deprived of private life. His residence, built in a privileged and prominent position, its mass dominating the aspect of the city, was the center of religious, political, military, and even intellectual authority. It was here that the foreign plenipotentiaries and emissaries came. It was here that major decisions on issues of peace and war, life and death, were made. The luxury and the splendor of the royal chattels were enhanced as a barometer of the strength of the economy, an essential element for the prestige of the king and of his kingdom. And the basilikos potoi, the royal drinking party, was always a political event of prime importance.

One of the earliest pieces of information we have on the Macedonian court is Herodotus' description of a symposium given by Amyntas I, in late Archaic times, in honor of the Persian legates of Darius. There we learn from the lips of the Macedonian king himself that, according to Macedonian custom, women of the family did not sit down at the symposia of men. However, the presence in the tombs of high-ranking women, such as the "Lady of Aigai," of objects associated with the procedure of sacrifice and the ensuing meal—iron spits, bossed bowls, oinochoai, and pateras—as well as of the symposium—kylikes, kantharoi, amphorae, couches, and so forth—indicates that in certain special circumstances of festive rites and celebrations, these women must have illumined symposia with their presence, just like the queens in the Homeric epics. And if this were the case with the queen-priestesses of the Archaic period, there is no reason to suppose that it would not obtain for wives, mothers, and sisters of kings, such as Eurydike, Olympias, and Thessalonike, while the Macedonian queens of the Hellenistic oikoumene, with paramount among them Cleopatra the Great, are known not only to have attended symposia but also frequently to have hosted them, sometimes with fateful historical consequences.

However, apart from "royal exceptions," the symposium was for the Macedonians, as indeed for all the Greeks, an entirely male affair and, in fact, in order to attend them as equals, a Macedonian had to have slain a boar, that is he had to have completed successfully the basic initiatory test in the rite of passage from adolescence to manhood.

As the finds from the cluster of queens' tombs, from the reign of Perdikkas II (454–413 B.C.), attest, the household effects of the palace of Aigai included chryselephantine couches and silver wine cups. In the reign of Perdikkas' successor Archelaos (413–399 B.C.), which was a splendid heyday for the kingdom of Macedon, the guests of the king, who was the greatest patron of the arts in his time, were hosted in rooms decorated by the most accomplished and most highly paid painter of the day, Zeuxes, and enjoyed the presence of the cream of Hellenic intelligentsia, since among the sovereign's friends and commensals were none other than Euripides and the tragic poet Agathon, amphitryon of Plato's Symposium.

The wealth and largesse of the Macedonian kings may well have provoked the democrats of the south, who looked upon it as a threat to the overturning of their own world. However, this does not by any means imply that the royal symposia did not meet the aesthetic demands of the intellectuals of the age, which they sometimes even surpassed. At the basilikoi potoi of the young philosopher-king Perdikkas III, brother of Philip II, the climate is known to have been especially strict, since in accordance with the royal host's tenets, entry was barred to those who were not conversant with geometry.

Philip II (359–336 B.C.), who was not only the greatest general of his age but also one of the most intelligent and astute Greek statesmen of all time, attached considerable importance to persuasion and to the victories that could be won at a diplomatic level. In his efforts to win as many friends and supporters as possible, in addition to all manner of gifts, compliments, and privileges he so generously bestowed, the father of Alexander the Great, who, for all the calumnies of his rivals, seems to have been a highly cultivated man, recruited culture. By putting his wealth and power to good use, he enhanced his court as a significant center of arts and learning, a tradition continued and consolidated by his son and by his son's successors, the Diadochoi.

In this context, the court festivals and the symposia of the munificent king, which of course went far beyond the bounds of measure and, like many other aristocratic habits of the Macedonians, were criticized by the censorious democrats, were not merely the order of the day but proved to be extremely effective political weapons. For through these Philip succeeded in impressing even his enemies, who nevertheless lost no opportunity to accuse him of wantonness, drunkenness, and barbarity.

For Demosthenes and his cohorts, who were not just political opponents but also fanatical enemies of Philip II, the squander and conspicuous consumption of the royal drinking parties were the palpable symbols of the barbaric tyranny that subjugation to the monarch's power would mean. However, the finds in the royal tombs and the palace of Aigai confute this impression and give us an unexpectedly full and vivid picture of the royal milieu in which Alexander grew up, in which luxury was harmoniously combined with elegance and wealth, with impeccable good taste.

The palace of Aigai, located in the same building insula as the theater, was evidently built in the final years of Philip II's reign. It was at once the seat of political authority and the center of cultural creativity, a veritable monument of magnificence, functionalism, and mathematical clarity, which, through the absolute consistency of its geometry, epitomizes the "good life." It is the concrete manifestation of the model of the ideal residence and, as the archetype of the building with peristyle, set its seal on the architecture of the Hellenistic world. It is estimated that in its androns, which occupied almost the entire ground floor and were equipped with all comforts down to the minutest detail, there was room for 278 couches. Thus, Philip II could hold a symposium for more than 500 guests at once, an unprecedented number by Greek standards, exceeded only by the legendary feasts of Alexander the Great, ruler of the world, and by his successors, who were to become potentates in the East.

Floors with inlaid marbles (*opus sectile*) and wonderful mosaics, heavy bronze-clad, wooden doors, walls with brightly colored stuccoes and adorned with choice paintings, cloth of gold vela, precious furniture, and vessels composed the setting for the royal symposia. The two richly ornamented couches, with inlays of glass and gold and ivory reliefs found in the tomb of Philip II, one of which is revetted with ivory on all sides and is one of the most expensive examples of its kind ever made, allow us to imagine the splendor and sumptuousness of the furnishings of the royal androns. Hand-crafted by gifted artists, the two couches—on one of which were preserved remarkably expressive portraits of the king, of his son and heir, and of their twelve most important relatives and companions (*hetairoi*)—rightly earn their place among the master-pieces of ancient art.

Of comparable quality and value was the rest of the royal domestic equipment in which gold and silver were the order of the day. The vessels for the bath, some of which (for example, the jug and the basin with handles) could also have been used for washing the hands before the symposium, were of bronze. Also of bronze was the oinochoe with the relief head of Medusa, which, together with the bronze patera, was used for the libations at the commencement of the symposium, as well as the peculiar yet attractive openwork lantern, the lychnouchos.

Silver was used in abundance for the symposium vessels, which are outstanding not only for their luxury but also their superb quality: the spare, clean lines of the forms are combined with graceful detail in an ensemble of unrivalled elegance, harmony, and charm.

Although the Athenians accused Philip II of being an uncontrollable wine drinker, all the vessels for the royal symposium—especially the cups, kantharoi, kalykes, and even the kylikes of Attic inspiration—are much smaller than the cups used in the Athenian symposia and are more like today's wineglasses.

The penchant for small symposium vessels, in contrast to the earlier larger vessels, as well as the use of new, fancier forms and shapes, which is observed initially in the royal equipment and subsequently in all Macedonian households, eventually becoming a fashion of universal appeal, may well denote changes in the procedure of the symposium and the "ceremony" of wine drinking. These had apparently become more complex and sophisticated, with a strong tendency toward refinement that is seen for the first time in the court of Philip II and was consolidated in the reign of Alexander the Great, setting the tone for Hellenistic symposia and following the more general rise in living standards.

In place of the voluminous kraters, the much smaller situlae (see the bronze situlae from Derveni and Thessaloniki [cat. nos. 5, 6]) appear with increasing frequency. These resemble little buckets or pails and were carried easily. Smaller cups became popular. These included the kalyx—a particularly precious and elegant wine cup the size of a cupped hand and recalling the calyx of a flower in shape, from the bottom of which a relief mask usually emerges to the surprise and delight of the drinker (see the silver kalyx [cat. no. 3] and the two clay ones [cat. no. 4] from Aigai)—and the miniature kantharos (see the bronze kantharos [cat. no. 18] and the silver one [cat. no. 22]). Smaller too, as a rule, are the diverse oinochoai and ewers. The small ladles with bird-shaped handles (see the silver ladle [cat. no. 12] and the bronze ones [cat. nos. 10, 11]) and the small intricate strainers (cat. nos. 16, 17])—including the one found in the tomb of Philip II, a veritable masterpiece in miniature that the craftsman proudly signed—decisively became the order of the day.

The sources refer to the bounty of the host who, instead of estimating beforehand, as was the norm, how much wine would go into a krater, so as to keep tabs on the cost of the symposium, gave his guests the opportunity to decide for themselves how much wine (and mixed in what proportion with water) they would like, placing all the necessities on the table of each. This seems to have happened at the royal drinking parties of Philip and of Alexander.

At the royal symposia choice wine came from the cellar, undiluted, in elegant oinochoai, to the table of each important guest, as did the fresh, cool water. Along with it came expensive, rare, heavy wines like today's port or Madeira, which were brought well sealed like precious perfumes in silver flagons, along with honey, myrrh, spices, and condiments of aromatic fruits and flowers—essential ingredients for the royal "cocktail." This wine was mixed, according to the rules of degustation and the desires of the drinker, in a situla and was served with an elegant ladle into cups, first passing through a strainer. Thus the enjoyment of wine become a true ritual, a highly specialized procedure addressed to the refined palate of a real "gourmet," who took pleasure in the taste of the drink as well as in the harmony of the music, the beauty of high art, the stimulation of high philosophy. . . . We should not forget that the symposia of Alexander, and of his father, were renowned not only for the wealth, luxury, and abundance of the vessels, drinks, and food but also for the participation of the leading musicians, actors, poets, and intellectuals of the time. And, of course, the most beautiful and witty courtesans were not absent either.

Inevitably, the new mode spread from the court to the royal companions and from them to the wealthy Macedonians, who, now truly masters of the world, eagerly strove to keep up as best they could with the demands of the day, sometimes verging on excess, such as the Macedonian Karanos—otherwise unknown—who, at his monumental marriage symposium, presented each of his guests with the solid gold cup with which they had drunk at the feast.

Andronikos, M. *Vergina: The Royal Tombs and Other Antiquities*. Athens, 1984.

Boerker, C. "Festbankett und griechischer Architektur." *Xenia* 4 (1983).

Carpenter, T. H. *Dionysian Imagery in Archaic Greek Art*. Oxford, 1986.

Dalby, A. *Σειρήνια Δείπνα*. Herakleion, 2000.

Denzer, J. M. *Le Motif du banquet couche dans le proche-orient et le monde grec du VII au IV siècle avant J.-C.* Rome, 1982.

Faust, S. *Fulcra: figürlicher und ornamentaler Schmuck an antiken Betten*. Mainz, 1989.

Hoepfner, W., and G. Brands. *Die Palaeste der Hellenistischen Koenige*. Basel, 1996.

Θέμελης, Π., and Ι. Τουράτσογλου. *Οι τάφοι του Δερβενίου*. Athens, 1997.

Martin, J. *Symposion*. Paderborn, 1931.

Murray, O., ed. *Sympotica: A Symposium on the Symposion*. Oxford, 1990.

Vernant, J. P. *Le Sacrifice dans l'antiquité*. Geneva, 1981.

Objects from the Tomb of Philip II

Commander in war, first in battle and in the hunt, guarantor of law and order in time of peace, bearer of divine blessing, person sacred and sacrosanct, the Macedonian king was like the kings of Homer, the *padre padrone* of his subjects. By reversing the existing dynamic, however, Philip II had succeeded in leading his kingdom from the brink of the abyss at Kolophon to triumphal glory. In so doing, he had superseded all these qualities and, at the moment of his unexpected death, was not only the invincible leader of the greatest power in the Hellenic world but also the officially recognized supreme general of all the Greeks. Through conviction and violence, Philip had achieved what had hitherto seemed unattainable: to unite under his authority the ever-truculent Greeks, thereby paving the way to the East.

Philip's son Alexander evidently knew this all too well. Fully aware of the power of ceremony and symbolism, Alexander understood that the moral legitimacy of his own authority and the emotive consolidation of the status quo were conveyed through the honors accorded to the dead ruler, who would thus find his place—literally and metaphorically—in the pantheon of heroes. So he took pains to ensure that his father's burial was the most magnificent funerary ceremony Greece had ever witnessed. This is borne out not only by the testimonies of the ancient sources but also by the finds themselves, which, individually and as a whole, are the most abundant as well as the most delightful artifacts ever found in a mortuary context in Greece after the Mycenaean period.

The mural masterpiece of the royal hunt, the unrivaled ivory-and-gold couches, the ornate silver vases, the unique set of bronze vessels, the precious gold wreaths and jewelry, as well as the gold-embellished weapons of Philip II—the same kind as those worn by his son—permit us to form a vivid picture not only of the wealth and the extravagance, the opulence and the splendor, but also of the outstandingly sophisticated aesthetics of the palace and the milieu in which Alexander the Great was born and raised.

The Symposium Vessels

In addition to the chryselephantine couches placed in the tomb of Philip II was a complete set of silver symposium vessels, provided to ensure that the kingly hero would live on in the blissful light of the Elysian Fields, eating, drinking, and making merry at the eternal banquets of the blessed. Comprising nineteen pieces, this ensemble surpasses, in luxury and quality, anything comparable found to date.

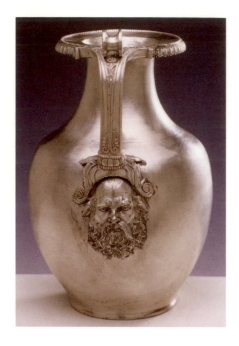

1. WINE JUG (OINOCHOE)

350–336 B.C.
Silver
Max. height 0.244 m, max. diameter
0.154 m, weight 1,196.94 g
From the burial chamber of the tomb
of Philip II
Museum of the Royal Tombs of Aigai,
Vergina (BM 2442)

Simple clay jugs of this shape, which were used for serving wine, appear to have been common in Classical times, as they have been found at Aigai and elsewhere. This particular silver oinochoe, so essential for serving wine that it accompanied its owner in the tomb, weighs almost 1.2 kilos and constitutes, together with the identical one found with it, the most valuable as well as the most elegant example of its kind to have survived.

However, as was the case with almost all of the royal plate items, the value lies not just in the preciousness of the material but in the classical austerity and clarity of form, which, combined with the highly accomplished craftsmanship and attention to detail, manifests the artist's virtuosity and creative imagination.

The entire body of the vase—base, belly, neck, rim—is fashioned from a single, rather thick sheet of silver formed by hammering and with the aid of a lathe. The cast handle, the small spool soldered to its shoulder, and the relief head of Silenus were worked separately, then soldered to the body of the oinochoe.

The pronounced curvature of the body, with its swollen, almost globular belly and narrow neck—the basis for dating the vase about the mid-fourth century B.C.— is balanced by the wide, flat rim with an elegant relief edge. The edge is in the form of an Ionic cymatium, a detail at once functional and decorative, since to it is attached the upper part of the robust, vertical handle which, by extending the rim with its curved back, adds stability and creates a sense of geometric severity and simplicity.

Function and decoration are also beautifully combined in the extremely elegant and well-designed handle, which, in order to embrace the rim, splays upward with a double pair of volutes and ends downward in a sprig of leaves and stems, thus fitting perfectly to the soft curve of the shoulder and forming the arc within which the Silenus head was attached. The spool on the shoulder of the handle seems to be largely decorative, reminiscent of earlier models in which a lid of some sort was affixed.

The care, precision, and skill with which the rich decoration of the handle has been executed in low relief are remarkable. The rows of tiny "beads"; the ring with an astragal rendered in perspective that seems to hold the sprig of leaves and stalks at its base; the fine relief bands; the volutes; the stylized palmettes; and the realistic lily flower on its back are all elements that serve the shape and the function of the vessel.

The artist's surpassing ability, however,

is without doubt most striking in his rendering of the face of Silenus, in which we find something of the nobility of the figure of Socrates, as described by Plato in his famous *Symposium*. Manolis Andronikos wrote of the identical figures of Sileni adorning both silver oinochoai.

I know of no other Silen with such total concentration on the inseparable mixture of beast and human. Socratic introspection and bestial sensuality, reflective man and scarcely suppressed lust after carnal indulgence are rarely to be read so clearly as in the eyes of these two Silen-philosophers.

It is obvious that the roots of these two figures lie deep in the classical tradition and that they have not been tainted by the violent currents of the world which would give birth to the new art—that which would be called Hellenistic.

The superb quality, assiduity, and accuracy of the construction and decoration, in conjunction with a series of stylistic and technical traits found in this oinochoe, its twin, and some of the other silver vessels found in Philip II's tomb, attest that these are the works of a talented toreutics artist, none other than the creator of the impressive bronze krater from Derveni, with its lavishly sculpted decoration of the Dionysias thiasos.

M. Andronikos, *Vergina: the Royal Tombs and the Ancient City* (Athens, 1984), pp. 145 ff.

A.K.

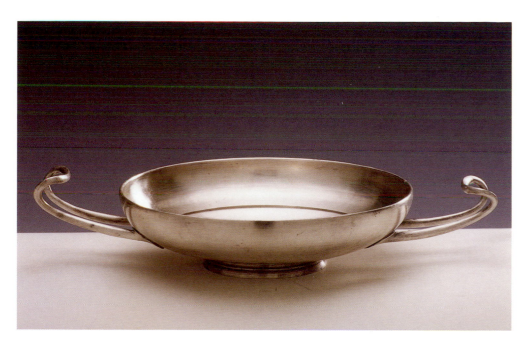

2. CUP (KYLIX)
 350–336 B.C.
 Silver
 Height (excluding handles) 0.036 m,
 diameter of rim 0.134 m,
 weight 265.71 g
 From the burial chamber of the tomb
 of Philip II
 Museum of the Royal Tombs of Aigai,
 Vergina (BM 2565)

Clay wine cups (*kylikes*) with a high or low foot were one of the most characteristic products of Attic pottery, particularly popular in Aigai, ancient capital of the kingdom of Macedon from the sixth century B.C. The silver kylix presented here is a more precious version of this traditional shape, and was deposited, together with three similar ones from the royal chattels in the palace at Aigai, in the tomb of Philip II. It is impressive not only for its weight and luxurious material but also for its elegance and exquisite finish.

The open, shallow cup was formed from a single, rather thick metal sheet that was hammered with extreme care and turned on a lathe. Zones of concentric circles drawn with a compass decorate the lower surface of the foot of the vase and mark the rim, but the true ornament of this simple vase is the elegant and exceedingly refined horseshoe handles, which, as they open boldly in space and twist, emphasize the pronounced curvature of the body.

Incised on the lower surface of the foot of the cup are the characters ΞΒ=, that is, 62 drachmas and 3 obols. Considering that a lifesize marble statue cost just 200 drachmas, we can appreciate the great value of this small cup. The drachmas used here for calculating the weight and the value of the kylix are Attic ones, but there is nothing strange in the use of the Attic weight standards, since this measurement system was not unknown in Macedonia. Indeed, it is not at all unlikely that these cups with their distinctive Attic shapes were made in a toreutics workshop in Attica and, along with so many other imported products, found purchasers in the royal court of Macedonia. Another possibility is that they were products of a branch of an Athenian workshop, set up in a region of the kingdom with wealthy customers.

M. Andronikos, *Vergina: the Royal Tombs and the Ancient City* (Athens, 1984), pp. 145 ff.

A.K.

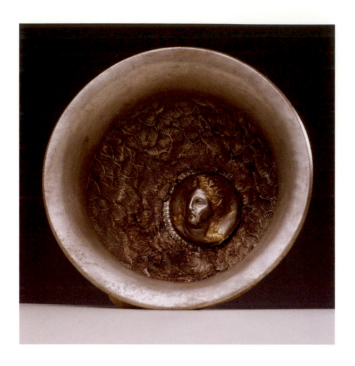

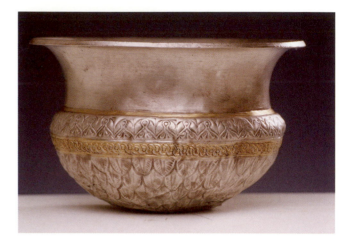

3. WINE CUP (KALYX)
 Last quarter of the 4th century B.C.
 Silver
 Diameter 0.096 m
 From a not particularly wealthy burial in the Cemetery
 of Aigai
 Museum of the Royal Tombs of Aigai, Vergina (BM 1626)

The wine cups known as *kalykes,* whose shape seems to have originated in the East, were already much loved in Macedonia by the reign of Philip II and often were made of precious metals. After the campaign in the East and the general rise in living standards that followed, the use of kalykes spread beyond the narrow confines of court circles and the king's companions (*hetairoi*). This is the case with this elegant cup, which closely resembles corresponding finds from Sevasti in Pieria and Derveni, Thessaloniki. It was made by hammering a fairly thin silver sheet and, as was customary, is lavishly decorated with repoussé motifs: a Lesbian cymatium and a guilloche, defined by gilded bands on the shoulder; lanceolate leaves in successive rows all over the body; and a double rosette with gilded center on the base.

As the contents of the cup were consumed, an agreeable figure of young Dionysos wearing an ivy wreath atop his long golden hair gradually came into view, embossed with care and attention in a silver medallion.

A.K.

4. TWO BLACK-GLAZE WINE CUPS
 Last third of the 4th century B.C.
 Clay
 Max. height 0.085 m
 From the Cemetery of Aigai
 Museum of the Royal Tombs of Aigai, Vergina
 (BM 2339, BM 2340)

In order to satisfy the needs of those who were not prepared or could not afford to purchase metal kalykes but wanted to follow the dictates of fashion, there were also clay cups, such as these two from Aigai. The spare decoration on them is confined to a band of tongue pattern on the shoulder and imitates metal models, adapted to the nature of the material from which they were made. A touching detail is the careful, widely spaced inscription on the rim of one of these cups: *ΥΓΙΕΙΑΣ* (health), which brings to mind the universal toast "To your health."

A.K.

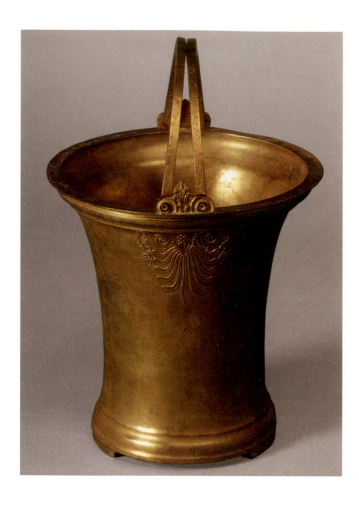

5. BASKET-SHAPED SITULA
Last decades of the 4th century B.C.
Bronze
Height 0.20 m
From Derveni cemetery, tomb B
Archaeological Museum of Thessaloniki (B 28)

This situla is a symposium vessel for water or wine. Two movable arched handles with finials in the form of a flower bud are affixed in twin suspension loops and attached to the hoop of the rim by an intervening acanthus half-leaf embellished with a palmette. Lower down, repoussé palmettes articulated from double volutes and spiraling stems with rosettes decorate the vessel's incurvate vertical wall. This piece is dated to the last decades of the fourth century B.C., although archaeologists differ on this issue.

Π. Θέμελης and Ι. Τουράτσογλου, *Οι τάφοι του Δερβενίου* (Athens, 1997), p. 73, pls. 18, 78.

E.T.

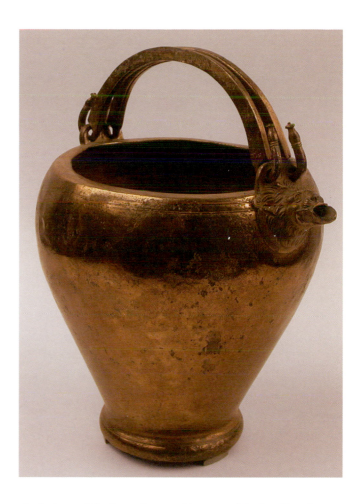

6. STAMNOS-LIKE SITULA
 Last decades of the 4th century B.C.
 Bronze
 Height 0.195 m
 From Derveni cemetery, tomb B
 Archaeological Museum of Thessaloniki (B 29)

At the base of the loops for attaching one of the handles of this situla, or bucket, is a spout in the form of a lion head with a jutting lower jaw. On the other handle, the now-broken and eroded hammered lead mask of a male, bearded figure (also in the Archaeological Museum of Thessaloniki; B 69) must have been attached. Although it is attributed here to the final decades of the fourth century B.C., there are differing views among archaeologists.

Π. Θέμελης and Ι. Τουράτσογλου, *Οι τάφοι του Δερβενίου* (Athens, 1997), p. 73, pl. 79.

E.T.

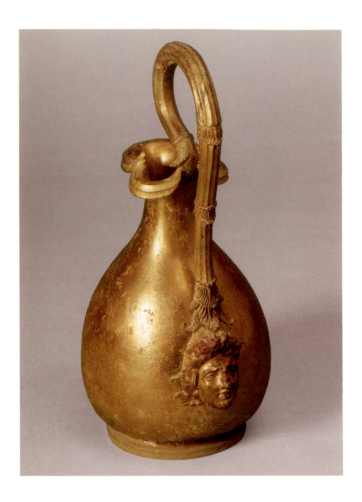

7. WINE JUG WITH TREFOIL SPOUT

Last decades of the 4th century B.C.
Bronze
Height 0.188 m
From Derveni cemetery, tomb B
Archaeological Museum of Thessaloniki (B 33)

The wide, rolled, everted rim and the vertical high-flung handles in the form of an acanthus stem distinguish this oinochoe, tentatively dated to the final decades of the fourth century B.C. The base of the handle, decorated with acanthus leaves, touches the mask of a youthful Pan.

Π. Θέμελης and I. Τουράτσογλου, *Οι τάφοι του Δερβενίου* (Athens, 1997), p. 75, pl. 84.

E.T.

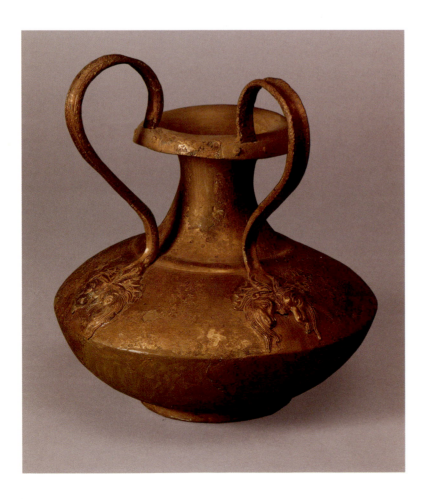

8. FLASK (LAGENOS)

Last decades of the 4th century B.C.
Bronze
Height 0.17 m
From Derveni cemetery, tomb B
Archaeological Museum of Thessaloniki (B 34)

This bronze lagenos has two vertical, high-flung, strap handles attached inside the rim and at the starting point of the biconical body. Developed below the handles is the decorative motif of two confronted goats' heads covered with acanthus half-leaves. It is tentatively dated to the final decades of the fourth century B.C.

Π. Θέμελης and I. Τουράτσογλου, *Οι τάφοι του Δερβενίου* (Athens, 1997), p. 75, pl. 85.

E.T.

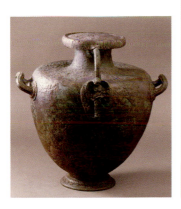

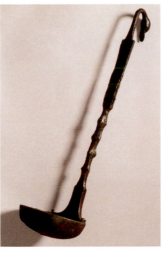

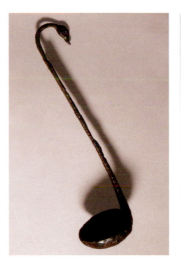

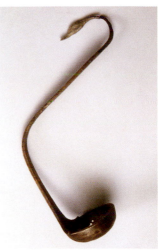

9. KALPIS HYDRIA
Ca. 430 B.C.
Bronze
Height 0.425 m
From tumulus I, tomb III,
ancient Aeneia
Archaeological Museum of
Thessaloniki (ΜΘ 7552)

This vase was intended for
carrying water, essential for
mixing with wine. The hoop
of the rim is decorated with a
repoussé tonguelike pattern and
a bead-and-reel design (astragal);
vegetal motifs decorate the
circular protuberances and the
base. On the oval strip of the
lower attachment of the handle
projects the cutout relief figure
of a young Nike stepping on the
decorated edge of an acanthus
leaf. The interesting winged
being, which can be compared
with the Nike of Paionios, is
also associated with mortuary
beliefs. The vase, possibly the
product of an Attic workshop,
presumably was a family
heirloom that had been used
as a cinerary urn in a later
burial of the third quarter of
the fourth century B.C.

Ι. Βοκοτοπούλου, *Οι ταφικοί
τύμβοι της Αίνειας* (Athens,
1990), pp. 53–55, pl. 31*α-β*.

E.T.

10. LADLE
Second half of the
4th century B.C.
Bronze
Length 0.265 m,
max. width 0.07 m
From Makryyalos,
field no. 951, tomb 187,
north cemetery of Pydna
Archaeological Museum
of Thessaloniki, Pydna
excavation (Πυ 10809)

This utensil is cast. From the
shallow bowl arises the vertical
strap handle, the lower part of
which is rendered in the form
of a branch. On the lowest
part of the base are two hook-
like protuberances; its upper
part has a cylindrical shape
that curves and terminates
in a swan's head. Ladles are
frequently found in sets of
symposium vases and were
used for drawing wine from
vessels.

M.B.

11. LADLE
Second half of the
4th century B.C.
Bronze
Length 0.248 m,
max. width 0.063 m
From Alykes Kitrous,
field of K. Chrysochoidis,
tomb 20, cist grave in
the form of a *theke,*
south cemetery of Pydna
Archaeological Museum
of Thessaloniki, Pydna
excavation (Πυ 886)

The vertical strap handle of
the rectangular section of this
cast-bronze vase rises from the
shallow bowl and acquires
cylindrical form toward the
top, where it curves and ends
in a swan's-head finial. At the
point where the handle joins
the body are two acanthus-
shaped knobs. The ladle was
used for drawing wine.

Μ. Μπέσιος and Μ. Παππά,
Πύδνα (Thessaloniki, 1995),
pl. 86Δ.

M.B.

12. LADLE
Third quarter of the
4th century B.C.
Silver
Height 0.27 m
From Aghios Mamas
cemetery, tomb 3
Archaeological Museum
of Polygyros (ΜΘ 17099)

The strap handle of this silver
ladle, with two hooklike knobs
at its base, tapers upward
to form a cylindrical shaft
that curves and ends in a
goose's-head finial modeled
in the round.

Σ. Μοσχονησιώτου,
"Νεκροταφείο στον Αγ.
Μάμαντα," *Το Αρχαιολογικὸ
Ἔργο στη Μακεδονὶα και Θρὰκη* 3
(1989), p. 353, figs. 5, 6.

E.T.

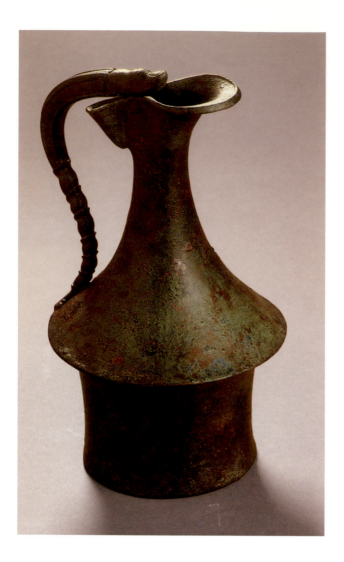

13. WINE JUG (OINOCHOE)

Second half of the 4th century B.C.
Bronze
Height 0.229 m, diameter of base 0.099 m
From Alykes Kitrous, field of K. Chrysochoidis,
tomb 35, cist grave, south cemetery of Pydna
Archaeological Museum of Thessaloniki,
Pydna excavation (Πυ 893)

The jug comprises a cylindrical body, conical shoulder,
and neck ending in a trefoil rim. The vertical, S-shaped
handle is attached to the shoulder with a metal sheet
in the form of a floral ornament. The lower half of
the handle is shaped as a stem; the upper is decorated
with a tonguelike pattern. The handle's upper finial is
rendered as a thumb. Preserved on the body beneath
the handle are traces of a now-lost palmette. The
outside of the base is decorated with relief rings.

M. Μπέσιος and M. Παππά, *Πύδνα*
(Thessaloniki, 1995), pl. 86Γ.

M.B.

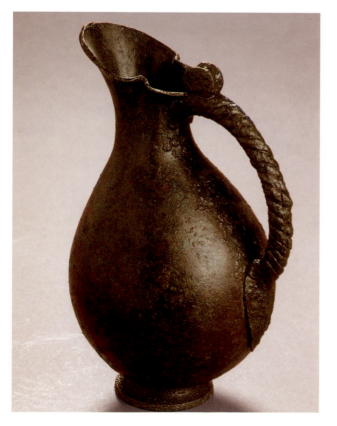

14. WINE JUG (OINOCHOE)

Second half of the 4th century B.C.
Bronze
Height 0.168 m, diameter of base 0.048 m
From Alykes Kitrous field of K. Chrysochoidis,
tomb 20, cist grave in the form of a *theke,*
south cemetery of Pydna
Archaeological Museum of Thessaloniki,
Pydna excavation (Πυ 885)

The vase has a piriform body that ends in a trefoil
spout with a beveled rim and is set askew on its low
base. There are two symmetrical depressions on the
outline of the rim. The vertical arched handle consists
of a twisted piece attached to the rim with a square
sheet of metal. On the upper part of the same finial,
higher than the rim, is a spool-shaped metal sheet.
The handle's lower finial, which attaches the handle
to the body, is leaf-shaped.

M. Μπέσιος and M. Παππά, *Πύδνα*
(Thessaloniki, 1995), pl. 86Δ.

M.B.

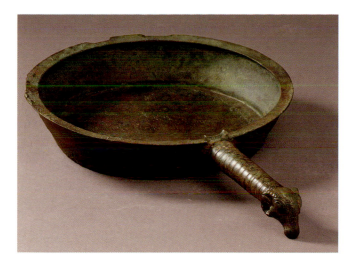

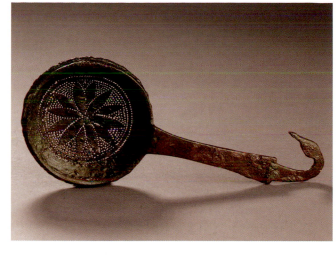

15. VESSEL IN THE FORM OF A FRYING PAN
 Second half of the 4th century B.C.
 Bronze
 Length (including handle) 0.397 m,
 diameter of rim 0.254 m, height 0.048 m
 From Alykes Kitrous, field of K. Chrysochoidis, tomb 35,
 cist grave, south cemetery of Pydna
 Archaeological Museum of Thessaloniki, Pydna excavation
 (Πυ 892)

This symposium vessel for carrying food or hot water for
washing one's hands has a shallow body with flaring walls and
a flat, wide rim projecting beyond the body. At center on the
bottom are two incised double circles. The tubular handle has
transverse rings and a ram's-head finial, and is attached to the
body with a metal sheet—semicircular below the body and
bird-shaped on the rim.

M. Μπέσιος and M. Παππά, *Πύδνα* (Thessaloniki, 1995),
pl. 86Δ.

 M.B.

16. STRAINER
 Second half of the 4th century B.C.
 Bronze
 Length (including handle) 0.19 m, diameter of rim 0.09 m
 From Makryyalos, field no. 951, tomb 187,
 north cemetery of Pydna
 Archaeological Museum of Thessaloniki, Pydna excavation
 (Πυ 7784)

Strainers were an essential vessel at symposia, for retaining
the lees when wine was poured into cups of various shapes
(*ekpomata*). This example has a shallow, hemispherical body.
On its pierced bottom is a decorative rosette with twelve
lanceolate petals. On the rim is horizontal strap handle with
a swan's-head finial.

 M.B.

17. STRAINER
 Second half of the 4th century B.C.
 Bronze
 Max. length 0.164 m, diameter of rim 0.11 m
 From Alykes Kitrous, field of K. Chrysochoidis, tomb 20,
 cist grave in the form of a *theke*, south cemetery of Pydna
 Archaeological Museum of Thessaloniki, Pydna excavation
 (Πυ 887)

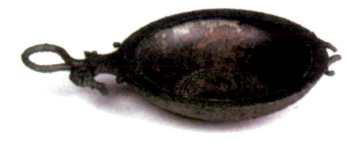

The central part of the bottom of this strainer is decorated with
a swirl of tiny holes surrounded by three circles with holes. The
shallow, bowl-shaped body has a flat rim, from which rise two
handles. One handle is a plaque with incurving sides and small
volute knobs ending in a swan head. All that remains of the other
handle is part of the bar of the square section, with volute knob.

M. Μπέσιος and M. Παππά, *Πύδνα* (Thessaloniki, 1995), pl. 86Δ.

 M.B.

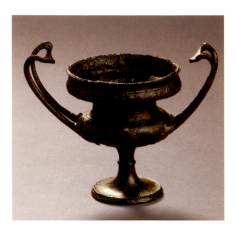

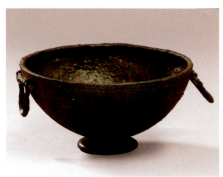

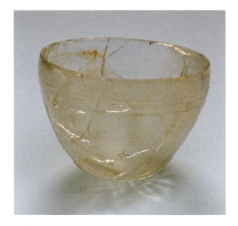

18. CUP WITH TWO HANDLES
(KANTHAROS)
Second half of the 4th century B.C.
Bronze
Diameter (including handles) 0.13 m,
height 0.08 m
From Makryyalos, field no. 951,
tomb 187, north cemetery of
Pydna Archaeological Museum of
Thessaloniki, Pydna excavation
(Πυ 7785)

The handles and foot of this kantharos
are cast. The double handles are attached
to the calyx-shaped body of the goblet
by their leaf-shaped finials. The high foot
has a flaring base and a modeled ring at
its midpoint. Cups of this type are partic-
ularly common among sets of symposium
vases in Macedonian tombs of the second
half of the fourth century B.C.

M.B.

19. KRATER
Second half of the 4th century B.C.
Bronze
Diameter of rim 0.167 m, diameter
of base 0.06 m, height 0.084 m
From Alykes Kitrous, field of
K. Chrysochoidis, tomb 20,
cist grave in the form of a *theke,*
south cemetery of Pydna
Archaeological Museum of
Thessaloniki, Pydna excavation
(Πυ 884)

A deep bowl with hemispherical body,
low base, and two movable handles
characterize this krater, a vessel used for
mixing water and wine. The rim, which is
cast, is encircled by a fine relief band. Its
base and its handles—which are attached
to the upper part of the body by horizontal
cylindrical bars, thicker in the middle
and with flattened ends—are also cast.
Its function also explains why it is often
found in ensembles of symposium vases
in richly furnished Macedonian tombs of
the second half of the fourth century B.C.

M. Μπέσιος and M. Παππά, *Πύδνα*
(Thessaloniki, 1995), pl. 86Δ.

M.B.

20. CUP (SKYPHOS)
Early 3rd century B.C.
Glass
Height 0.075 m,
diameter of rim 0.099 m
From Alykes Kitrous,
field of K. Chrysochoidis,
Macedonian tomb,
south cemetery of Pydna
Archaeological Museum of
Thessaloniki, Pydna excavation
(Πυ 404)

Although extensively cracked, this rare
example of a half-section glass skyphos—
a cup of colorless transparent glass that
was cast using the lost-wax technique—
is intact. On the exterior is a horizontal
ridge below the rim, and three relief
cockleshells embellish the lower part of
the bowl. The interior is undecorated.

M. Μπέσιος, *ΑΔ* 39 (1984): Χρονικά,
p. 221: Macedonian tomb sarcophagus 1;
M. Μπέσιος and M. Παππά, *Πύδνα*
(Thessaloniki, 1995), pl. 88A. See the
fragments of a comparable skyphos
from tomb A at Derveni (Π. Θέμελης and
Ι. Τουράτσογλου, *Οι τάφοι του Δερβενίου*
[Athens, 1997], pp. 41, 42).

M.B.

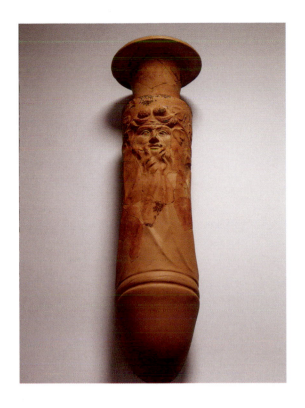

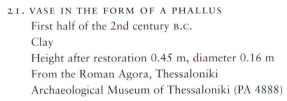

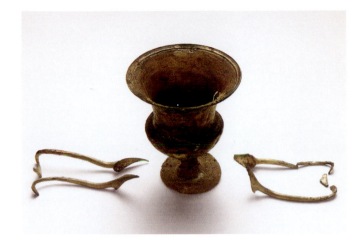

21. VASE IN THE FORM OF A PHALLUS
 First half of the 2nd century B.C.
 Clay
 Height after restoration 0.45 m, diameter 0.16 m
 From the Roman Agora, Thessaloniki
 Archaeological Museum of Thessaloniki (PA 4888)

The vase has been mended and restored from numerous
sherds. Most of the body, neck, and rim as well as the
finial of the glans penis are preserved. The dominant
figure depicted on the body is Dionysos at a mature age.
Ivy shoots arising from the god's head encircle the vase,
simultaneously creating the "ribs" of the phallus. Visible
on the neck is vegetal decoration in "West Slope" style,
with silvering on the olive leaves. Traces of white pigment
are found on the rest of the vase. The fine fabric of the
clay and the elegant decoration suggest this is the product
of an East Aegean workshop. Perhaps the vessel was
intended for use at symposia or in cult observances.

Π. Αδάμ Βελένη, et al., "Κλειστά χρονολογημένα σύνολα
από την αγορά της Θεσσαλονίκης," in Πρακτικά Ε′
Συνάντησης για την Ελληνιστική Κεραμεική (Athens, 2000),
p. 294, no. 191, fig. 146β.

P.A.-V.

22. CUP WITH TWO HANDLES (KANTHAROS)
 Third quarter of the 4th century B.C.
 Silver
 Height 0.10 m, diameter 0.086 m
 From Aghios Mamas cemetery, tomb 3
 Archaeological Museum of Polygyros (MΘ 17098)

This kantharos has a calyx-shaped body and a low, columnar
foot with banded base and modeled rings around its midpoint.
The curving part of each of the double-attached handles is in
the form of a schematic leaf; the finials on the body are of
lanceolate leaves.

Σ. Μοσχονησιώτου, "Νεκροταφείο στον Αγ. Μαμάντα,"
Το Αρχαιολογικὸ Έργο στη Μακεδονὶα και Θρὰκη 3 (1989),
p. 353, figs. 5, 6.

E.T.

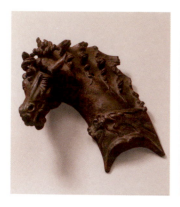 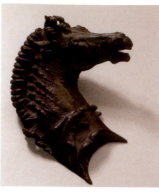 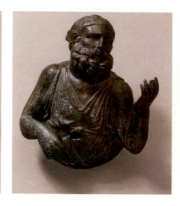 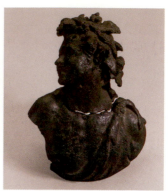

23. PROTOME OF A HORSE FROM A FULCRUM FACING LEFT
Late 2nd century B.C.
Bronze
Height 0.175 m
From the banqueting hall at the Villa of Dionysos, Dion
Archaeological Museum of Dion (MΔ 7480)

24. PROTOME OF A HORSE FROM A FULCRUM FACING RIGHT
Late 2nd century B.C.
Bronze
Height 0.17 m
From the banqueting hall at the Villa of Dionysos, Dion
Archaeological Museum of Dion (MΔ 7481)

25. BUST OF HERAKLES AS A DECORATIVE APPLIQUÉ OF A FULCRUM
Late 2nd century B.C.
Bronze
Height 0.13 m
From the banqueting hall at the Villa of Dionysos, Dion
Archaeological Museum of Dion (MΔ 7482)

26. BUST OF A YOUNG SATYR AS A DECORATIVE APPLIQUÉ OF A FULCRUM
Late 2nd century B.C.
Bronze
Height 0.15 m
From the banqueting hall at the villa of Dionysos, Dion
Archaeological Museum of Dion (MΔ 7483)

This horse protome is the second crowning member of a fulcrum found in the same location. There are many similarities in the quality of work with a related protome faces the right, so it is likely they belonged to the same *kline,* or couch. They differ, however, in the proportions of the head and in the presentation of the horse mane. The difference might be simply a matter of gender; that is, perhaps this is a stallion and the other a mare. Here, the locks of the mane are particularly emphasized as individual details, with heightened curves and corkscrewlike design. A similar mane is seen on a protome of a horse (Rhode Island School of Design Museum, Providence) that dates about 100 B.C.

D. Pandermalis, *Discovering Dion* (Athens, 2000), pp. 184–85. For the Providence protome of a horse, see S. Faust, *Fulcra: figürlicher und ornamentaler Schmuck an antiken Betten* (Mainz, 1989), pp. 74–75, pl. 41.
 D.P.

This horse protome is the crowning member of the fulcrum of a couch (*kline*). As commonly seen in fulcrums of this type, there is strong movement in the head and neck; the horse's mouth is open and its mane is well tended. A similar mane is on a protome from Priene (now in the Antikenmuseum, Berlin), dated to the late second century B.C. The work on the fulcrum from Dion shows particular care in the details of the mane and the eyes, which are incised. A leopard skin is tied at the front of the horse's neck.

D. Pandermalis, *Discovering Dion* (Athens, 2000), pp. 184–85. For the Berlin protome of a horse, see S. Faust, *Fulcra: figürlicher und ornamentaler Schmuck an antiken Betten* (Mainz, 1989), p. 148, pls. 13, 1 and 38.1.
 D.P.

This unusual item, found next to the protome of the horse that faces right (cat. no. 24), represents Herakles as Queen Omphale—with a headband and wearing a woman's sleeveless chiton, in dramatic contrast to his full beard and broad shoulders. His strong hands are poised to spin wool; in his right hand he held a spindle and in the left a distaff, now lost. The hole beneath his belt tie most likely was used to attach the appliqué to the fulcrum or perhaps to support the spindle.

D. Pandermalis, *Discovering Dion* (Athens 2000), pp. 184–85.
 D.P.

Found next to the protome of the horse that faces left (cat. no. 23), this example represents a young Satyr with an ivy wreath. He wears a deerskin tied on his right shoulder. He has pointed ears, and two small holes at his hairline indicate where horns were once attached. At the bottom of his chin is preserved one of the two typical goatee tufts. Satyrs were popular themes for the decoration of symposia couches. This decorative appliqué invites comparison with a similar protome from the Mahdia shipwreck (Tunisia).

D. Pandermalis, *Discovering Dion* (Athens, 2000), pp. 184–85. For the protome from Mahdia, see S. Faust, *Fulcra: figürlicher und ornamentaler Schmuck an antiken Betten* (Mainz, 1989), pp. 107–8.
 D.P.

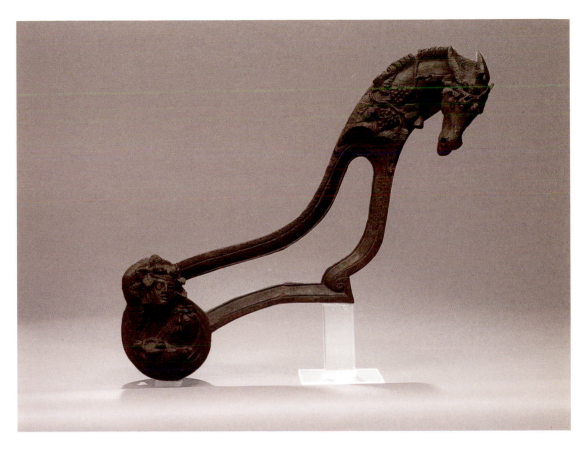

27. FITTING OF A SYMPOSIUM COUCH (FULCRUM)
Second half of 2nd century B.C.
Bronze
Height 0.325 m, length 0.455 m
From a public building in insula 3 of sector A at Pella
Archaeological Museum of Pella (Δ 311A)

The fulcrum terminates above in the head of an ass adorned with vine leaves and bunches of grapes and below with a protome of Dionysos. The god wears a himation, leaving his right shoulder bare, and an ivy wreath atop his long hair, which falls onto his shoulders. He holds a wine cup (*kantharos*) in his left hand and raises his right arm behind his head.

The decoration of symposium couches with separate curved bronze fittings as headrests was common from the second half of the fifth century B.C. until the end of the first century A.D. The ornaments are inspired by the world of mythology, particularly the Dionysiac cycle: the upper ends frequently are decorated with protomes of animals, mainly asses and horses, and the lower with relief protomes, usually of Dionysos, Satyrs, maenads, Eros figures, Artemis, and so on.

The discovery of three similar fittings at Pella indicates that symposium couches decorated in this manner were common in the city. In conjunction with other metal objects and by-products of metalworking found at the site, these point to the existence of metalsmith workshops in the Macedonian capital, with significant output in terms of both quantity and quality.

M.L.-A.

WOMEN IN MACEDONIA

Maria Lilibaki-Akamati

The texts of Antiquity are not forthcoming on the position of women in the ancient world, at least in comparison to the copious information they provide on the world of men. Our understanding of a woman's life in Greece in the early first millennium B.C. comes largely from Homeric poetry. The wife of the king, for example, was mistress of his household, responsible for managing his residence and vigilant about the security of his possessions. She attended to the hospitality of guests and was present at drinking parties for the men, but more often she spent her time in the women's quarters (*gynaikonites*), spinning and weaving in the company of her handmaidens. This was the milieu of her authority. Marriage was a social transaction aimed at creating relationships of dependency and obligation between families, with the bride in the role of valuable commodity and the groom offering lavish gifts to the bride's father. However, our knowledge of the ordinary womenfolk of that period is limited, as epic poetry mentions them only circumstantially. We assume that they were little different from the Homeric heroines. These heroines were chiefly the consorts of the kings and heroes, whom the poet differentiates—despite the similarity of their social position— by the characteristics he ascribes to them. On the one hand there is the venerable queen, Hecuba; the perfect chatelaine, Penelope; and the loyal and loving spouse, Andromache. On the other hand there is Helen, object of erotic passion, whose actions plunge the peaceful life of the nation and the family into turmoil.

As far as we can tell from literary sources—the majority of which refer to the women of Athens—the position of women in the years that followed remained much the same. In Archaic and Classical times, because legitimate offspring were essential to ensure the inheritance of property, women were devoted to managing domestic affairs and bringing up children, and were excluded from political life. No respectable woman took part in symposia, even when they were held in her home. And, in contrast to Homer's heroines, women were not allowed to attend theatrical performances or to speak in public. The woman's realm continued to be the gynaikonites, whence she administered the house and the servants. There were, however, rural women who shared arduous agricultural tasks with the men.

Judicial orations are important sources of information regarding marriage contracts, which were governed by complicated legislation concerning the dowry (the bride's property that was offered to the groom), its management, and its transfer in the event of death or divorce. As far as marriage was concerned, freedom of choice for the female was nonexistent; from childhood a girl was obliged to obey the decisions of her father or of her legal guardian. It was not uncommon for the husband's concubines to live with the wife in her new home, though this might not have been true in all Greek cities and there may have been differences in the colonies or in rural areas. Nevertheless, in this period women everywhere were treated primarily as the instrument of reproduction, with restricted rights or none at all. Religious rituals and festivals were a respectable woman's only means of participation in the social life of the city. The widespread participation of women in the Thesmophoria, the festival in honor of Demeter, goddess of agriculture, and in Dionysiac cults inspired literary masterpieces. The ceremonies of the family hearth as well as funerary practices were the exclusive prerogative of women.

The involvement of women, such as the poetess Sappho on Lesbos, in intellectual pursuits was exceptional, though mainly limited to the colonies and the Aegean Islands, since girls did not go to school but were brought up at home by female slaves, occupied in domestic tasks and games.

The women of the common folk seem to have enjoyed greater independence. They frequented the marketplace (*agora*) and engaged freely in transactions. Working women were employed as midwives, wet nurses, and nursemaids, and as matchmakers facilitated marriages by bringing interested families into contact. The only truly independent women in Classical Athens were the courtesans (*hetairai*), about which there is abundant information, since they were the principal characters in many plays of New Comedy. They circulated freely, took part in symposia, received whomsoever they pleased in their homes, and managed their own property.

The life of a woman in the regions under Dorian influence, such as Sparta, is different. There, women broke away from the guardianship of the father and the husband, lived in the countryside, participated in athletics, competed with men in acts of bodily endurance, and layed an active role in social life. Marriages, based on physical attraction, were by capture of the bride, who was entitled to manage her property and held a recognized position in public life, in many ways reminiscent of the women of Hellenistic times. In another Dorian city, Gortys in Crete, it is confirmed epigraphically that women owned and managed personal property.

In the second half of the fourth century B.C. women enjoyed somewhat greater freedom, harbinger of their increasing independence in the Hellenistic period, during which—with the decline of the old values of the city-states, principally after the Peloponnesian War—the status of women improved. As conservative customs became outmoded and living standards rose due to the expansion of maritime communications and trade (mainly following the campaign of Alexander the Great), and as a result of contact with Dorian cities in which the position of women was different, women acquired new social acceptance. Directing their household for long intervals of time while their husbands were at war, they emerged from the confines of the home to visit the marketplace, to buy and sell produce, and to mix with other women.

In Hellenistic times the life of women was vastly different from what it had been in the preceding periods, as we learn from the numerous texts as well as from the visual arts. This period was one of remarkable mobility, for men and women alike. Hellenistic women, whose role models were the queens, were cosmopolitan, thanks to their exposure to new cultures following the expedition of Alexander the Great. Some new cities maintained old conservative values, but most adapted to the changes in social and economic needs. In Alexandria, in Egypt, for example, women, like men, were occupied with legal and financial issues. The dowry was no longer an imperative contribution of the bride to the marriage and there was respect for unmarried mothers and for women involved in liberal arts and other professions, working publicly and dealing with men. Works of art shed light on the changes that had taken place, but since the majority of these do not mention the women's ethnic origins it is difficult to pinpoint the geographical distribution of the information they provide. Nonetheless, the coroplastic workshops in eastern Mediterranean cities, with creations that represent ordinary females—their fashions, accomplishments, education, and activities—offer particularly illuminating images of Hellenistic women. Similar information can also be gleaned from Hellenistic poetry.

Queens, such as those of the house of the Ptolemies in Egypt, made their mark on the Hellenistic period through their appearance and activities. Berenice II (258–220 B.C.), a woman who wielded prodigious political power, is known to engaged in poetry and religion, to have attended horse races in the pan-Hellenic games, to have controlled her own merchant ships transporting cargoes of grain, and to have run her own perfumery producing attar of roses. To commemorate the victory of Berenice's chariots at the Nemean Games, Kallimachos wrote the first victory ode to a woman. She was deified posthumously and the temple of Berenice Sotera was erected in her honor, with maidens of aristocratic origin as her priestesses.

Cleopatra, Egypt's most famous queen and scion of the Ptolemaic dynasty, was renowned for her intelligence, education and charm, and had a decisive influence on the flow of historical events in the first century B.C. as well as on the lives and political careers of powerful men of the Roman State.

Apart from queens and priestesses, however, there were other wealthy and sophisticated women who enjoyed public honors and who, thanks to access to education, distinguished themselves in poetry, painting, medicine, and other arenas.

In Macedonia in the Classical period, the lives of the women of the royal house of the Temenides, who came from eastern and western Macedonia, Illyria, Thrace, and Epirus, are well documented. The marriages of the princesses were celebrated with great pomp and circumstance, including state banquets and games, such as those organized on the occasion of the wedding of Cleopatra, daughter of Philip II, to the king of the Molossoi. These marriages were arranged by the king for military and political reasons. Polygamy was customary for the Macedonian kings, serving military and political purposes while at the same time ensuring large numbers of male offspring whom the king promoted to superior state offices, thereby creating a social class directly dependent on him and favorably disposed toward him. The everyday life of the women of the royal house was simple and very like that of Athenian women. They helped in the preparation of the daily meals, wove cloth, and participated in formal banquets. However, they also played an important role in state affairs, as attested by the activity of women such as Eurydike and Olympias—mother and wife of Philip II, respectively—statues of whom were set up in the Philippeion at Olympia. These women enjoyed special treatment, were permitted to be the regents of kings who were still minors, and were actively involved in matters of state. The target of scandal-mongering in democratic cities of Greece, Eurydike is presented as full of machinations and power plays. Olympias, on the other hand, the mother of Alexander, had general supervision of his kingdom while he was away in Asia, had jurisdiction over religious matters, and represented the Macedonian state, sometimes alone, by taking cargoes of grain from Cyrene, or by collaborating with Alexander and Antipater. In gratitude for her support during his campaign, Alexander decided that after her death Olympias should be worshiped as a goddess. After Alexander's death, Olympias—as queen mother—issued decrees "on behalf of the kings and herself" as well as "in the name of the house of Philip and of his son Alexander," with recipients being the military divisions that had sworn allegiance "to Olympias and the kings." Even so, and despite her prestige, she failed to unite the royal house. Greek and Latin authors have embellished Olympias' biography with all manner of scandals, most of which are unlikely to be true, since they express the defamation and the hostility that had broken out between the supporters of Olympias and her opponents, those who supported Cassander. Indeed, it was Cassander who ordered the execution at Olympias, soon after his accession to the throne.

The women of the royal house of Macedon inevitably had direct influence on the women in the Macedonian cities, who adopted all the innovations brought by the Hellenistic period and were living like all other women in the Hellenistic world. From the inscriptions on funerary and dedicatory stelae we know their names, while the ethnic names bear witness to their movements. Their participation in religious rites is attested by the rich ex-votos in the sanctuaries, and their involvement with mortuary ritual is revealed by the host of grave goods accompanying the burials. Most of these objects, except those directly associated with the dead, are related to females, for example the host of female figurines that have been found in sepulchral monuments.

The fact that Euripides wrote his drama Bacchae at Pella surely is not unrelated to the participation of women in the orgiastic worship of Dionysos. The rapid spread in

Macedonia of mystical religious movements, such as Orphism and Eastern cults, is due in large part to their wide acceptance by the female population, since their teachings appealed to the psychological world of women. Magic seems to have fascinated Macedonian women as well, as indicated by the wishes and curses they inscribed on lead strips (*katadesmoi*) and placed in the tombs of the prematurely deceased, in the belief that this would bring about their desires. In his *Life of Alexander*, Plutarch refers to the superstitiousness of Olympias, who took part in licentious rites with large tame snakes coiled around the thyrsoi and wreaths.

The frequent representation on funerary stelae of deceased women with their maidservants bears witness to the wide use of slaves by women, at least women of the "bourgeoisie." The presence of papyruses, kitharas, and other objects in the women's hands confirms female involvement with letters as well as with fine arts, such as music. The possibility of women taking part in commercial transactions and of acting as guarantors is attested by a contract of purchase from the Chalkidike.

Excavations yield invaluable information on all the above issues, especially on the appearance of women in Macedonia in Classical and Hellenistic times. It is from these that we know about women's attire, hairstyles, jewelry, and cosmetic accessories. These finds are works of sculpture but primarily of coroplastic art—vases, toilet objects, and so on. Most plentiful are terracotta figurines, which, because they were relatively inexpensive, were frequently dedicated in sanctuaries and graves. These figurines— their clothing, coiffures, and the various objects they hold—represent ordinary women participating in festivals or funerary rites, seeking the benefaction of celestial and chthonic deities for good fortune in life and after death. Greater freedom is seen in the dress and hairstyles of the female figurines of Late Classical and Hellenistic times than of earlier periods. This freedom is also reflected in works of art by the movement of the figures and by the objects they hold or that accompany them: fans, musical instruments, flowers, birds, and so on. All reflect contemporary fashion, which has moved away from the traditional, conservative models and aspires to enhance female elegance and grace.

The main garment worn by women in Macedonia—and the rest of Greece—was the long chiton, which usually was made of wool or linen and was worn next to the body. Its abundant vertical pleats completely covered the feet or left visible only the front of the footwear, mainly sandals with high soles and colored thongs/straps. A sleeveless chiton was fastened on the shoulders with fibulae, dress pins, or buttons of bronze, silver, or gold. When the chiton was very long it was drawn up above the girdle and cinched at the waist, forming a sort of fold known as the *apoptygma*. As seen from the terracotta figurines of Hellenistic times, however, the chiton was usually narrow and girdled high below the bosom by a narrow belt, imparting height and suppleness to the body. The neck opening could be larger and looser, leaving one shoulder bare, though more commonly it was slightly semicircular or triangular and plunging. Sometimes the chiton was white and sometimes colored, as indicated by the yellow and red pigment preserved on some figurines, colors added on the white slip coating their surface.

The second most common garment, the himation, was made of wool or linen and was sometimes extremely fine and diaphanous. It was placed over the chiton and clung to the body, emphasizing its form. The himation was worn in various ways, either swathed around the body, enveloping it entirely or leaving the lower part of the torso or one breast exposed, or wrapped around both wrists. In some cases it was flung over both shoulders, like a shawl, and in others it was draped over one shoulder and swathed tightly round the body, leaving the lower part of the chiton visible. It often covered the head and almost always the arms. Characteristic of all himations is the rich and varied drapery, which indicates that for women the himation was not merely

a utilitarian garment, but one that revealed the personality of the wearer, as well as different trends in fashion. The coroplast intended to enhance the beauty of the attire, using the gesture of the hand on the waist, characteristic of almost all figurines, which results in various folds underneath the himation. On most figurines the colors preserved on the himation are purple and blue. The hems and borders of the garments were colored too, as, for example, the blue bands on a terracotta female protome (cat. no. 17).

The Classical peplos is encountered to a limited extent on Macedonian terracottas, primarily on figures of religious or mythological content, such as the figurine of Nike from Pella (cat. no. 12), suggesting that this conservative garment, which was common in Archaic and Classical times, was not in vogue.

It should be noted that the cerements of the women in the tombs of royal and wealthy families were embellished with ornaments of gold—bands, rosettes, and so forth.

The hairstyles of the women of Macedonia were no different from those of women in the rest of Greece. Hair was long but only rarely did it fall freely on the shoulders. The most common coiffure among the terracotta figurines is that of the fourth century B.C., which appears with many variations on copies of Aphrodite Knidia. In the Knidian style, the hair is parted in the middle and follows the outline of the head in tresses drawn to the side and tied behind in a bun or chignon of diverse form, high or low on the head. Sometimes long locks fall on the shoulders.

Another hairstyle is the so-called melon type. The hair, parted usually into four sections on each side of the head, is tied behind in a bun with ringlets. Less common are the *tettix* and *lampadion* hairstyles, in which the hair is tied behind in a bun but the arrangement on the front differs. In the tettix two or three rows of highly schematic spiral curls are formed above the forehead, whereas in the lampadion a mass of hair is marked off on top of the head by a ribbon and locks of hair sometimes fall onto the shoulders. The red and yellow pigment preserved on the coiffure of many female figurines indicates a preference for strongly colored hairstyles.

The typical accessories worn on the heads of these figures were one or two colored ribbons—on some figurines they are purple and pink—that are wound around the head, the circlet (*stephane*), a kind of diadem with ring-shaped base, and a radiate incised or relief ornament above. The orange and yellow color of the stephane on some figurines perhaps indicates that in life it was made of metal, possibly gilded bronze. Very often the hair is covered by a cloth headdress known as the *kalyptra* or the *tegidion*, as when its edges are stretched outward (see, for example, cat. nos. 7, 14). Wreaths usually had a thick cylindrical member (to which the plant branch was affixed) wound with ribbon. The presence of wreaths on the heads of many of the female figurines points to their widespread use not only in religious rites but also at social ceremonies and events, such as weddings and symposia. The frequent use of leaves and berries of ivy, the sacred plant of Dionysos, denotes the wide diffusion of the god's cult in Macedonia and the wide participation of women in the cultic rites. The frequent presence of figurines of Aphrodite in houses, sanctuaries, and graves is likewise interpreted in the same context of intense mysticism, which is reinforced by the religious currents of the time. Worship of Aphrodite as a sepulchral goddess who protected the dead was widespread in Macedonia. Typically the goddess is represented half-naked, with the himation covering her lower body and colorful straps on her torso; less often she is portrayed nude. The figurines of Aphrodite reflect the contemporary conception of the beauty of the female body, which differs significantly from that of Classical times. Female bodies are more voluptuous, with emphasis on those parts which enhance feminine allure—the buttocks, the abdomen, the breasts—further bolstered by the relaxed pose, the torsion of the body, and the movement of the figures.

The women of Macedonia appear to have been inordinately fond of jewelry ever since the founding of the Macedonian kingdom. Female graves dating to the seventh century B.C. have yielded a large number of pieces of jewelry (necklaces, bracelets, finger rings, fibulae, dress pins, and hair rings, among other pieces) similar to those that have been found in other parts of the Greek mainland, proving close contact between regions.

The most common pieces of jewelry are earrings. Most were of gold, which is denoted on the figurines by covering the earrings with gold leaf or painting them yellow, but there are also earrings of silver and of bronze. The finger rings were gold and many were set with seals or gems. However, major advances made in the jeweler's art are evidenced mainly by the ornate necklaces, many of them wonderful creations in which different techniques are combined. In some cases actual necklaces display a remarkable resemblance to those rendered on the figurines, usually in relief and painted yellow or covered with gold leaf. Of comparable quality are the pendants, which often hung from necklaces. Bracelets of gold and bronze adorned the women's arms, but most were of silver, shown on figurines as white. Several of the utilitarian items, such as fibulae and dress pins, also of bronze, silver, or gold, are examples of superb crafts-manship. We should also mention the many imitation pieces of jewelry in gilded clay, which were used by a host of women of the popular classes who could satisfy their needs with less expensive trinkets. Jewelry was kept in silver boxes/caskets (*pyxides*) and black-glaze pottery with West Slope–style decoration and with relief figures on the lids, as well as red-figure depictions of women's pursuits in the gynaikonites, such as bedecking the bride.

The extant traces of color on the faces of the female figurines bear witness to the widespread use of cosmetics, which were usually kept in tasteful miniature vases of clay, bronze, and lead. The facial features were highlighted by applying black pigment on the eyebrows and eyelashes, and pink and red on the cheeks and the lips. Also widespread was the use of perfumes, as indicated by the large number of exquisite vials or unguentaria of glass, silver and lead, and alabastra of stone, clay, and faience. The extraordinary use of ostrich eggs for containers, such as that found in an Archaic grave at Aigai, also merits mention.

Other toilet accessories, virtually the same as those of today, were not unknown. Women used bronze razors, bronze and silver tweezers, bone or ivory combs, and bronze mirrors—plain or folding—with decorated handles, sometimes of other materials, such as ivory, that are exquisite examples of master craftsmanship.

In the light of the aforesaid, it is logical to argue that a large number of the objects and installations that served the care and hygiene of the body—such as the clay and marble bathtubs in private residences and in public buildings/sanctuaries and bath houses—must have been used by the women of Macedonia, who apparently spent a great deal of time on their appearance and their intellectual cultivation. Thus they adapted to the spirit of the new age, as it took shape after the magnificent campaign of Alexander the Great.

Cantarella, E. H. "Θέση της γυναίκας στην Αθήνα της κλασικής εποχής." *Αρχαιολογία* 21 (1986), pp. 14ff.

Ελληνικός Πολιτισμός. Μακεδονία, Το βασίλειο του Μ. Αλεξάνδρου. Athens, 1993.

Fantham, E., et al. *Women in the Classical World.* New York, 1994.

Fracelière, R. *La Vie quotidienne en Grèce au siècle de Pericles.* Paris, 1959.

———. *L'amour en Grèce.* Paris, 1971.

Greek Ministry of Culture, National Hellenic Committee—International Cultural Corporation of Australia. *Ancient Macedonia.* Exhib. cat. Athens, 1988.

Hammond, N. G. L. *The Macedonian State.* Oxford, 1989.

Houston, M. G. *Ancient Greek, Roman and Byzantine Costume and Decoration.* London, 1965.

Λιλιμπάκη-Ακαμάτη, Μ. *Λαξευτοί τάφοι Πέλλας.* Athens, 1994.

———. *Το ιερό της Μητέρας των Θεών και της Αφροδίτης στην Πέλλα.* Thessaloniki, 2000.

Mossé, C. *La Femme dans la Grèce antique.* Paris, 1983.

Pekridou-Gorecki, A. *Mode im antiken Griechenland: Textile Fertigung und Kleidung.* Munich, 1989.

Reinsberg, B. C. *Ehe, Hetarentum und Knabenliebe im antiken Griechenland.* Munich, 1989.

Republic of Greece, 17th Ephorate of Prehistoric and Classical Antiquities. *Pella and Its Environs.* Thessaloniki, 2003.

Σιγανίδου, Μ., and Μ. Λιλιμπάκη-Ακαμάτη. *Πέλλα.* Athens, 1996.

Yalouris, N., et al. *The Search for Alexander: An Exhibition.* Exhib. cat. Boston, 1980.

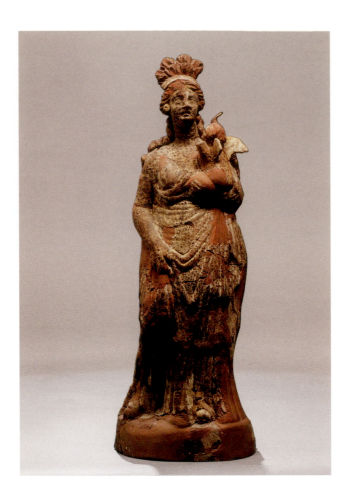

1. FEMALE FIGURINE
Mid-2nd century B.C.
Terracotta
Height 0.403 m
From a rock-cut chamber tomb in
the east cemetery of Pella
Archaeological Museum of Pella (1977.201)

The figure, wearing a chiton of probably heavy
woolen cloth covering the whole body, holds a
fan in one hand and an infant Eros in the other.
Her hairstyle is the so-called *tettix*, with rows of
spiral curls above the forehead and a bun at the
back. She wears disc-shaped earrings and on her
head is a circlet with dentate margin. Remnants of
pigmentation are preserved: purple on the himation,
red on the hair, and orange on the circlet.

M.L.-A.

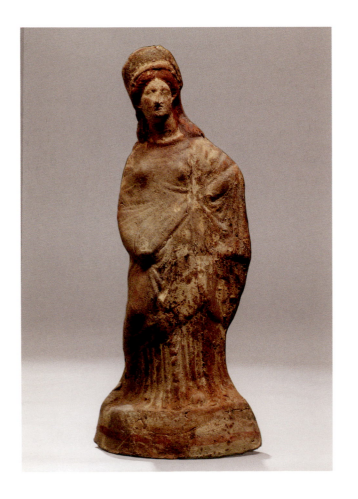

2. FEMALE FIGURINE
Mid-2nd century B.C.
Terracotta
Height 0.325 m
From a rock-cut chamber tomb in
the east cemetery of Pella
Archaeological Museum of Pella (1977.202)

This figure, like to cat. no. 1, wears a chiton and
a himation covering her whole body. Her hair is
dressed in the well-known Knidian style, with bun
at the back and long tresses on the shoulders. She
wears disc-shaped earrings and on her head is a circlet
with dentate outline. Pink pigment is preserved on
her lips.

M.L.-A.

3. FEMALE FIGURINE

Mid-2nd century B.C.
Terracotta
Height 0.34 m
From a rock-cut chamber tomb in
the east cemetery of Pella
Archaeological Museum of Pella (1978.183)

The hairstyle of this figure is Knidian, with a bun
at the back and long tresses falling on the shoulders.
She wears a chiton and a himation of rather heavy
cloth that covers the body. On her head is a circlet
decorated with relief discs. Pink pigment is preserved
on her neck and face; red pigment on her hair
and lips.

M.L.-A.

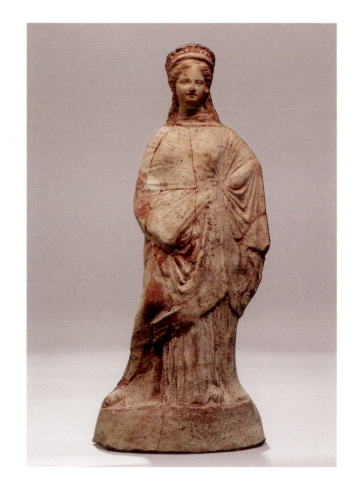

4. FEMALE FIGURINE

Late 3rd century B.C.
Terracotta
Height 0.28 m
From a rock-cut chamber tomb in
the east cemetery of Pella
Archaeological Museum of Pella (1976.274)

This small figurine is dressed in a chiton and a
himation, probably of linen and with multiple folds,
swathed tightly around the body, leaving much of
the lower part of the chiton visible. She is adorned
with earrings and has a melon hairstyle with a bun
at the back, formed from free curls. On her head is
an ivy wreath. Pink pigment is preserved on both the
face and the chiton.

M.L.-A.

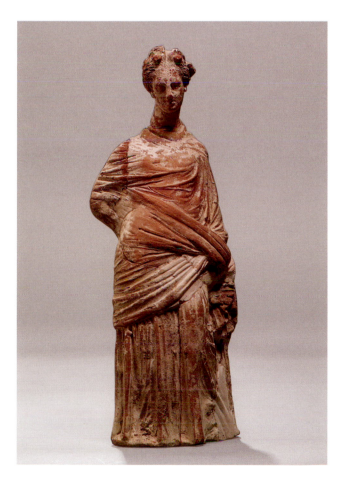

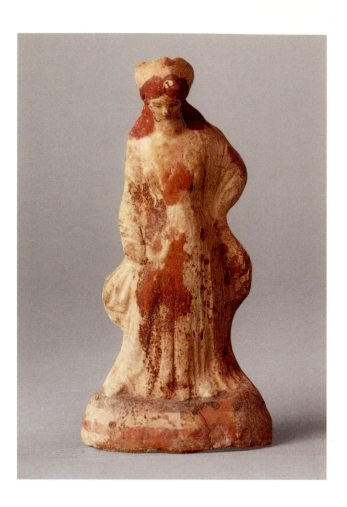

5. FEMALE FIGURINE
Mid-2nd century B.C.
Terracotta
Height 0.25 m
From a rock-cut chamber tomb in
the east cemetery of Pella
Archaeological Museum of Pella (1978.186)

The preserved pigments on this terracotta figure
(red on the hair and lips; pink on the neck and
wrists; black on the eyebrows, eyelashes, nostrils,
outline of the hair, and locks on either side of the
neck) convey the popularity and liberal use of cos-
metics by Macedonian women. The figure wears a
chiton and a himation that covers her left shoulder
and is wrapped around her right wrist. Her hair
is dressed in Knidian style with a bun at the
back and long tresses (indicated in color) on
the shoulders.

M.L.-A.

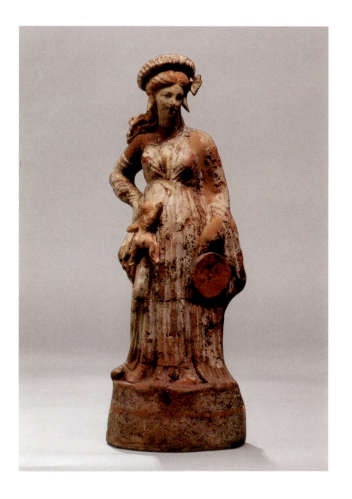

6. FEMALE FIGURINE
Mid-2nd century B.C.
Terracotta
Height 0.325 m
From a rock-cut chamber tomb at Pella
Archaeological Museum of Pella (1978.187)

The figure wears a chiton and a himation covering
her left shoulder and wrapped around her right
wrist. In her left hand she holds a bossed bowl
(*omphalos phiale*); an infant Eros figure is attached
to her right thigh. Her long hair falls freely onto her
right shoulder. She wears an ivy wreath and earrings
with lanceolate finials. Several pigments are preserved:
red on the hair, phiale, and sandals; yellow on the
earrings and on the forehead line of the hair; black,
which was used to emphasize the rest of her hair
and her eyes, nostrils, and mouth; and white, which
was used to denote a silver bracelet on her right arm.
Like cat. no. 5, this figurine conveys the particular
care Macedonian women took with their appearance,
both in the elegant attire and in the highlighting of
the facial features with appropriate colors.

M.L.-A.

7. FEMALE FIGURINE
Early second half of the 2nd century B.C.
Terracotta
Height 0.35 m
From a rock-cut chamber tomb in
the east cemetery of Pella
Archaeological Museum of Pella (1977.229)

The chiton on this figure is girdled high on the
bosom with a deep triangular opening on the neck
and a himation leaving the right shoulder bare. On
her head is an ivy wreath, over which is a *tegidion*,
and she wears earrings with lanceolate finials. Red
pigment is preserved on her hair and on the right
sandal. In her left hand she holds a dove.

M.L.-A.

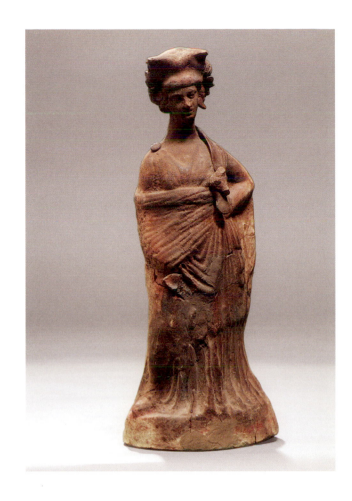

8. FEMALE FIGURINE
Late 2nd century B.C.
Terracotta
Height 0.435 m
From the sanctuary of the Mother of the Gods
and of Aphrodite at Pella
Archaeological Museum of Pella (1983.47)

Wearing a sleeved chiton with deep triangular opening
on the neck and a himation, leaving her breasts
bare and forming a thick overfold below them, this
terracotta female holds an infant Eros in her left
hand. Her hair is coiffed in Knidian style, with a
chignon behind and long tresses on her shoulders,
and she wears earrings with lanceolate finials. On
her head are an ivy wreath and a circlet with dentate
outline, and on her right arm is a bracelet, indicated
by incision.

M.L.-A.

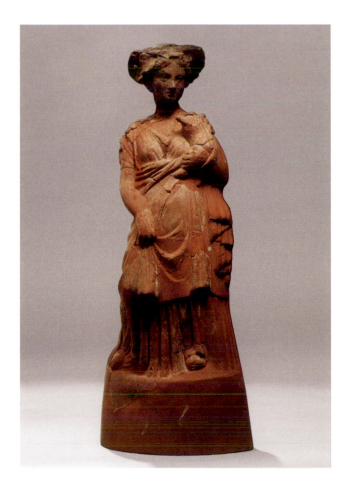

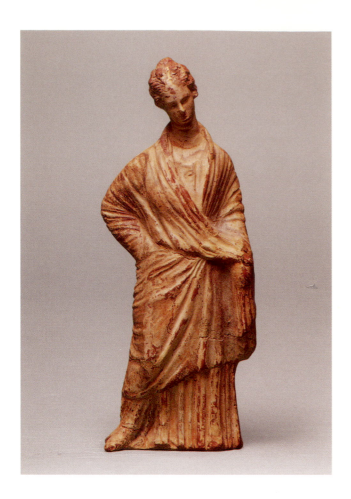

9. FEMALE FIGURINE
Last quarter of the 3rd century B.C.
Terracotta
Height 0.275 m
From a rock-cut chamber tomb in the
east cemetery of Pella
Archaeological Museum of Pella (1976.271)

A chiton and a heavy himation covering the body
but leaving a triangular opening on the neck adorns
this female figure. She bears a melon hairstyle with
a round bun at the back. Her head originally was
wreathed, as indicated by holes for inserting the
leaves and fruits. Traces of red pigment are pre-
served on her hair and lips, blue on her himation,
and yellow on her hair. There are also remnants of
gold leaf on the hair and the upper part of the torso,
suggesting a necklace.

M.L.-A.

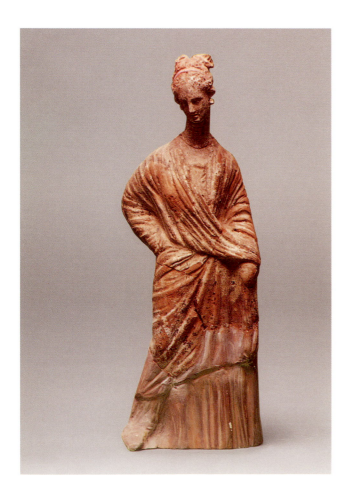

10. FEMALE FIGURINE
Late 3rd century B.C.
Terracotta
Height 0.30 m
From a rock-cut chamber tomb in the
east cemetery of Pella
Archaeological Museum of Pella (1976.267)

The figure is dressed in a chiton, with a deep semi-
circular opening on the neck, and a himation that
covers the body but leaves a triangular opening on
the torso. The hair, dressed in the melon style with
curls and a bun at the back, is decorated with two
ribbons. In the ears are round earrings covered with
gold leaf. Remnants of pink pigment are preserved
on the lips, the hair, and the ribbons.

M.L.-A.

11. SEATED FEMALE FIGURINE

Second half of the 4th century B.C.
Terracotta
Height 0.135 m
From a cist grave in the east cemetery of Pella
Archaeological Museum of Pella (1980.457)

This figurine, clothed in a chiton and a himation of flimsy cloth with ample folds that also covers the head, is a typical example of the superb standard of coroplastic art at Pella. The movement of the body and the treatment of the drapery of the garments indicate the influence of contemporary sculpture. This subject is particularly popular because it offers the opportunity to create three-dimensional compositions with relaxed poses and body torsions. On the other hand, the lavish drapery suggests that this feature was typical of the garments that well-dressed Macedonian women wore in daily life.

M.L.-A.

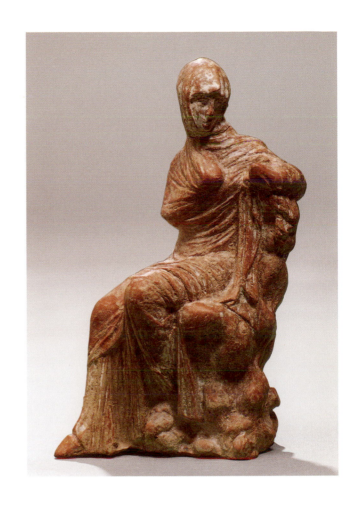

12. NIKE FIGURINE

Early second half of the 2nd century B.C.
Terracotta
Height 0.375 m
From a rock-cut chamber tomb in the east cemetery of Pella
Archaeological Museum of Pella (1977.212)

This figure wears a peplos with long *apoptygma* and sandals with platform soles. She probably had a trumpet (*salpinx*) or some other object hanging from a broad strap over her left shoulder. Her hairstyle is Knidian, with a bun at the back and luxuriant curls, and on her head is an ivy wreath. She wears earrings with lanceolate finials and a relief necklace is discernible on her bosom. There are remnants of yellow pigment on her wings, wreath, and earrings. The peplos, a common garment in Archaic and Classical times, was not worn by Macedonian women in daily life and is encountered only on figures of religious or mythological content.

M.L.-A.

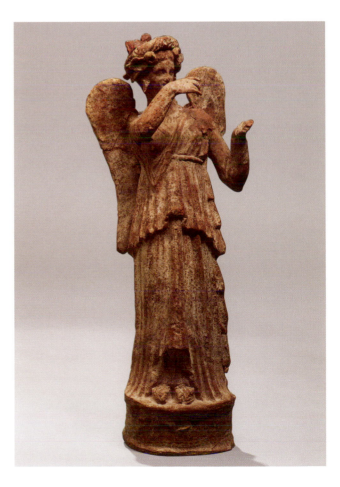

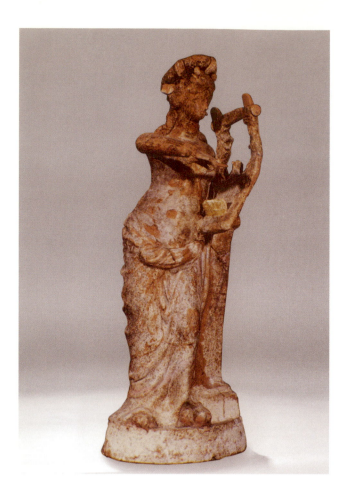

13. FIGURINE OF HALF-NAKED APHRODITE WITH KITHARA

Early second half of the 2nd century B.C.
Terracotta
Height 0.435 m
From a rock-cut chamber tomb in the east cemetery of Pella
Archaeological Museum of Pella (1977.230)

In this example the figure wears a himation, which covers the lower body and forms a thick overfold in the abdominal area, and sandals with platform sole. She leans against a cippus, on which stood a colonnette (only a small part of which has survived). In one hand she holds a kithara and in the other a plectrum. Her hair is dressed in Knidian style, with tresses resting on her shoulders. She wears an ivy wreath on her head and a ring with a disc-shaped bezel on the fourth finger of her left hand. Purple pigment is preserved on the himation, kithara, and cippus; dark gray on the torso; and possibly blue—now faded—on the kithara.

The half-naked female leans on a support, a common subject in sculpture in the fifth century B.C. as well as in vase painting, which inspired coroplasts of the Hellenistic period, who created new types with a great variety of supplementary elements. The frequent appearance of half-naked female figures in graves, sanctuaries, and even houses in Macedonia indicates that the hypostases of different deities had been conflated in the popular consciousness in the Hellenistic period. The chthonic usage of Aphrodite is confirmed at Pella by the large number of figurines of her found in graves. The presence of the kithara alludes to the goddess's qualities as patron of music and of lyre-playing and singing contests, as well as to the cult of the dead, since there was a widespread belief that they were entertained with music in the underworld. Of course, the possibility that these Aphrodite figurines were found in the graves of those who, when living, were involved with music cannot be ruled out. It should be noted further that the hairstyle of the goddess is the same as that of ordinary women, which points to a different conception of her from that in the Classical period.

M.L.-A.

14. FIGURINE OF HALF-NAKED APHRODITE
Early second half of the 2nd century B.C.
Terracotta
Height 0.455 m
From a rock-cut chamber tomb in the east
cemetery of Pella
Archaeological Museum of Pella (1977.205)

The figure leans against a cippus crowned by a
colonnette. She wears a himation covering the lower
part of the body and forming a thick overfold in the
abdominal area, as well as sandals with platform
soles. In her left hand—the index finger of which
has a ring with a disc-shaped bezel—she holds a
kithara, and, in her right hand, a plectrum. Her hair
is drawn back behind her head, and long locks rest
on her shoulders. On her head she wears a *tegidion*
and she has round earrings. Red pigment is preserved
on the hair and the kithara, purple on the himation.
In this example, as in cat. no. 13, the goddess is
represented with the headdress and the jewelry
of an ordinary woman.

M.L.-A.

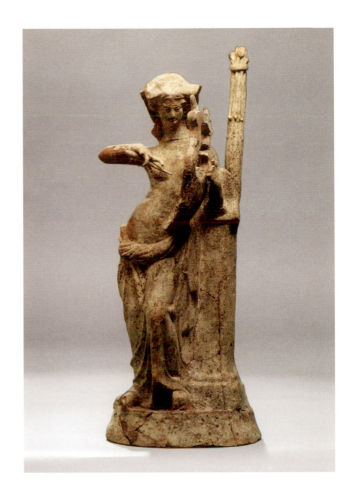

15. FIGURINE OF HALF-NAKED APHRODITE
Late 2nd century B.C.
Terracotta
Height 0.49 m
From the sanctuary of the Mother of the Gods
and of Aphrodite at Pella
Archaeological Museum of Pella (1983.8)

Aphrodite leans against a cippus crowned by a
colonnette. As in cat. nos. 13 and 14, she wears a
himation covering the lower part of the body and
sandals with platform soles. The hair is in Knidian
style, with a chignon at the back and long locks
falling to the shoulders. On her head are a thick
cylindrical wreath and a finer one of ivy; she also
wears disc-shaped earrings with lanceolate finials.
The rendering of the body on this figurine, as on
cat. no. 16, is characteristic of the preference in
Late Hellenistic times for voluptuous females, with
emphasis on the buttocks, belly, and breasts.

M.L.-A.

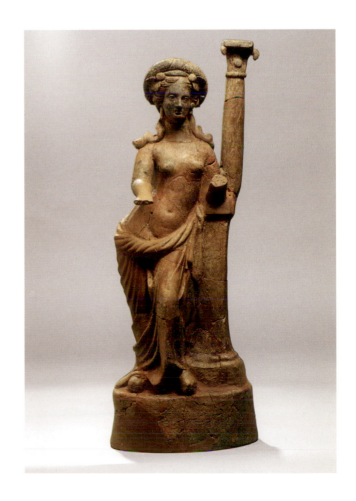

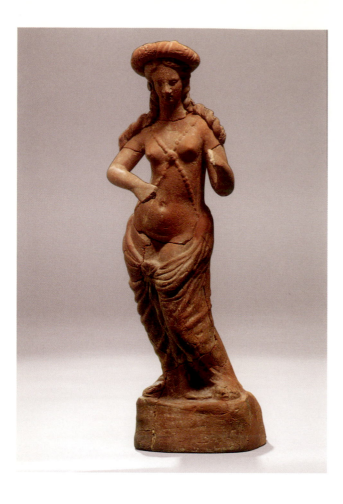

16. FIGURINE OF HALF-NAKED APHRODITE
ANADYOMENE
Late 2nd century B.C.
Terracotta
Height 0.345 m
From the sanctuary of the Mother of the Gods
and of Aphrodite at Pella
Archaeological Museum of Pella (1983.79)

This Aphrodite Anadyomene wears a himation
covering the lower body, leaving the upper part of
the thighs exposed. On her naked torso are crossed
straps rendered in relief. She wears sandals with
platform soles, adorned with relief discs where the
thongs cross. Her hair is dressed in Knidian style,
with a cylindrical chignon at back and long locks
resting on her shoulders, and she wears earrings
with lanceolate finials. On her head is a cylindrical
wreath.

M.L.-A.

17. FEMALE PROTOME
Second half of the 4th century B.C.
Terracotta
Height 0.20 m
From a cist grave in the east cemetery of Pella
Archaeological Museum of Pella (1976.46)

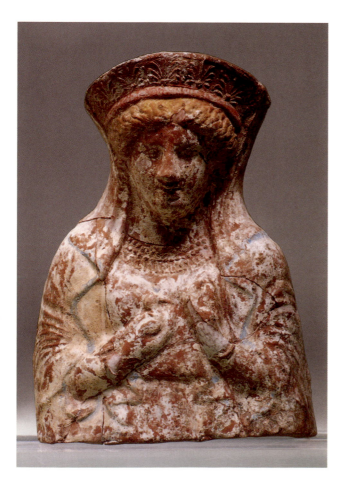

The figure wears a sleeved chiton with *apoptygma*
(an additional piece of fabric that hangs over the
shoulders to the waist of the dress). On her head is
a circlet decorated with relief palmettes, from which
hangs the *epiblema* (veil) covering her shoulders
and arms. She holds a dove and a flower. The hair is
dressed in Knidian style. Yellow pigment is preserved
on the hair, red on the cylindrical member of the
circlet, and blue on the ribbons at the edges of
the *epiblema*. Visible on the neck are relief beads,
strikingly similar to the gold necklace in cat. no. 19.

Female protomes enjoyed wide dissemination
in sanctuaries and graves from the sixth century B.C.
into Late Hellenistic times. Their interpretation is
not always easy, since they were not an offering to a
particular deity. In all probability they are represen-
tations of chthonic deities. The Pella protomes with
flower and dove can be identified as Persephone
or Aphrodite. The presence of jewelry on these
figures and the rich coloration indicate that the
Macedonians in Hellenistic times wanted their
deities to have an outward appearance similar to
ordinary women. In the case of the protomes, it is
primarily the *epiblema* that suggests the divine
nature of the figure.

M.L.-A.

18. FEMALE PROTOME

Second half of the 4th century B.C.
Terracotta
Height 0.215 m
From a cist grave in the east cemetery of Pella
Archaeological Museum of Pella (1976.383)

The female depicted here wears a sleeved chiton with *apoptygma* and an *epiblema,* which hangs from the back of the head. On each of the chiton's sleeves are three fibulae. As in cat. no. 17, this figure holds a flower and a dove. Red pigment is preserved on the top of the head, the eyebrows, and the lips, as well as on the objects held; yellow pigment remains on the hair surrounding the face and on the necklace with lanceolate finials. There is a small white rosette on the front of the head.

M.L.-A.

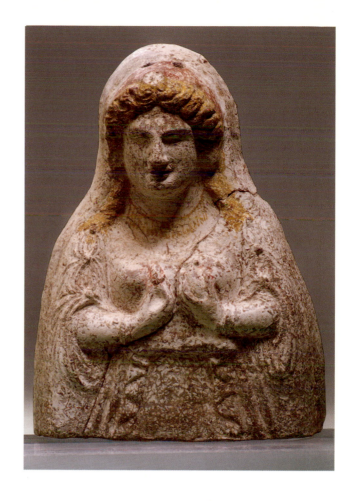

19. NECKLACE

Second half of the 4th century B.C.
Gold
Length 0.282 m
From a cist grave in the east cemetery of Pella
Archaeological Museum of Pella (1976.629)

From a braided wire band hang loops with pendant lanceolate leaves. The sheet-metal terminals are decorated with repoussé palmettes. The necklace displays a considerable resemblance to those indicated on the protomes in cat. nos. 17 and 18.

M.L.-A.

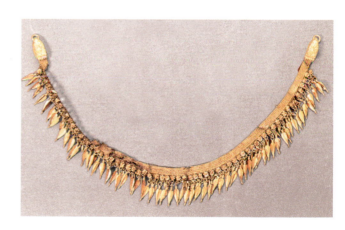

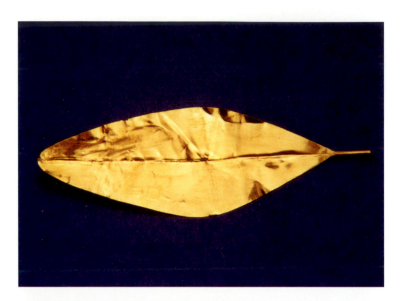

20. INSCRIBED LAUREL OR MYRTLE LEAF

Late 4th century B.C.
Gold
Length 0.083 m
From a cist grave in the east cemetery of Pella
Archaeological Museum of Pella (1989.76)

The leaf is inscribed with the female name
ΦΙΛΟΞΕΝΑ (Philoxena), the suffix of which
(–α) is characteristic of the Doric dialect of the
Macedonians. The placing of gold leaves inscribed
with the name of the dead inside the grave was
customary during Late Classical times at Pella, as
well as in other regions of Greece (Peloponnese).

M.L.-A.

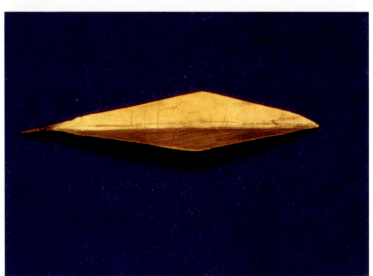

21. INSCRIBED LEAF

Late 4th century B.C.
Gold
Length 0.028 m
From a cist grave in the east cemetery of Pella
Archaeological Museum of Pella (1992.365)

This leaf is inscribed with the female name
ΗΓΗΣΙΣΚΑ (Hegesiska), the suffix of which
(–α) is characteristic of the Doric dialect of the
Macedonians.

M.L.-A.

Vessels for the Female Toilet

After the Persian Wars ended, the Kingdom of Macedon, under the strong leadership of Alexander I (496–454 B.C.), doubled its territory and made a dynamic entry into the pages of history. The king erected a gold portrait statue of himself at Delphi, and life in the royal court at Aigai in the fifth century B.C. reached an unprecedented level of opulence and splendor, presaging the magnificent reigns of Philip II and Alexander the Great.

Incontrovertible witnesses to this development are the impressive grave goods from the cluster of tombs of queens that included not only jewelry but also an outstanding series of rare and precious perfume vials (*unguentaria*), from which we can form an unexpectedly rich picture of the extravagance and cosmopolitanism of the royal toilet. Precious perfumes, myrrh, cosmetic oils, and various unguents, essential for daily beauty care, were consumed in apparently large quantities by coquettes of the court—who had access to and could afford these choice products from all parts of the known world—to enhance their allure and to take with them on their final journey.

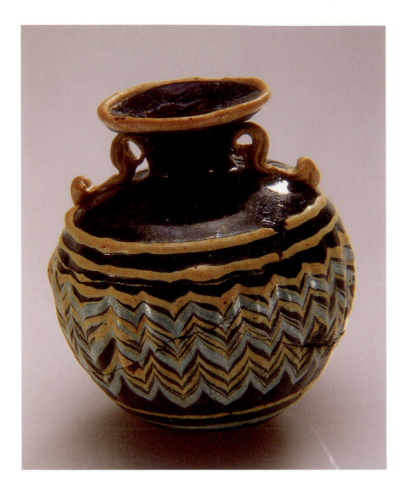

22. UNGUENTARIUM
 Ca. 500 B.C.
 Glass
 Max. height 0.058 m
 From the Cemetery of Aigai
 Museum of the Royal Tombs of Aigai, Vergina
 (BO 1420)

Made in some workshop in Rhodes, the Aegean islands, eastern Ionia, or even Phoenicia, using a particularly complicated technique of glass casting, these attractive polychrome perfume vials traveled to all corners of the ancient world from as early as the Archaic period. Thanks to their unusual and vibrant colors—dark blue, light blue, bright yellow—their deep luster, and the smooth texture of the semi-opaque glass, they were not unlike semiprecious stones and apparently were just as expensive, evidence of the quality of their precious content.

 This miniature vessel, which could be hung from its two tiny handles, belonged to the toilet of the gold-rich "Lady of Aigai" and accompanied her in the tomb. It was found resting on her abdomen, at about the height of the pudenda. The globular form recalls to some degree the characteristics of Corinthian unguentaria, the aryballoi, which were popular at Aigai in the sixth century B.C.

A.K.

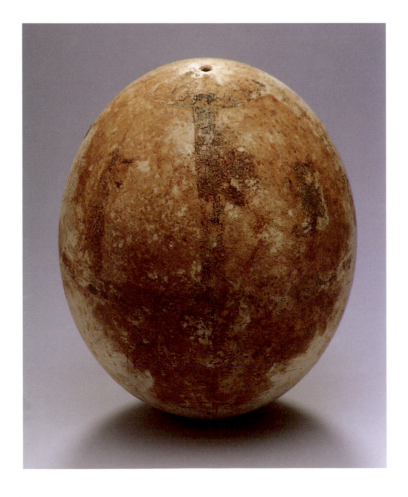

23. UNGUENTARIUM
 Ca. 430–420 B.C.
 Ostrich eggshell
 Height 0.161 m, max. diameter 0.128 m.
 From the Cemetery of Aigai
 Museum of the Royal Tombs of Aigai, Vergina
 (BO 1422)

This rare object, exotic for Greek lands, is the better preserved of a pair of ostrich eggshells that reached Aigai from Egypt or Phoenicia full of precious perfume. The eggshell, which has a two-centimeter circular hole at its lower end, must have been fixed to a stable base of some other material, perhaps wood, which has perished without trace. The smaller hole (0.5 cm. in diameter) at the top would have been used for controlling the flow of the valuable liquid contained inside the eggshell and may have been closed by a wooden stopper. Preserved on the surface of the unguentarium are traces of painted decoration in dark blue: a multipetaled rosette which blossoms around its "mouth," a horizontal zone around its middle, and vertical zones dividing it into quarters, in which were painted motifs that are no longer decipherable.

A.K.

24. LARGE ALABASTRON

Ca. 430–420 B.C.
Alabaster
Max. height 0.408 m
From the Cemetery of Aigai
Museum of the Royal Tombs of Aigai, Vergina
(ΒΛ 53)

Made of the material that gave its name to this category of perfume flasks, this unusually large alabastron, with its very wide rim, extremely narrow neck, and rather swollen body strongly reminiscent of its exotic models, may well have reached Macedonia from Egypt. Its remarkable size suggests a correspondingly large quantity of content, the value of which must have been considerable.

A.K.

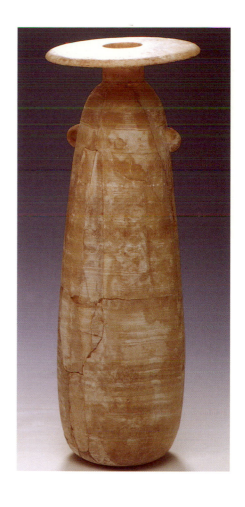

25. LARGE UNGUENTARIUM

344–343 B.C.
Alabaster
Max. height 0.38 m
From the Cemetery of Aigai,
looted tomb of Queen Eurydike
Museum of the Royal Tombs of Aigai, Vergina
(ΒΛ 54)

This huge alabaster unguentarium was found—together with many other smaller alabastra and a few squat lekythoi, the distinctive Attic perfume-oil flasks of the fourth century B.C., among which are two by the so-called Initiation Painter, perhaps the best vase painter of the period—in the looted Macedonian tomb of Queen Eurydike, grandmother of Alexander the Great. A customary object of the royal toilet, this unguentarium is about the same size as cat. no. 24, which was found in the same tomb cluster, but presents notable differences: its rim is narrower, its neck wider, and its profile more linear; sturdier and more geometric, it seems to be the product of a Greek workshop. At that time, small alabastra of alabaster or clay were becoming particularly popular in Macedonia and their use spread, mainly due to the increased wealth that came in the wake of the conquest of the East. Nonetheless, the difference in size and in the quality of craftsmanship—in combination with the host of other unguentaria, also larger than normal—suggests social superiority and royal riches.

A.K.

26. PLEMOCHOE EXALEIPTRO
Ca. 430–420 B.C.
Marble
Max. height 0.18m, diameter of
body 0.195 m
From the Cemetery of Aigai
Museum of the Royal Tombs of
Aigai, Vergina (BΛ48)

Exaleiptra, small vases with shallow
bodies and inverted rims designed to
prevent spilling their contents, were
vessels of the female toilet that contained
cosmetic ointments or aromatic oils. They
were essential for mortuary rites, as the
rubbing of the deceased's body with
perfumed oil was a basic element of the
burial procedure. Made in the pottery
workshops of Corinth and in Macedonia
by local vase makers, these clay objects
became one of the most typical grave
goods and are found in most tombs in
the region.

For the wealthy and privileged there
were, of course, more valuable versions,
such as the impressive iron exaleiptro
with the heavy bronze tripod base that
was found in the tomb of the gold-rich

"Lady of Aigai." Nevertheless, the
exceptionally elegant marble exaleiptro
discussed here is one of the rarest and
most impressive examples of the type to
have survived.

Without handle and in the shape of
the plemochoe, the Attic version of the
exaleiptro, which became popular in the
fifth century B.C., is known from clay
specimens and from frequent depictions
in scenes in the women's quarters
(*gynaikonites*) in red-figure vase painting.
The marble exaleiptro from Aigai is
made of three separate parts: the slender
lathe-turned foot with slightly concave
profile; the wide, shallow body whose
pronounced curvature converges down-
ward to match that of the foot; and
the swollen, shield-shaped lid, which
balances the whole with its volume.
The beauty of the vessel is based on the
harmonious proportions and the bold
interplay of alternating curves.

The impression of elegance created
by the audacious yet classical economy
of form is enhanced by a series of refine-
ments that become even more interesting
when the hardness and unyielding nature

of the material is taken into account:
the disc of the base with the prominent
cavetto on its circumference stands on
three tiny integral legs in order to ensure
stability, while a delicate relief ring marks
the point where the foot opens, like the
calyx of a flower, to receive the body;
relief rings form the perimeter of the
flat base on which the body sits, fitting
exactly upon the foot, simultaneously
interrupting and emphasizing the exuber-
ant curve of the profile. There is marked
inward and downward turn of the rim,
forming the characteristic retention band
that holds back the content; while a fine
relief ring distinguishes a recessed zone
which recalls a rim-band on the edge of
the small shield of the lid, with which
an integral ledge on the inside fits snugly
into the aperture.

The knob that existed at the top
of the lid (which was probably in the
form of a drop-shaped bud) has broken,
but traces of a foliate ornament that
crowned the lid, painted in deep purple,
enable us to form an impression of the
magnificence of this unique object in its
pristine state.

A.K.

27. TWO LEKYTHOI UNGUENTARIA
Ca. 430–420 B.C.
Marble
Max. height 0.245 and 0.27 m
From the Cemetery of Aigai
Museum of the Royal Tombs of
Aigai, Vergina (BΛ 45, BΛ 46)

Lekythoi, the characteristic Attic vases for perfumed oils and unguents that were essential for both the female toilet and funerary rites were usually made of clay. Examples in other, precious materials, such as these two marble lekythoi from Aigai, are extremely rare. Elegant and slender, these two lekythoi are considerably smaller than their clay counterparts and display a notable peculiarity: cut horizontally at the level of the shoulder, they are actually made of two separate pieces—one the tall cylindrical body with integral base, the other the upper part, with the neck, the distinctive mouth, and the handle, which functions as a lid, "closing" the lower part. The two sections fit together with absolute precision, thanks to an oblique recess at the point of union, and are fixed by a narrow vertical integral ledge with the upper section. Given that even ordinary clay lekythoi often have in

their interior a much smaller integral clay container for the oil, the possibility that there was an analogous system here cannot be precluded, namely that the two marble lekythoi concealed smaller unguentaria made of some other material, perhaps wood.

Both vases have painted decoration, which is better preserved on the smaller one. Traces of pigment on the rim, the handle, and the shoulder indicate that the upper part of the vase, which on clay lekythoi is black, was here painted bright red. A band of the same color emphasizes the end of the body at the level of the shoulder, while another band, of deep purple, exists just above the base. An olive branch, from which the color has flaked but whose ghost survives, crowned the body at about mid-height. The decoration of the other lekythos, on which several traces of the red pigment are preserved—on the upper part and, more minimally, on the body—must have been comparable.

The superb quality and craftsmanship, as well as features present on both lekythoi and on the marble exaleiptro found with them—the cavetto on the circumference of the disc of the base and

the fine relief ring that distinguishes the curve of the foot from the body—give credence to the hypothesis that these three vases were made in the same workshop. The workshop must have been in Attica, in part because of the characteristic shapes of the three objects and also because the best Greek stone carvers had gravitated to that part of Hellas during this period to work on projects initiated by Pericles.

The three marble vessels, together with the large alabaster alabastron, the ostrich eggshells, and nine white lekythoi (among them some of the best examples from the brush of the "Woman Painter," of no value to the ancient tomb-robbers and so left behind) were found in the looted tomb of an eminent lady in the court of Aigai, who was buried in the cluster of the queens in the reign of Perdikkas II. These vases, evidence of sumptuousness as well as of refinement, bear witness to a new order manifested by a preference for showy stone vessels—as a rule, of marble or alabaster—which was to become the fashion and was to set its seal on the taste of the women of the Macedonian court until the reign of Alexander III.

A.K.

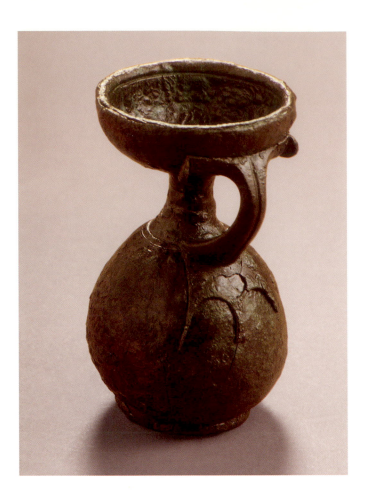

28. LEKYTHOS (OF TALCOTT TYPE)

Second half of the 4th century B.C.
Bronze
Height 0.09 m, diameter of rim 0.06 m
From Makryyalos, field no. 951, tomb 187,
north cemetery of Pydna
Archaeological Museum of Thessaloniki,
Pydna excavation (Πυ 7786)

This lekythos has a disc base, piriform body, and
slim neck ending in a bowl-shaped rim. A modeled
ring defines the junction between the body and the
neck. The upper part of an arched handle widens at
the point of attachment to the rim and ends in two
spool-shaped finials; the lower part has a midrib on
the outside and terminates in acanthus leaves, which
are affixed to the body of the vase. The rim and
the handle are cast.

M.B.

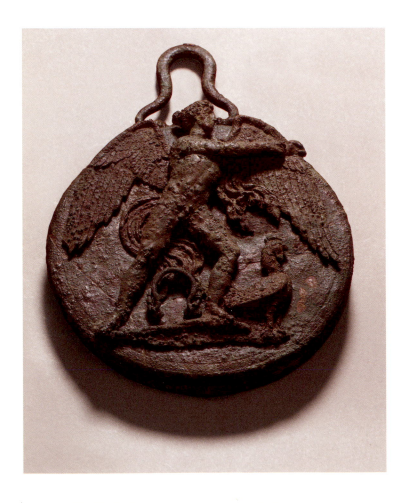

29. FOLDING MIRROR

Ca. mid-4th century B.C.
Bronze
Diameter of lid 0.15 m
From tumulus I, tomb III, ancient Aineia
Archaeological Museum of Thessaloniki
(ΜΘ 7553)

Folding mirrors, with movable omega-shaped (Ω)
handles and concentric circles in relief on the lower
surface, were basic to a woman's toilet in Hellenistic
times. Represented in relief on the lid is the young
Eros with his bow, in wide stride and facing left.
His folded-back himation is held in place at the
left shoulder and continues toward his right leg,
by which is a cockerel, also directed leftward. This
mirror, found in the same tomb as the bronze hydria
(see "The Symposium," cat. no. 9), is also attributed
to an Attic workshop.

Ι. Βοκοτοπούλου, *Οι ταφικοί τύμβοι της Αινείας*
(Athens, 1990), pp. 55–56, pl. 32a-γ.

E.T.

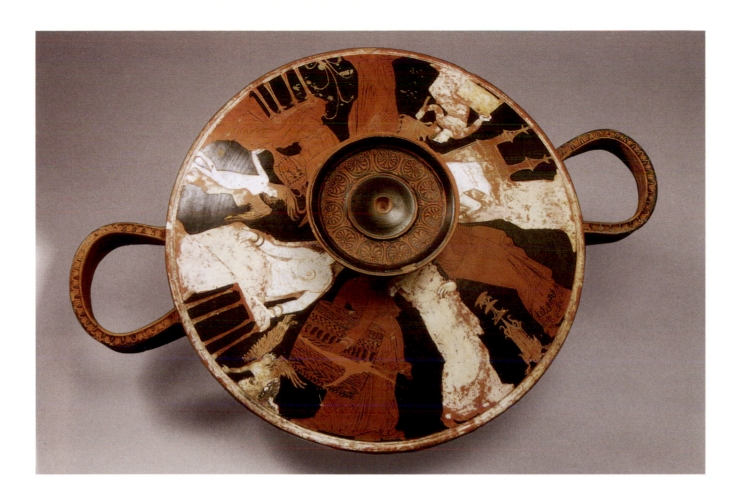

30. RED-FIGURE LEKANIS
Third quarter of the 4th century B.C.
Clay
Height 0.23 m, diameter 0.39 m
From Peristerona, in the district of Langada
Archaeological Museum of Thessaloniki
(ΜΘ 4880)

The body is decorated with a zone of palmettes between a checkered pattern and an Ionic cymatium lower down, as is the surface of the handles. Depicted on the lid are preparations for a marriage ceremony. The representation is developed in two scenes, with the seated bride-to-be as the central figure: in one scene she is in the midst of two infant Eros figures and handmaidens, who attend her after the prenuptial bath, an old custom linked with the fertility of the couple; in the other, her hair is being coiffed. Characteristic of the decoration technique is the addition of pigments—such as white on the figures—and the gilding of certain objects, such as jewelry.

B. Tsigarida and D. Ignatiadou, *The Gold of Macedon: Archaeological Museum of Thessaloniki* (Athens, 2000), p. 28, fig. 18.

E.T.

JEWELRY IN MACEDONIA

Eleni Trakosopoulou

The concept of making and wearing jewelry is interwoven with the human expression of interest in personal appearance and with the need for survival and protection against evil. Beyond its decorative role, jewelry at times is charged with mythical beliefs, apotropaic properties, the alluring qualities of good fortune, or magical powers.

Most pieces of ancient jewelry have been recovered from graves in which they were normally placed in their functional positions upon the body of the deceased. They can be distinguished into two groups: a larger one that includes jewelry worn by their owner while alive, and a smaller one that encompasses jewelry intended exclusively for funerary use. Only a limited number of items of jewelry come from the excavations of sanctuaries.

Pieces of jewelry gradually acquired various shapes and diverse individual decorative elements and motifs. Many of these derive from the domain of religion and ritual, such as snakes, pomegranates, demonic creatures, and so on, that display similarities with their counterparts in the civilizations of the East. These influences reached their peak in early protohistorical times with the expansion of Greek culture through the many colonies and in the Classical-Hellenistic period with the dominant presence of the Macedonians on three continents. In fact, in this later period the style of jewelry is consistent with the common style (*koine*) of Hellenistic artistic expression.

The mid-fourth century B.C. marks the beginning of the heyday of Greek jewelry in the realm of Macedon, which coincides at a social and political level with the reign of Philip II. The Macedonian workshops evolved, and their craftsmen ultimately produced exquisite masterpieces.

Alongside vegetal ornaments, simple or elaborate, figures and iconographic subjects inspired by the rich thematic repertoire of Hellenistic art appeared, such as the cycle of Aphrodite and of Dionysos, the beloved deities par excellence of the Greek-speaking East. The magical Herakleion Amma, the "Herakles knot," an earlier motif (actually the reef knot), was also predominant, particularly on necklaces and diadems. From the second half of the fourth century B.C., when it was accredited with protective and curative properties, it was literally paramount.

In general, it is worth noting the correlation of the demigod hero Herakles with beliefs concerning the heroization of the dead. Moreover, the frequent representation of divine and winged figures, as well as of chariots, may well be related in some way to the ideology and myth-making surrounding life after death and the transport of the imperishable, everlasting soul to the sphere of the immortals on Mount Olympus. Human figures are present too among the decorative subjects on jewelry, obviously influenced by portraits of eponymous persons of the day, such as members of the royal families.

There were two main techniques of working and decorating pieces of jewelry wrought in metal. The first consisted of hammered sheets decorated with incised, engraved, or relief designs, executed using hollow matrixes of stone or wood as well as bronze plaques-templates on which the selected ornament was in intaglio. For individual decorative motifs, small stamps or dies were used. The second technique involved cast items made in stone or clay molds in which the ornament was again in intaglio. An innovative new work was, of course, the result of the free rendering of the artist's

design in wax (*cire-perdue* casting). The decoration of jewelry was complemented by the equally fundamental techniques of filigree and granulation.

Wreaths were used from as early as the Archaic period. Some remnants of wreaths from the seventh and the early decades of the sixth century B.C. have survived in sanctuaries, while in the late sixth and fifth centuries B.C. they are encountered as grave goods. Most extant wreaths were recovered from graves and date from the second half of the fourth century B.C. The practice of wreathing the dead was probably associated with aspirations of ensuring an honored status in the afterlife.

The source of inspiration for creating wreaths was nature. Wreaths of oak, laurel, and olive branches alluded, respectively, to Zeus, Apollo, and Athena. More widely diffused were wreaths of myrtle, which were linked with Aphrodite, Demeter, and Persephone. Examples of gold wreaths were discovered in the royal tombs at Vergina. A rare piece is the wreath from Pieria, with ivy leaves and berries.

Diadems, decorative headbands (*taeniae*), fillets, or circlets, initially were associated with the royal lineage of Persia, whence they passed to the Macedonians after the conquests of Alexander the Great. The cradle of the diadem's long artistic tradition is the Near East, with Syria as epicenter. Known to the Minoan and the Mycenaean worlds, the majority as sepulchral objects, diadems spread to other regions of Greece during protohistorical times. Precious gold diadems may have been intended exclusively for mortuary use.

The usual shapes of diadems are the rectangular parallelogram or the elongated ellipse. Pedimented diadems, prominent at Eretria and on Skyros during the Geometric period, are rare. This shape reappeared in the fourth century B.C.

The incised linear decoration of the protohistorical diadems is variegated by a few embossed representations of animal friezes and anthropomorphic beings. During the Archaic period in the Greek islands, the principal decorative motif was the rosette. In the sixth century B.C. vegetal-floral ornaments prevailed that were considerably enriched and embellished in Classical times. Representative of this era is the diadem from Akanthos, which bears an appliqué ornament. In the second half of the fourth century B.C., a period of intensive activity for the Macedonian goldsmiths' workshops, a distinctive group of diadems was produced, their common feature being the Herakles knot.

Earrings were by far the favorite adornment of women in Antiquity and form the most numerous category of jewelry. Macedonia can boast a large collection of earrings from prehistoric and protohistorical times, with many interesting morphological and decorative traits.

The elaborate Archaic Macedonian earrings are either omega-shaped (Ω) or strap-shaped. Even in this period, simple designs were enriched with new and complex forms that were either appliqué ornaments or earrings in the round in their own right. Artistic experimentation in Classical times yielded impressive silver and gold earrings. Two of the most representative types of this period are earrings with conical, pyramidal pendants and boat-shaped earrings, represented in the exhibition by two pairs of gold earrings from Akanthos. In Hellenistic times there was a rich array of simpler types. Dominant was the hoop, formed either from a fine band or from one or more twisted wires and terminating usually in a lion head. In some case, figures in the round, the majority of the infant Eros (Cupid), were incorporated in the hoop. Frequent, too, was the use of semiprecious stones or other materials for rendering decorative elements.

Pendants and **necklaces** comprise the second largest category of jewelry from Antiquity. These are considered the first creations of the goldsmith's craft, which from early times was influenced by the consummate artistry and skill attained in the Middle East.

Pendants were used either as a single neck ornament hanging from a leather thong, thread, or wire or in a composite necklace. The loop or the added suspension strip, often found on the back surface, relates to a third possible use as dress ornaments. Fibulae or pins helped secure their fastening to the garment.

The creations bequeathed by the Macedonian goldsmiths of Classical times include interesting ornaments of this kind. The notable artistic activity of the fourth century B.C. is represented in the exhibition by twelve small pendants of various shapes from the cemetery of Akanthos as well as by a precious pendant, gift to the dead, from a grave found in the tumulus of the Macedonian tomb at Phoinika in Thessaloniki. The goods (accompaniments for the dead) from the Akanthos grave clearly were not just articles of adornment but had amuletic properties as well, since analogous figures and shapes are identifiable in the diverse miniature artworks, such as the head of Silenus, tortoise, palm of the hand, double ax, pomegranate, club, and cockleshell. The costly disc-shaped pendant from Thessaloniki, with a repoussé representation of a head framed by a luxuriant coiffure in the middle of which is a Herakles knot, dates to the mid-fourth century B.C.

The necklaces in the exhibition represent all the known types. The earliest piece of jewelry from Vergina, having a total of sixty-one spherical beads decorated with parallel impressed grooves, as well as the Classical necklaces from Akanthos are characteristic examples of the type consisting of assorted beads and pendants. It enjoyed wide dissemination and remarkable longevity, from the eighth century B.C. into Hellenistic times. Beads and exquisitely fashioned pendants of diverse shapes, such as pomegranates, globular or pointed-bottomed vases, and pyramids, occur in different combinations following the general aesthetic of the age.

On present evidence, chain necklaces, known in southern Greece from the late ninth century B.C., apparently spread to Macedonia during the Late Archaic period. They are found, for example, at Sindos and Vergina, where the version formed from twisted wire also occurs. The terminals of the chains are usually snake heads, but from Classical times onward heads of other animals, mainly lions, as well as of human figures are also featured. Particularly noteworthy is their combination with the Herakles knot, as exemplified by the necklace from Pydna. Necklaces of this type were fastened to the garment by means of fibulae.

The Hellenistic strap necklace with spear-head elements from Pella represents another large group that shares the form of a band of continuous ornaments or plaques, from which are suspended pendants, often vase-shaped, which were particularly popular and in great demand on the market. The wide dissemination of strap necklaces is seen in the last quarter of the fourth century B.C.

Pins were not merely utilitarian objects for fastening garments but also played a decorative role in relation to both attire and coiffure. They were most widely disseminated in the Late Mycenaean period, probably in connection with the establishment of the peplos as part of sartorial fashion.

The basic type of the earliest pin, with a disc-shaped head, spherical bead, or kindred decorative element at the distal end of the shaft, was established until Archaic times, with limited variations in form and decoration, most often incising and granulation. As time passed, filigree technique was also applied, which enriched the Archaic pin through greater detail in the execution of motifs, achieving a more sophisticated artistic effect. Intricate gold pins, important finds from the Archaic period, have been found only in Macedonia and only in cemeteries, such as at Sindos, Aiani, and Vergina—the provenance of the impressive pair in the exhibition, with spherical beads and disc-shaped finials. The gold double-pin from Vergina represents the so-called Illyrian type, with trilobe head, particularly widespread throughout northern Greece and the Balkan Peninsula. This type is also associated with male dress.

The **fibula** and the pin share features in their development, such as the time period in which they started and a common purpose, which in the case of the fibula extends to fastening pieces of jewelry on garments, diadems, and headdresses. The fibula presents an interesting typology: spectacle, bow, arched. The most dynamic type is the arched, which held sway over a long period, from the Early Iron Age, throughout the Archaic period, and into at least Classical times. Most fibulae are of bronze, though iron ones occur, while precious fibulae of silver or gold, represented in the exhibition by a magnificent specimen from Vergina, are rare.

Austere prehistoric **bracelets**, usually fashioned from shell, gain prominence in the Early Iron Age and the Archaic period, when metal becomes the main material from which they are made and artistic influences from Near Eastern regions bear fruit. The earliest simple bracelets of circular shape gradually acquired a more composite form, frequently consisting of several spirals with plain or decorated hoops and terminals. Preeminent is the bracelet with zoomorphic terminals, primarily snake heads, a type elaborated under Oriental influence. Their popularity is virtually diachronic, from the eighth century B.C. into Hellenistic times. Presented in the exhibition is a silver pair of the last quarter of the fourth century B.C. from Akanthos, with characteristic twisted hoop and ram's-head terminals.

The functional positions of bracelets were no different than they are today, the majority being worn on the arms—upper and lower—and the wrists. Some cases of anklets, associated with child burials, are known.

Finger rings of simple form, made from a strip of precious metal, are known in northern Greece from prehistoric times. They were decorated with banded patterns and incised linear designs, and, less often, with bands of elaborate guilloche. Among the most common types is the simple solid hoop, represented in the exhibition by an Archaic example from Vergina.

The intaglio decoration of the bezel, familiar mainly in the Mycenaean world, presents a rich iconographic repertoire in the Archaic period as well as in subsequent years. In the Classical period the elliptical or circular bezel dominates, decorated with vegetal-floral images, animals or fantastic creatures and deities, and scenes from religious and domestic life.

BIBLIOGRAPHY

Amandry, P. *Collection Hélène Stathatou*. I. *Les Bijoux antiques*. Strasbourg, 1953. II. *Les Objets byzantins et postbyzantins*. Limoges, 1957. III. *Objets antiques et byzantins*. Strasbourg, 1963. IV. *Bijoux et petits objets*. Athens, 1971.

Axmann, U. *Hellenistische Schmuckmedaillons*. Berlin, 1986.

Barr-Sharrar, B. *The Hellenistic and Early Imperial Decorative Bust*. Mainz, 1987.

Boardman, J. *Greek Gems and Finger Rings*. London, 1970.

Βοκοτοπούλου, I., et al. *Σίνδος*. Exhib. cat. Athens, 1985.

Deppert-Lippitz, B. *Griechischer Goldschmuck*. Mainz, 1985.

Despini, A. *Greek Art-Gold Jewellery*, Athens, 1996.

Georgoula, E., ed. *Greek Jewellery From the Benaki Museum Collections*. Exhib. cat. Athens, 1999.

Guzzo, P. G. *Oreficerie dalla Magna Grecia*. Taranto, 1993.

Higgins, R. A., ed. *Greek and Roman Jewellery*. London, 1961; Los Angeles, 1980.

Kypraiou, E., ed. *Greek Jewellery, 6000 Years of Tradition*. Exhib. cat. Athens, 1997.

Ninou, K. ed. *Treasures of Ancient Macedonia*. Exhib. cat. Thessaloniki, 1979.

Ogden, J. *Jewellery of the Ancient World*. London, 1982.

Tsigarida, B., and Ignatiadou, D. *The Gold of Macedon, Archaeological Museum of Thessaloniki*. Exhib. cat. Athens, 2000.

Williams, D. *The Art of the Greek Goldsmith*. London, 1998.

Williams, D., and J. Ogden. *Greek Gold: Jewellery of the Classical World*. London, 1994.

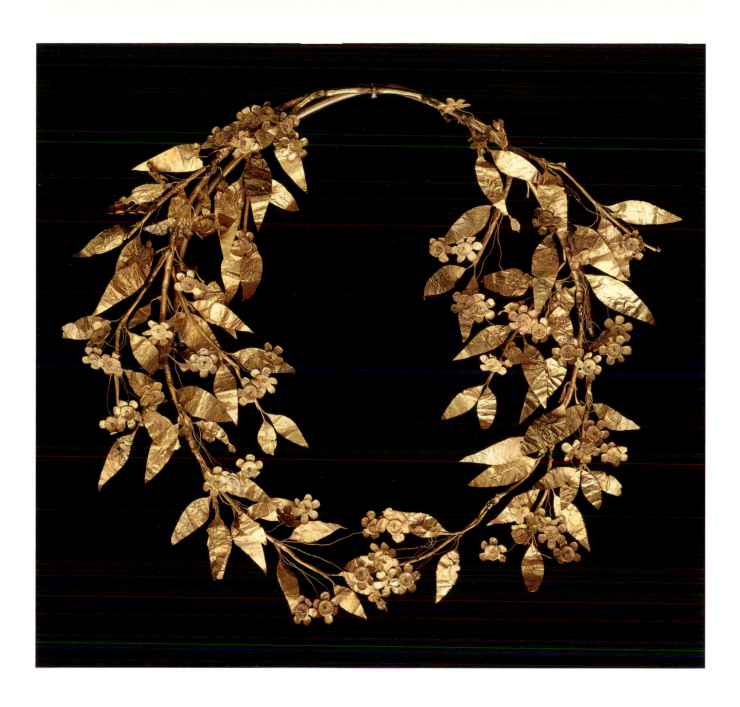

1. WREATH OF FLOWERING MYRTLE
 4th–3rd century B.C.
 Gold
 Diameter 0.305 m
 Provenance unknown
 The Museum of Fine Arts, Houston
 Gift of Miss Annette Finnigan (37.5)

This wreath is composed of myrtle leaves and flowers in gold leaf that are inserted into the central curving stem. The flowers consist of rosettes with a central disc. Such wreaths are common in funerary contexts together with other grave offerings. Many examples representing different botanical types are known from Macedonian graves.

H. Hoffmann, *Ten Centuries That Shaped the West: Greek and Roman Art in Texas Collections*, exhib. cat. (San Antonio, 1971), no. 212; Peter C. Marzio, "Introduction," in *A Permanent Legacy: 150 Works from the Collection of the Museum of Fine Arts, Houston* (New York, 1989), pp. 84–85.

S.M.-C.

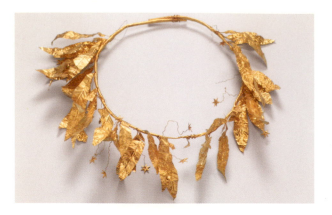

2. WREATH OF FLOWERING MYRTLE

Third quarter of the 4th century B.C.
Gold
Diameter approx. 0.18 m
From a funerary *cistus* in a tumulus at Evropos, Kilkis
Archaeological Museum of Thessaloniki
(MK 4810)

Th. Savvopoulou, *ΑΔ* 50 1995 (2000), Χρον. Β' 2, 487, pl. 160 δ-ε.

E.T.

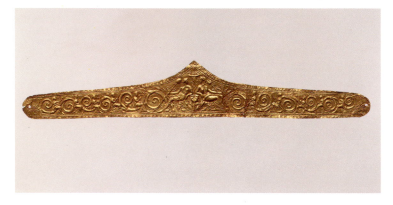

3. PEDIMENT-SHAPED DIADEM

Last quarter of the 4th century B.C.
Gold
Length 0.368 m, height at center 0.059 m
Said to be from Madytos
The Metropolitan Museum of Art, New York, Rogers Fund 1906 (06.1217.1)
Photograph © 1993 The Metropolitan Museum of Art

The diadem, worked in relief, features the god Dionysos and his beloved Ariadne seated back to back but with heads turned to face each other. Each holding a thyrsos, they are perched at the center on an elaborate acanthus whose tendrils spiral outward toward each end. Among the spirals are five seated women on either side, probably Muses engaged in different activities. Several play musical instruments: harp, lyre, pipes, and lute—and another holds a book.

The diadem is from a group of jewelry, part of which was purchased by the Metropolitan Museum of Art in 1906, that is said to be from a tomb at Madytos along the Hellespont.

The Search for Alexander: Supplement to the Catalogue (New Orleans, 1982), no. S11;
D. Williams and J. Ogden, *Greek Gold: Jewelry of the Classical World*, exhib. cat. (New York, 1994), no. 62.

S.M.-C.

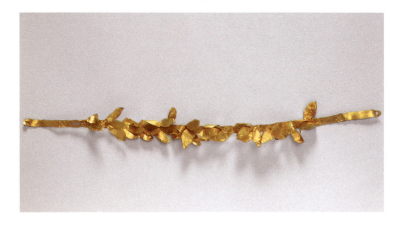

4. BANDED DIADEM DECORATED WITH OLIVE LEAVES

Last quarter of the 4th century B.C.
Gold
Length 0.253 m
From Akanthos cemetery
Archaeological Museum of Polygyros (I.115.70)

The stalks of the olive leaves that decorate this diadem are affixed in clusters of holes.

E.T.

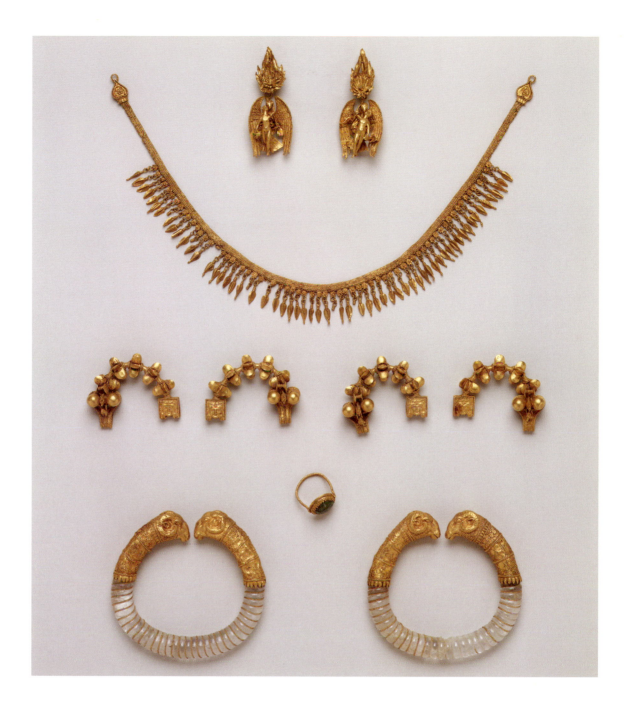

5a. STRAP NECKLACE WITH
BEECHNUT PENDANTS
End of the 4th century B.C.
Gold
Length 0.33 m
Said to be from near Thessaloniki
from the so-called Ganymede Group
The Metropolitan Museum of Art, New York,
Harris Brisbane Dick Fund, 1937 (37.11.8)
Photograph © 1993 The Metropolitan
Museum of Art

The necklace strap consists of three doubled
loop-in-loop chains. At the lower edge are attached
tiny rosettes from which hang beechnut pendants.
The terminals are shaped like ivy or vine leaves
bordered by beaded wire and centered with a rosette.

The Ganymede Group includes a set of jewelry,
presumably from a tomb, that consists of a pair of
earrings, four fibulae, two bracelets, a ring, and this
necklace.

D. Williams and J. Ogden, *Greek Gold: Jewelry
of the Classical World*, exhib. cat. (New York, 1994),
no. 30.

<div align="right">S.M.-C.</div>

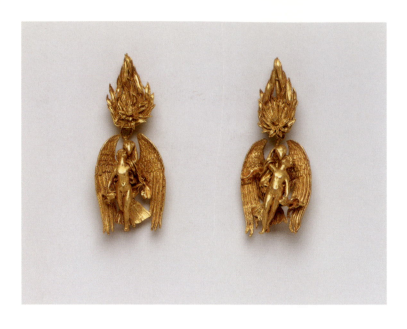

5b. EARRINGS WITH GANYMEDE AND THE EAGLE

End of the 4th century B.C.
Gold
Height 0.06 m
Said to be from near Thessaloniki
from the so-called Ganymede Group
The Metropolitan Museum of Art, New York,
Harris Brisbane Dick Fund, 1937 (37.11.9, .10)
Photograph © 1993 The Metropolitan
Museum of Art

Each large honeysuckle palmette supports a pendant figure of Ganymede being carried off by an eagle. The spread wings of the eagle, actually Zeus in disguise, form a dramatic backdrop for the god's youthful love interest, the mortal Ganymede. These earrings give their name to the so-called Ganymede Group.

The Ganymede Group includes a set of jewelry, presumably from a tomb, that consists of a necklace, four fibulae, two bracelets, a ring, and these earrings.

D. Williams and J. Ogden, *Greek Gold: Jewelry of the Classical World*, exhib. cat. (New York, 1994), no. 31.

S.M.-C.

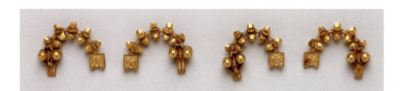

5c. TWO PAIRS OF FIBULAE

End of the 4th century B.C.
Gold
Length 0.05 m, height 0.038 m
Said to be from near Thessaloniki
from the so-called Ganymede Group
The Metropolitan Museum of Art, New York,
Harris Brisbane Dick Fund, 1937
(37.11.13–.16)
Photograph © 1993 The Metropolitan
Museum of Art

The four fibulae constitute two pairs, each pair made in mirror image for fastening at the shoulders. Each fibula, consisting of an arched bow threaded with five "paddle wheels," terminates in a hinge plate and a catch plate. The hinge plate is decorated with the head of a woman (either Herakles' mistress Omphale or perhaps the hunt-goddess Artemis) wearing the skin Herakles took from the Nemean lion. Griffins and horse protomes appear above the catch plate. This type of fibula was popular in Macedonia and may have originated there.

The Ganymede Group includes a set of jewelry, presumably from a tomb, that consists of a necklace, a pair of earrings, two bracelets, a ring, and these fibulae.

D. Williams and J. Ogden, *Greek Gold: Jewelry of the Classical World*, exhib. cat. (New York, 1994), no. 33.

S.M.-C.

5d. BRACELETS

End of the 4th century B.C.
Gold, rock crystal
Width 0.08 m, height 0.078 m
Said to be from near Thessaloniki
from the so-called Ganymede Group
The Metropolitan Museum of Art, New York,
Harris Brisbane Dick Fund, 1937
(37.11.11–.12)
Photograph © 1993 The Metropolitan
Museum of Art

These bracelets were carved from rock crystal in
such a way as to appear twisted. A spiral-beaded
wire running through the valleys enhances the effect.
The finials are gold rams' heads, finely finished and
with multiple ornate collars decorated with palmettes,
ivy chains, grape leaves, flowers, and quatrefoils.

The Ganymede Group includes a set of jewelry,
presumably from a tomb, that consists of a necklace,
a pair of earrings, four fibulae, a ring, and these
bracelets.

D. Williams and J. Ogden, *Greek Gold: Jewelry of
the Classical World*, exhib. cat. (New York, 1994),
no. 32.

S.M.-C.

5e. RING

End of the 4th century B.C.
Gold, emerald
Height 0.021 m, diameter of bezel 0.014 m
Said to be from near Thessaloniki
from the so-called Ganymede Group
The Metropolitan Museum of Art, New York,
Harris Brisbane Dick Fund, 1937 (37.11.17)
Photograph © 1993 The Metropolitan
Museum of Art

The ring is set with an oval cabochon emerald of
good color but flawed. The emerald is held fast by a
dogtooth setting. Emeralds first appear in the Greek
world in Early Hellenistic times, coming from Egypt
or possibly the Urals.

The Ganymede Group includes a set of jewelry,
presumably from a tomb, that consists of a necklace,
a pair of earrings, four fibulae, two bracelets, and
this ring.

D. Williams and J. Ogden, *Greek Gold: Jewelry of
the Classical World*, exhib. cat. (New York, 1994),
no. 34.

S.M.-C.

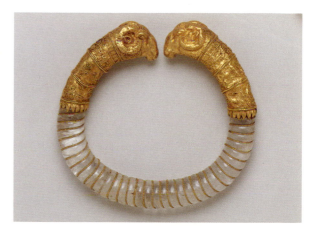

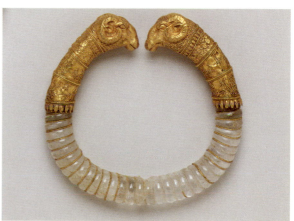

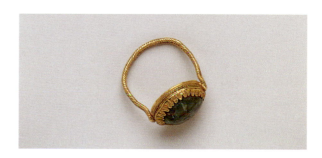

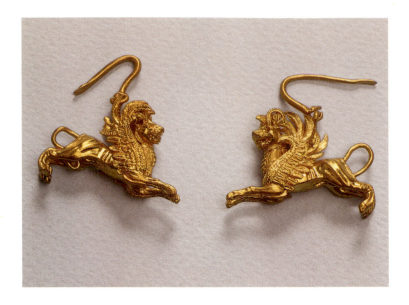

6. EARRINGS WITH LION-GRIFFIN
Second half of the 4th century B.C.
Gold
Max. length 0.03 m, max. height 0.03 m
From Alykes Kitrous, field of K. Chrysochoidis,
tomb 52, cist grave of mud bricks in the form
of a *theke*, south cemetery of Pydna
Archaeological Museum of Thessaloniki,
Pydna excavation (Πυ 5745)

Found inside the ossuary with the burned remains of
the dead female's bones, each of these gold earrings
is in the form of a hook, from which hangs a lion-
griffin, in a flying gallop, with crest and horns on its
head.

Μ. Μπέσιος, "Νότιο νεκροταφείο Πύδνας,"
Το Αρχαιολογικό Έργο στη Μακεδονία και Θράκη 15
(2001), Thessaloniki 2003, pp. 371ff.

<div align="right">M.B.</div>

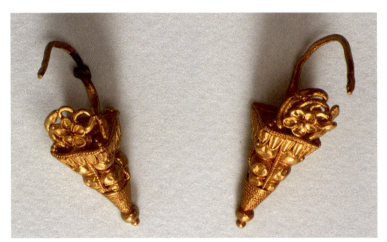

7. EARRINGS WITH PYRAMIDAL PENDANT
Last quarter of the 4th century B.C.
Gold
Height (a) 0.0315 m, (b) 0.033 m
From Akanthos cemetery
Archaeological Museum of Polygyros
(I.161.427a, b)

These earrings are decorated with cymatia, globules,
and parallel rows of wires. Each apex consists of a
rosette and a coiled snake, part of whose body also
forms the suspension hook. Earrings of kindred type
are also encountered at Amphipolis.

<div align="right">E.T.</div>

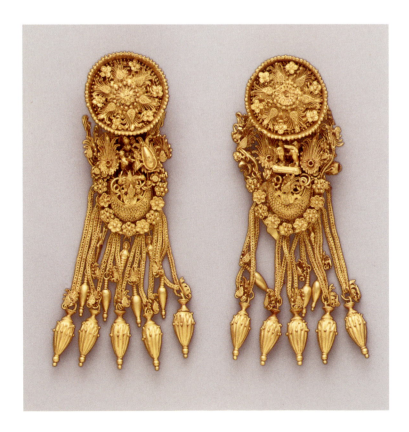

8. DISC EARRINGS WITH BOAT-SHAPED PENDANT
Late 4th–early 3rd century B.C.
Gold
Height 0.065 m
Said to be from Western Asia Minor
The Metropolitan Museum of Art, New York,
Rogers Fund (48.11.2, .3)
Photograph © 1990 The Metropolitan
Museum of Art

Each disc is decorated with wires and granulation
that radiate from a central rosette with motifs that
include palmettes and quatrefoils. Attached to the
disc is a boat-shaped element with a profusion of
palmettes and spirals filling the open space. Perched
at center on top of the boat is a miniature Nike
driving a two-horse chariot. The bottom is edged
with rosettes and tiny busts of female figures. Longer
and shorter chains descending from the edging end
in small plain seeds and larger ribbed seeds.

H. Hoffmann and P. F. Davidson, *Greek Gold:
Jewelry from the Age of Alexander*, exhib. cat.
(Boston, 1965), no. 54i; D. Williams and J. Ogden,
Greek Gold: Jewelry of the Classical World, exhib.
cat. (New York, 1994), no. 70.

<div align="right">S.M.-C.</div>

9. DISC EARRINGS WITH BOAT-SHAPED PENDANT

Last quarter of the 4th century B.C.
Gold
Height 0.074 m
Said to be from Madytos
The Metropolitan Museum of Art, New York,
Rogers Fund, 1906 (06.1217.11, .12)
Photograph © 1989 The Metropolitan
Museum of Art

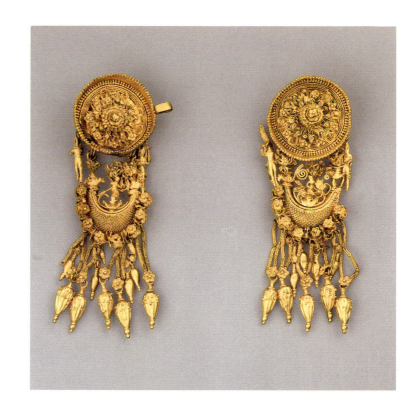

Each disc is decorated with wires and granulation to form concentric zones of motifs that include a broad band of palmettes, spirals, and quatrefoils around a central rosette. Attached to each disc is a boat-shaped element. A youthful Eros stands at either side and a tiny Muse playing a lyre is perched at center on top of each boat. The bottom is edged with rosettes and protomes of the winged horse Pegasus in miniature. Longer and shorter chains descending from the edging end in small plain seeds and larger ribbed seeds.

The earrings are from a group of jewelry, part of which was purchased by the Metropolitan Museum of Art in 1906, that is said to be from a tomb at Madytos along the Hellespont.

The Search for Alexander: Supplement to the Catalogue (New Orleans, 1982), nos. S21, 22; D. Williams and J. Ogden, *Greek Gold: Jewelry of the Classical World*, exhib. cat. (New York, 1994), no. 63.

S.M.-C.

10. BOAT-SHAPED EARRINGS WITH PENDANT

Late 4th century B.C.
Gold
Height 0.042 m
From Akanthos cemetery
Archaeological Museum of Polygyros
(MΘ 7461)

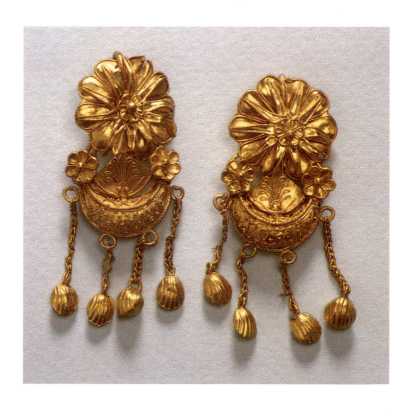

A cockleshell-shaped pendant hangs from each of these boat-shaped gold earrings. On the bows of the boat are two zones of wire rinceaux and volute motifs. Inside the hull is a strip decorated with a palmette and framed by rosettes, corresponding to the prow and the stern. The composition is crowned by a rosette, which masks the suspension hook. Superimposed on the petals of this rosette are lanceolate ones, which sprout from a small, overlying central rosette.

E.T.

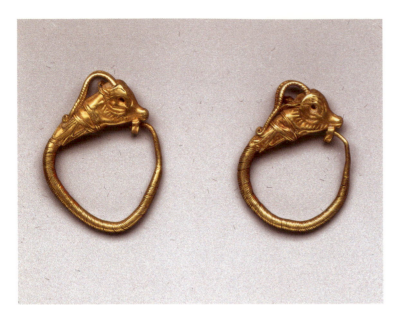

11. HOOP EARRINGS WITH GAZELLE HEAD

4th–3rd century B.C.
Gold
Height 0.026 m
Provenance unknown
Brooklyn Museum, New York, Ella C.
Woodward Memorial Fund (05.449.1, .2)

These hoop earrings have finials in the shape of gazelle heads whose eyes were originally inlaid with colored stones. This type of earring, derived from Persian art, enjoyed widespread popularity in the Greek Hellenistic world.

The Search for Alexander, exhib. cat. (Boston, 1980), no. 70.

S.M.-C.

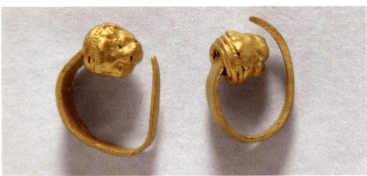

12. STRAP EARRINGS

First quarter of the 3rd century B.C.
Gold
Height (a) 0.01 m, (b) 0.012 m
From Akanthos cemetery
Archaeological Museum of Polygyros
(I.159.238)

Lion heads are affixed to the widest part of the metal strip that tapers toward its pointed end.

E.T.

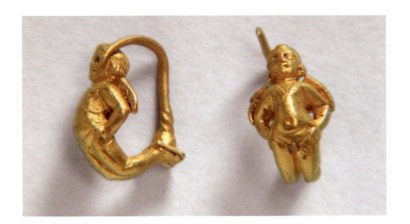

13. EARRINGS WITH EROS FIGURE

Late 4th century B.C.
Gold
Height (a) 0.021 m, (b) 0.022 m
From Akanthos cemetery
Archaeological Museum of Polygyros (I.29.6)

Eros figures are incorporated into the hoop of these earrings so that their bodies follow its curvature. Their arms, which are bent and rest on the hips, are in an analogous position.

E.T.

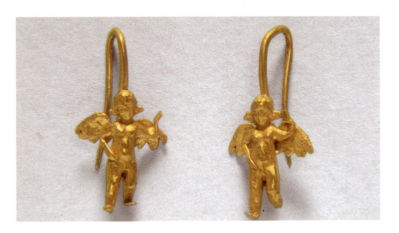

14. EARRINGS WITH EROS FIGURE

First quarter of the 3rd century B.C.
Gold
Height (a) 0.022 m, (b) 0.021 m
From Akanthos cemetery
Archaeological Museum of Polygyros
(I.115.66)

Here each of the Eros figures are rendered flying, with the left hand raised above the corresponding shoulder and the right hand resting on the hip of the right leg, which is to the fore.

E.T.

15. EARRINGS WITH PENDANT
IN THE FORM OF EROS

3rd–2nd century B.C.
Gold
Height without hook 0.035 m
Provenance unknown
The Museum of Fine Arts, Houston,
Gift of Miss Annette Finnigan (37.42.1, .2)

Each earring features a childlike Eros suspended from a rosette disc inset with garnets and twisted wires. Eros, holding a phiale in one hand and a scroll in the other, is nude except for a bandolier across his chest.

H. Hoffmann, *Ten Centuries That Shaped the West: Greek and Roman Art in Texas Collections*, exhib. cat. (San Antonio, 1971), no. 216; *The Search for Alexander*, supplement to the catalogue (New Orleans, 1983), pl. 72; B. Deppert-Lippits, *Griechisher Goldshmuck* (Mainz, 1985), pl. 166.

S.M.-C.

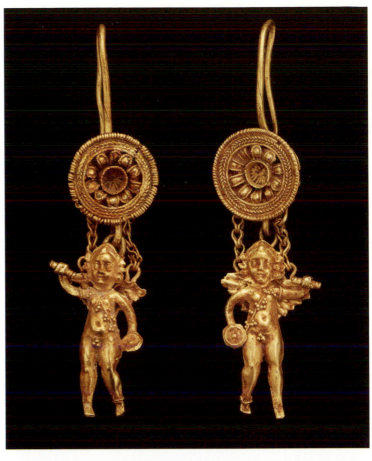

16. EARRINGS WITH PENDANT
IN THE FORM OF A GOOSE

3rd–2nd century B.C.
Gold
Height without hook 0.045 m
Provenance unknown
The Museum of Fine Arts, Houston,
Gift of Miss Annette Finnigan (37.43.1, .2)

Each earring features a goose suspended from a green glass spacer bead below a small cup-shaped rosette. The bird is perched on a cylindrical base. Details are rendered in filigree.

The Search for Alexander, exhib. cat. (Boston, 1980), no. 71; H. Hoffman, *Ten Centuries That Shaped the West: Greek and Roman Art in Texas Collections*, exhib. cat. (San Antonio, 1971), no. 217.

S.M.-C.

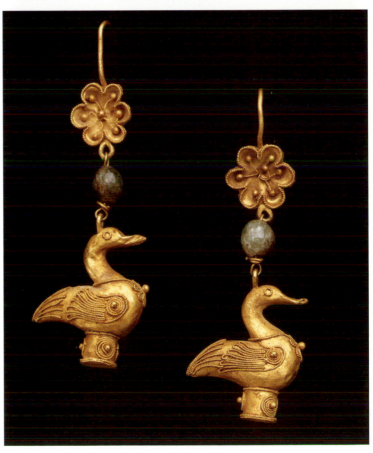

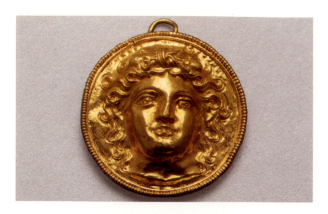

17. PENDANT

Mid-4th century B.C.
Gold
Height 0.032 m
From a grave in the tumulus of the
Macedonian tomb at Phoinika, Thessaloniki
Archaeological Museum of Thessaloniki (MΘ 12258)

The repoussé head of a youthful figure characterizes this gold-sheet pendant. The hair, dressed in ring curls and parted in the middle, is adorned with a Herakles knot above the forehead.

E.T.

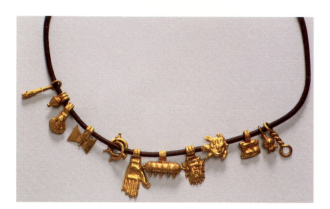

18. NECKLACE CHAIN WITH
TWELVE AMULET PENDANTS

4th century B.C.
Gold
Length approx. 0.20 m
From Akanthos cemetery
Archaeological Museum of Polygyros (MΘ 7468)

The twelve amulet pendants on this necklace, most with a wide grooved suspension loop and all cut from a gold sheet, represent a variety of shapes: the head of Silenus, a double axe, two alternating links with knobs, a pomegranate, a club, a cockleshell, a tortoise, the palm of a hand, an astragal, a biconical bead, and an indeterminate object (possibly a cistus perhaps of magical content), as well as twisted wire that forms the loop at its free end. Related are the contemporary bone pendants found in northern Greece and now in the Archaeological Museum of Abdera.

E.T.

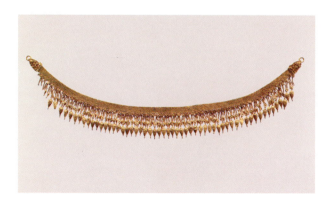

19. STRAP NECKLACE WITH
SEEDLIKE PENDANTS

Last quarter of the 4th century B.C.
Gold
Length 0.323 m
Said to be from Madytos
The Metropolitan Museum of Art, New York,
Rogers Fund, 1906 (06.1217.13)
Photograph © 1993 The Metropolitan Museum of Art

The necklace strap consists of five doubled loop-in-loop chains. At the lower edge are attached tiny rosettes and the foreparts of the winged horse Pegasus in miniature. From them hangs a festoon made of pairs of chains terminating in rosettes and ribbed, seed-like pendants (of which fifty-five out of a probable sixty-one are preserved). The large terminals are decorated with a rosette and palmette.

The necklace is from a group of jewelry, part of which was purchased by the Metropolitan Museum of Art in 1906, that is said to be from a tomb at Madytos along the Hellespont.

The Search for Alexander: Supplement to the Catalogue (New Orleans, 1982), no. S23; D. Williams and J. Ogden, *Greek Gold: Jewelry of the Classical World,* exhib. cat. (New York, 1994), no. 64.

S.M.-C.

20. BEAD NECKLACE

Late 4th century B.C.
Gold
Length approx. 0.22 m
Akanthos cemetery
Archaeological Museum of Polygyros (I.165.3)

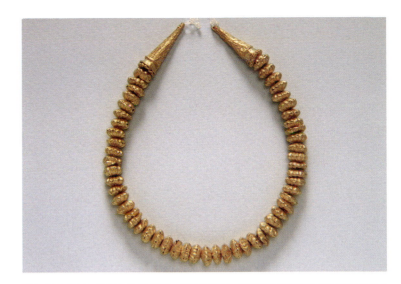

This gold necklace is comprised of fifty-four spherical beads and two truncated conical beads, one at each end. The spherical beads are formed from two hollow spheres of metal sheet decorated with parallel impressed grooves; the truncated conical ones are embellished with motifs executed in filigree technique.

E.T.

21. BEAD NECKLACE

Last quarter of the 4th century B.C.
Gold
Length 0.416 m
From Akanthos cemetery
Archaeological Museum of Polygyros
(I.161.426)

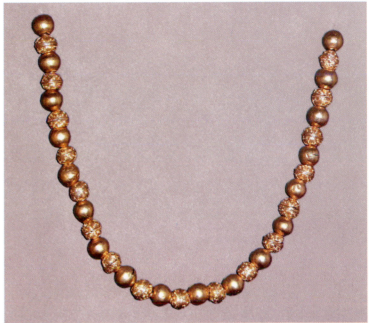

The thirty-five spherical beads that comprise this gold necklace are formed from two hollow spheres. Seventeen of the beads are embellished with spirals and globules.

E.T.

22. NECKLACE

Second half of the 4th century B.C.
Gold
Length 0.44 m
From Alykes Kitrous, field of K.
Chrysochoidis, tomb 52, cist grave of mud bricks in the form of a *theke*, south cemetery of Pydna
Archaeological Museum of Thessaloniki,
Pydna excavation (Πυ 5748)

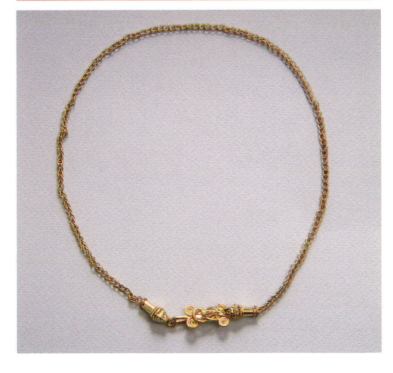

Found inside the ossuary together with the burnt bones of the dead female, this necklace consists of a simple chain with lion-head terminals. In the mouth of one lion head is a hook and in the other a Herakles knot with four spirals at the ends and a female head in the center.

Μ. Μπέσιος, "Νότιο νεκροταφείο Πύδνας,"
Το Αρχαιολογικό Έργο στη Μακεδονία και Θράκη 15 (2001), pp. 371ff.

M.B.

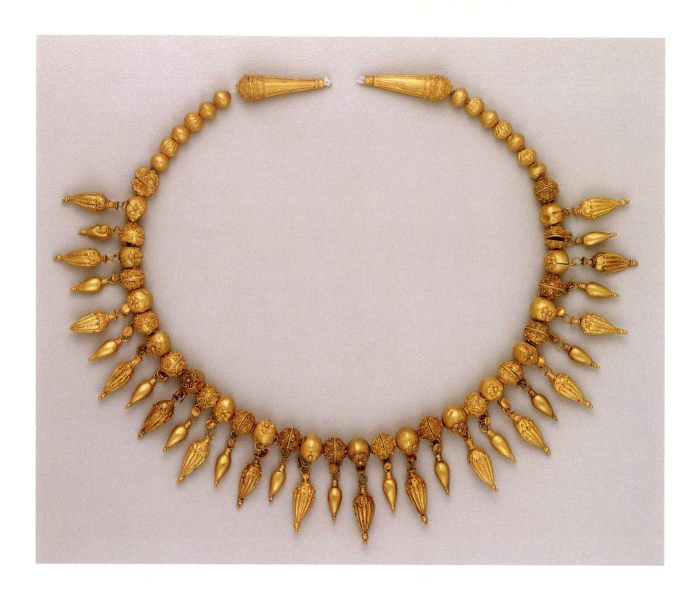

23. NECKLACE WITH SEEDLIKE PENDANTS
Late 4th century B.C.
Gold and enamel
Length restrung 0.377 m
Provenance unknown
Indiana University Art Museum,
from the Burton Y. Berry Collection
(IUAM70.105.4)
Photograph: Michael Cavanagh,
Kevin Montague
© 2004 Indiana University Art Museum

The necklace as now composed is strung with both smooth and filigreed beads from which smooth and filigreed seedlike pendants are suspended. The terminals consist of tapering elements suggestive of the club Herakles used to kill the Nemean lion.

The Search for Alexander, exhib. cat. (Boston, 1980), no. 56; W. Rudolph, *A Golden Legacy: Ancient Jewelry from the Burton Y. Berry Collection,* exhib. cat. (Bloomington and Indianapolis, 1995), no. 45, pp. 191–93.

S.M.-C.

24. MEDALLION-DISC WITH BUST OF ARTEMIS

2nd century B.C.(?)
Gold, garnet, enamel
Diameter 0.079 m
Provenance unknown
Princeton University Art Museum,
Museum purchase (y1938-50)
Photograph: Bruce M. White

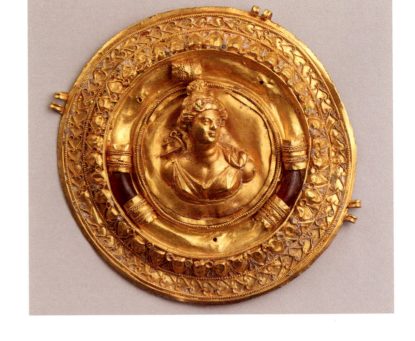

The medallion-disc with central emblem in high relief features a bust of Artemis. The goddess of the hunt carries a quiver over her right shoulder. Surrounding her are decorative zones in concentric circles, one with a circle of garnets (only two preserved) set into gold bands and two others with leafy motifs outlined in filigree. Around the exterior are four sets of loops (three preserved) that presumably supported gold chains. The function of this type of medallion has been much debated. Suggestions include breast ornaments, hairnets, and lids for small vessels called pyxides.

H. Hoffmann and P. F. Davidson, *Greek Gold: Jewelry from the Age of Alexander*, exhib. cat. (Boston, 1965), no. 92a.

S.M.-C.

25. PAIR OF BRACELETS

Last quarter of the 4th century B.C.
Silver
(γ) height 0.057 m, width 0.062 m;
(δ) height 0.057 m, width 0.061 m
From Akanthos cemetery
Archaeological Museum of Polygyros
(I.161.429 γ,δ)

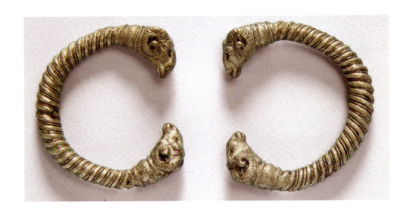

Each of these silver bracelets consists of a hoop of braided, twisted wire, and ram's-head terminals.

E.T.

26. PAIR OF STRAP BRACELETS

Late 4th century B.C.
Gold
Diameter (.7) 0.055 m, (.8) 0.057 m
From Akanthos cemetery
Archaeological Museum of Polygyros
(I.29.7, .8)

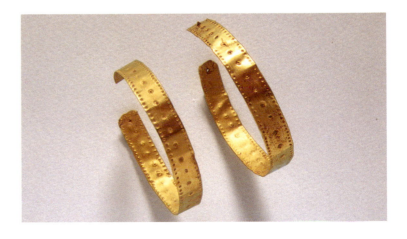

These two strap bracelets are adorned with stippled decoration.

E.T.

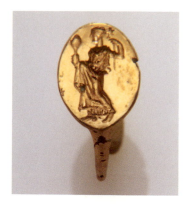

27. FINGER RING
Late 5th century B.C.
Gold
Max. width 0.022 m
From the Cemetery of Aigai
Museum of the Royal Tombs of Aigai,
Vergina (BM 1741)

This plain though precious (solid 24-karat gold) ring escaped the notice of the robbers who looted the tomb of one of the women of Aigai who died in the reign of King Archelaos (413–399 B.C.). As indicated by its broad, flat, oval bezel bearing an intaglio representation, it is a signet ring—a favorite and ubiquitous piece of jewelry in Classical as well as Hellenistic times—whose special value derives from the preciousness of its material as well as the outstanding quality of its engraving.

The ring's sole ornament is the intaglio representation, which occupies almost the entire surface of the bezel. A standing female figure, perhaps the goddess Aphrodite, appears to be wearing a new ribbon in her hair and is coyly admiring herself in a mirror she holds to her face.

Her pose, hairstyle, and delicate dress with its abundant drapery, even the charming way in which her himation is swathed round her hips, leaving the torso exposed and falling over her raised right arm, recall types familiar from scenes in Attic vase painting of the late fifth century B.C. Nevertheless, given the excellence of Macedonian metalwork and gold jewelry, as well as the high demand for such precious products in the markets of the kingdom, it cannot be ruled out that this ring was created by a goldsmith who settled in the area of Aigai, which, thanks to the prudent policy of Archelaos, was enjoying a splendid heyday, maintaining close and cordial relations with Athens, the center of Hellenic culture.

The decision of the Greek noblewoman to choose for her seal the eternal archetype of female vanity is by no means fortuitous. On the contrary, it accords perfectly with the feeling emitted by the varied toilet vessels and pieces of jewelry and complements, in an unexpectedly direct and eloquent manner, the picture of the secret world of the women of ancient Macedonia.

A.K.

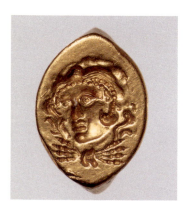

28. FINGER RING WITH HEAD OF HERAKLES
4th century B.C.
Gold
Length of bezel 0.025 m,
diameter of hoop 0.027 m
Provenance unknown
The Metropolitan Museum of Art,
Funds from various donors, 1910
(10.132.1)
Photograph © 1990 The Metropolitan Museum of Art

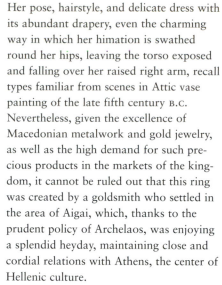

On the bezel, in intaglio, is the head of Herakles wearing the skin of the Nemean lion that he had clubbed to death. Herakles appears frequently in Macedonian art and iconography, presumably as a visual reminder of the mythical descent of the royal dynasty from that hero.

The Search for Alexander: Supplement to the Catalogue (New York, 1982), no. S55.

S.M.-C.

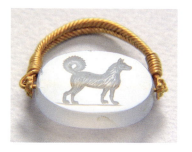

29. FINGER RING WITH CHALCEDONY SEALSTONE
Second half of the 4th century B.C.
Gold and chalcedony
Length of gemstone 0.025 m
From Alykes Kitrous, field of K. Chrysochoidis, tomb 52, cist grave of mud bricks in the form of a *theke*, south cemetery of Pydna
Archaeological Museum of Thessaloniki, Pydna excavation
(Πυ 5749)

This unusual finger ring was found inside the ossuary together with the burnt bones of the dead female. The gold hoop is formed from two elements, around which is coiled gold wire. One gold wire spirals around one end, then passes through the hole piercing the long axis of the gemstone, terminating at the other end, where it spirals again. The gemstone is elliptical and bears an intaglio representation of a sheepdog on one face. It is attached so that it swivels.

Μ. Μπέσιος, "Νότιο νεκροταφείο Πύδνας," *Το Αρχαιολογικό Έργο στη Μακεδονία και Θράκη* 15 (2001), pp. 371ff.

M.B.

30. FINGER RING WITH ELLIPTICAL BEZEL
Late 4th century B.C.
Gold
Diameter 0.017–0.02 m
From Akanthos cemetery
Archaeological Museum of Polygyros (I.165.2)

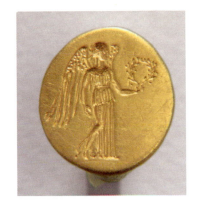

This gold ring bears a representation of Nike holding a wreath in her outstretched left hand.

For a related ring from Akanthos, see Kate Ninou, ed., *Treasures of Ancient Macedonia*, exhib. cat. (Thessaloniki, 1979), no. 360.

<div align="right">E.T.</div>

31. FINGER RING WITH CIRCULAR BEZEL
Late 4th century B.C.
Gold
Diameter 0.016 m
From Akanthos cemetery
Archaeological Museum of Polygyros (I .29.5)

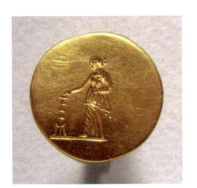

Represented on this gold finger ring is a standing female figure, possibly a priestess, in front of an incense burner, toward which she extends her right hand.

For a similar ring from Akanthos, see Kate Ninou, ed., *Treasures of Ancient Macedonia*, exhib. cat. (Thessaloniki, 1979), no. 361, pl. 48.

<div align="right">E.T.</div>

32. FINGER RING WITH ELLIPTICAL BEZEL
Last quarter of the 5th century B.C.
Gold
Diameter 0.02 m, length of bezel 0.015 m
From Akanthos cemetery
Archaeological Museum of Polygyros (I.140.1)

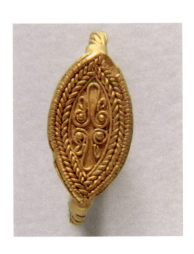

This finger ring of gold has a braided wire hoop and an elliptical bezel with pointed ends, decorated with a double palmette.

<div align="right">E.T.</div>

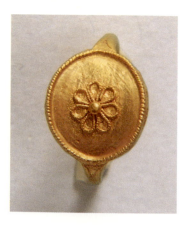

33. FINGER RING WITH CIRCULAR BEZEL
Second half of the 4th century B.C.
Gold
Diameter 0.0185 m, length of bezel 0.013 m
From Akanthos cemetery
Archaeological Museum of Polygyros
(I.115.68)

This gold finger ring has a central rosette ornament
of fine spiraling wire.

E.T.

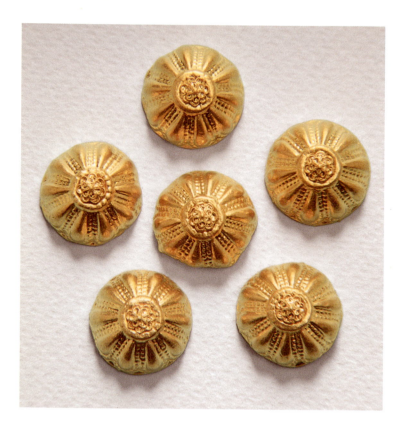

34. SIX BUTTONS
Second half of the 4th century B.C.
Gold
Diameter 0.018 m
From Alykes Kitrous, field of K. Chrysochoidis,
tomb 52, cist grave of mud bricks in the
form of a *theke*, south cemetery of Pydna
Archaeological Museum of Thessaloniki,
Pydna excavation (Πυ 5746)

These six gold buttons, found inside the ossuary
along with the burnt bones of a deceased female,
were intended for the sleeves of the chiton. They are
hemispherical with a loop inside for sewing to the
garment. The outside is decorated with a repoussé
rosette of twelve petals, with traces of granulation
on the outline of the petals and the center.

M. Μπέσιος, "Νότιο νεκροταφείο Πύδνας,"
Το Αρχαιολογικὸ Ἔργο στη Μακεδονὶα και Θρὰκη 15
(2001), pp. 371ff.

M.B.

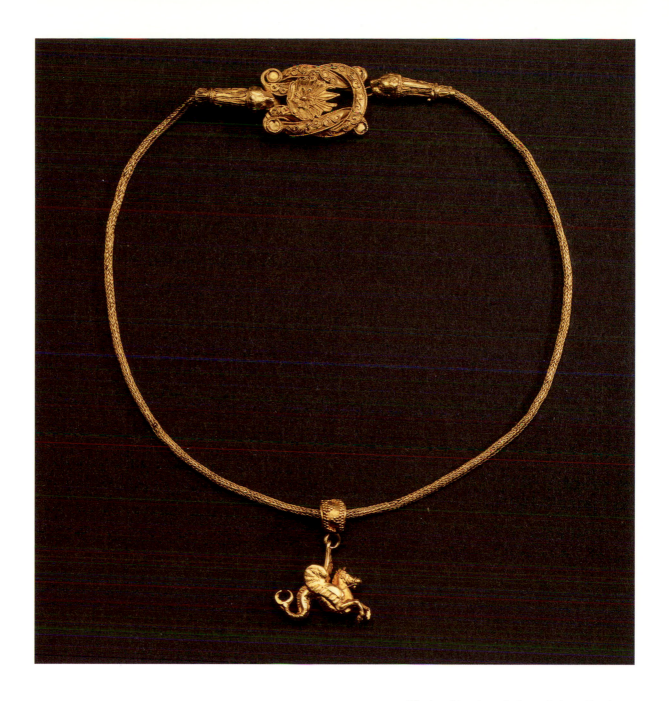

35. THIGH BAND WITH ADDED PENDANT
Late 4th century B.C.
Gold
Length of band 0.306 m
Provenance unknown
The St. Louis Art Museum,
Museum Purchase (382.1923)

The band is a loop-in-loop chain ending in lion's-head finials. Its clasp in the shape of a large and elaborate Herakles knot is decorated with running tendrils bordered with beaded wire, the ends curled around to form scrolls. The center of the knot is decorated with a honeysuckle palmette surmounted by a rosette. Terracotta figurines show that the band was worn around the upper thigh with the clasp facing forward. The pendant, an added piece of later date, is in the form of a hippocamp.

The Search for Alexander, exhib. cat. (Boston, 1980), no. 82.

S.M.-C.

THE LADY OF AIGAI

Angeliki Kottaridi

At the southern edge of the Macedonian basin, in the foothills of Mount Pieria, lies Aigai, first capital of the Macedonians and cradle of the Temenides, the dynasty that ruled for three and a half centuries and gave to Greece—and history—two of its most famous heroes, Philip II and Alexander the Great. To the north of the city spreads the vast necropolis, a cemetery renowned in Antiquity for its treasures, as it was the place where tradition dictated that the kings of Macedon be buried.

Located by the northwest gate in the city wall, near the sanctuary with the royal ex-votos, in a conspicuous position where a stream separates it from the rest of the necropolis, is a very important cluster of tombs that, in the overall picture of the Aigai cemetery, is distinguished in many ways. Nine tombs were found in this cluster: four pits, of unusually large dimensions, dating from 540 until circa 470 B.C.; three monumental cist graves, two of the fifth century B.C. and one of the fourth century B.C.; and two Macedonian tombs. One of them, the tomb with the wonderful gold-embellished marble throne and the impressive Ionic façade of its inner chamber, is not only the earliest monument of its class (344–343 B.C.) but also one of the most important, since all evidence suggests that it belonged to Queen Eurydike, wife of Amyntas III and mother of three kings—Philip II among them—as well as grandmother of Alexander the Great. The rest of the tombs in the group, all of which (save one) were looted, belong to women. Despite the looting, exceptionally rich grave goods were discovered throughout, which, in conjunction with the form and the location of the monuments themselves, proves that all the noblewomen laid to rest there were preeminent members of the royal family.

Near the center of the cluster was the only tomb that escaped the attention of ancient robbers; miraculously, it was uncovered intact, full of treasures that recall those of the gold-rich royal shaft graves of Mycenae. The tomb, dated circa 500 B.C., is an enormous pit—approximately four meters wide, five meters long, and five meters deep—with a spacious wooden cistus (the actual tomb) at the far end. West of the pit, resting on an iron trivet on an earthen step outside the wooden cistus, was the bronze cauldron in which water would have been heated for the ritual bath of the dead, together with an upturned elaborate bronze jug and a cup that probably were used in the funerary libations.

Inside the wooden cistus lay the dead noblewoman, attired in a rich gold-embellished cerement, bedecked with splendid jewelry, and surrounded by precious grave goods: a bronze hydria; thirteen repoussé bossed bowls (twelve bronze and one gilded silver, the latter particularly precious as it preserves the earliest known inscription from Aigai); an iron exaleiptro with an ornate bronze tripod base; an elegant glass unguentarium; a model iron four-wheeled cart decorated with fine gold bands to which wooden draft animals (now lost) probably were yoked; a few iron spits (*obeloi*); a strange, hollow silver wand; a silver-and-gold tubular object, perhaps a distaff; and half a dozen terracotta busts of the goddess, high-quality products that likely were from an East Greek–Ionian coroplastic workshop.

To the right of the deceased were traces of her wooden scepter, adorned with amber and ivory. This object would have had symbolic value, denoting the special sacerdotal office of the gold-rich lady, in much the same way as did the bronze triplet double axes found in burial sites—in the same cemetery—of wealthy females that date to the Early Iron Age (eleventh–seventh century B.C.).

The deceased's right of precedence in religious sacrifices and rituals is indicated, I believe, by the numerous bossed bowls, the characteristic libation vessel of the period; the gold-embellished iron spits and the miniature four-wheeled cart also bear witness to this woman's special status.

It seems that in the context of carrying out her sacral duties, the gold-rich Lady of Aigai had the right to appear in public and to participate with her cart, like the priestess mother of Kleobes and Biton from Argos, in ritual processions and litanies as well as at banquets held in honor of the gods at whose cult ceremonies she officiated.

In the Creto-Mycenaean world—as in the kingdoms of the Geometric period, which are brought to life in the epic poetry of Homer—the king, undisputed chieftain of the group and descendant of the godhead, was the living link between his people and the divine, securing the latter's blessing. As ultimate bearer of sacred authority, he performs all legal rites and is accompanied by his wife, who plays the role of high priestess. In the frontier kingdom of Macedon, which remained outside the sociopolitical developments in the south and thus preserved the institutions and customs of the epic unaltered into Hellenistic times, this tradition—which, like the mortuary habits of the Macedonians, comes from the distant heroic past—finds parallels in the Mycenaean kingdoms and is vital throughout the Archaic period. It was to continue in the reigns of Philip II and Alexander with Eurydike and Olympias and reached its zenith with the queens of the Hellenistic period—Arsinoe, Berenice, Cleopatra, and others—who did not confine themselves only to the role of high priestesses but were declared goddesses themselves.

Examination of the osseous remains of the Lady of Aigai has shown that at her death she was in her early thirties—a mature woman by the standards of the time. Although her name eludes us, indications are that she was the wife of Amyntas I, who outlived her, and perhaps the mother of the future Alexander I (498–454 B.C.), then an adolescent.

Libation vessels, phialai (bowls) and pateras, were found in abundance in virtually all the tombs in the cluster. The twenty-six terracotta heads of demons and deities that were recovered from the tomb of another queen-priestess, buried in the reign of Alexander I, refer to special rituals. Temenid kings frequently resorted to polygamy for several reasons: to secure the fertility of the royal house, primarily for the purposes of succession; to ratify alliances and treaties; and to obtain the friendship of powerful and dangerous neighbors. All male offspring had, according to their age and abilities, an equal chance of acceding to the throne. However, at least as far as the performance of the holy duties of the queen was concerned, there must have been some ranking among the wives of the royal family, as it seems likely that this particular royal tomb cluster was for some, not all, of them.

Comparable finds of the same period from the cemeteries at Sindos, Archontiko, and Aiani show that similar institutions and customs possibly existed among neighboring tribes and peoples and that the wives of their kings and rulers were also at times called upon to play the role of priestess. This was, after all, the case even in the democracy of Classical Athens, where the wife of the archon basileus, the renowned basilinna, was premiere celebrant in the rites of the Sacred Marriage (Hieros Gamos), of paramount importance for the city. However, even the finds from the richest female burial at Sindos, which dominated the fertile Axios Valley, pale— as an ensemble—in comparison to the splendor and wealth of the find from Aigai. Wound in purple and gold from head to foot, with a scepter at her side, the Lady of Aigai was laid to rest at the time that the democracy was consolidated in Athens, with nothing to envy the Mycenaean queens whose presence haunted the Greek myths.

When the wood of the cistus rotted away, the masses of earth that filled the enormous burial pit trapped the queen's body, which was in a state of decomposition. The flesh perished, together with the textiles, the wood, and the leather, but the gold strips and the jewelry remained intact and unchanged in situ, keeping their shape and form over the centuries. So, thanks to the weight of the earth, which concealed the tomb from plunderers and preserved the objects in more or less their original position, we now are, through careful excavation and exhaustive documentation, able to appreciate the appearance of the magnificent costume of the gold-bedecked lady.

THE COSTUME OF THE
LADY OF AIGAI, CA. 500 B.C.

The dead woman was laid supine, with her head toward the east and her arms alongside the torso. She wore at least two garments: a fine chiton and, over it, a densely woven but still quite fine peplos. It is certain that she also wore an *epiblema*, a kind of overgarment that is somewhere between the short himatia of penguin type, as depicted in black-figure vase-painting, and the traditional neo-Hellenic *segounia*. Minimal traces indicate that at least one of these garments, perhaps the peplos, was a pale but vibrant purple color.

Fibulae usually are associated with chitons, but here they probably fastened the peplos, as indicated by the fact that there were only two, fairly large, and they were found below the shoulders, a little way above the breasts—the point where, as can be seen on statues and in representations, the front and back of the peplos normally overlapped and were fastened together.

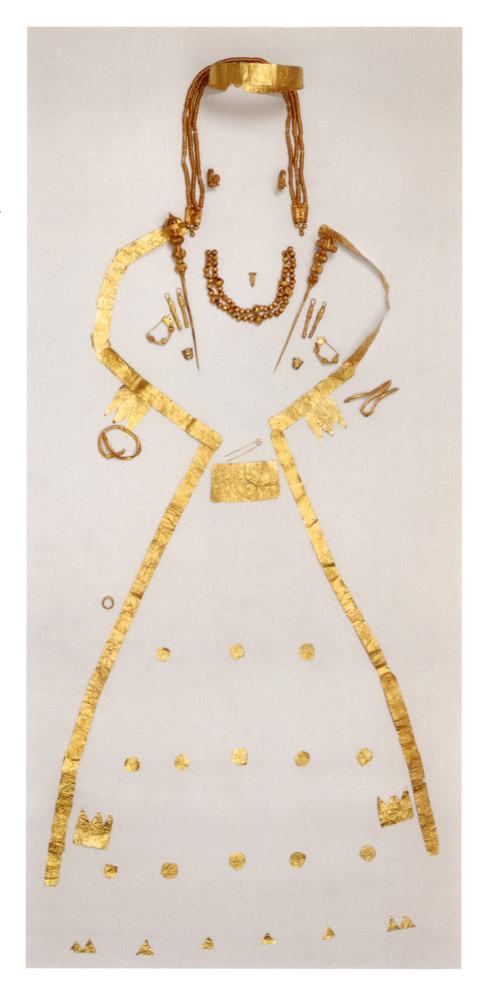

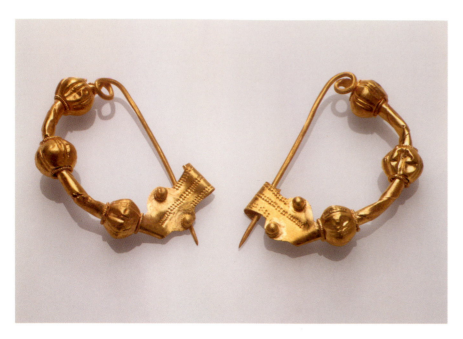

TWO ARCHED FIBULAE
Ca. 500 B.C.
Gold, max. length 0.06 m, max. width
0.035 m
From the Tomb of the Lady of Aigai
Museum of the Royal Tombs of Aigai
(BM 1972, BM 1973)

The two rather large and heavy fibulae of characteristic shape are made of pure gold, which is quite unusual for the time. A thick gold wire forms the pin of the fibula, with the essential loop, for functional reasons, on the back. The wire then flattens into a strip, which is wound to form a hollow arched tube that ends in the characteristic catch-plate in which the pin fastens. The catch-plate terminal of the fibula is in the form of a schematic snake head, with two large gold globules for eyes. Three ribbed gold beads pasted onto the little tube decorate the arch.

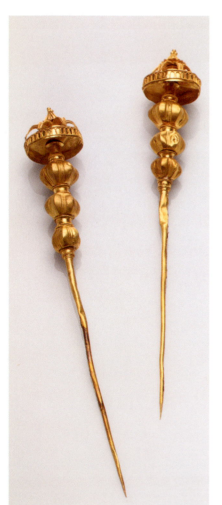

TWO LARGE PINS
Ca. 500 B.C.
Gold
Max. length 0.285 m, diameter of
head 0.035 m
From the Tomb of the Lady of Aigai
Museum of the Royal Tombs of Aigai
(BM 2016, BM 2017)

Higher up than the fibulae, two enormous pins, with their impressive gold heads, adorned the woman's shoulders. They probably held together both garments—the chiton and the peplos—and kept them in the desired position. These two pins, each of them almost a foot in length, are not only the largest but certainly the most precious specimens found to date. They unexpected size brings to mind the tragic story of the ill-fated messenger killed by women who, enraged by his bad tidings, pierced him with their pins.

Fashioned from thick gold sheet forming a cylinder, the pin is reinforced along its entire length by a solid silver core, making it more resistant and functional. The impressive and elegant head, which takes up more than one-third of the pin's overall length, is equally elaborated but more austere and articulated with greater geometric clarity than the corresponding examples from the Sindos cemetery. Its shape recalls a popular type in those years, known from much smaller pins of silver or bronze, which some scholars associate with Peloponnesian workshops.

Three ribbed beads passed onto the fixed core are separated by hollow rings and, as they increase progressively in size, create a rhythmical succession that culminates in the traditional disc, from the center of which unfolds a gold narcissus. Delicate filigree ornaments embellish the flower, the circumference of the disc, and even the rings between the beads. By playing with light and shadow, the goldsmith succeeded in making the bulky piece of jewelry seem lighter, reflecting his great skill.

The "apron" of the peplos was adorned with gold strips with repoussé geometric motifs and discs with rosettes sewn onto it: a broad rectangular double strip (Museum of the Royal Tombs of Aigai [BM 1992]; length 12.2 cm) with repoussé triangles and drop-shaped motifs, stitched through small holes in its four corners, was found at the center of the garment, just below the waist. Below this, small discs with rosettes (Museum of the Royal Tombs of Aigai [BM 2004, BM 2045–66]; approx. diam. 2.5 cm) were sewn in three rows through two small holes at their center, like buttons, while two double and four single triangular strips (Museum of the Royal Tombs of Aigai [BM 2038–43]; max. width 2.8–5.6 cm) formed a shimmering border on the hem.

More unusual was the *epiblema*, a peculiar overgarment, the existence of which is documented by the large banded gold strips which were sewn at its edges and enable us to form an idea of its appearance. Made of heavier and stiffer fabric than the chiton and the peplos, the epiblemma covered the back to about midcalf, passed with wide opening over the shoulders so that the heads of the pins were visible, leaving the bosom free (similar to the *segounia* of the folk costume of Epirus), and fastened on the waist with a gold double pin (Museum of the Royal Tombs of Aigai [BM 2020]; length 7.2 cm), a very plain piece of jewelry that men also used, to fasten their capes. The overgarment then opened obliquely toward the sides, leaving visible the gold-embellished "apron" of the peplos.

The entire front of the *epiblema*, from the shoulders to the hem, was decorated with border bands of gold strips sewn to the cloth: a long strip with repoussé guilloche (Museum of the Royal Tombs of Aigai [BM 2157]; length 60.2 cm); three sheets, in poor condition, with mythical subjects (Museum of the Royal Tombs of Aigai [BM 2152, BM 2155–56]; length 55.7 cm, 30.4 cm, and 27.3 cm, respectively) that were embossed in the same mold as the diadem (see BM 2153); a badly damaged long strip, the representation on which is indecipherable (Museum of the Royal Tombs of Aigai [BM 2158]; length 35.7 cm); and fifteen smaller strips, of varying length, with repoussé rosettes (Museum of the Royal Tombs of Aigai [BM 2000, length 7.8 cm; BM 2001, length 8.5 cm; BM 2002, BM 2003, length 7.1 cm; BM 2007, length 8.2 cm; BM 2008, length 8.4 cm; BM 2009, length 6.7 cm; BM 2010, length 8.6 cm; BM 2011, length 10.9 cm; BM 2012, length 9.8 cm; BM 2013, length 16.2 cm; BM 2005, length 6.7 cm; BM 2006, length 5.2 cm; BM 2014, length 9.5 cm; BM 2044, length 7.8 cm]).

Sewn onto the upper part of the *epiblema*, in the position of the arms and next to the gold border, was a rectangular strip (Museum of the Royal Tombs of Aigai [BM 2034, BM 2037]; length 6.5 cm and 6.7 cm, respectively) decorated with triple zigzags and repoussé geometric motifs, which might have marked the openings through which the hands passed.

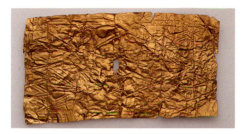

Rosettes, BM 1992

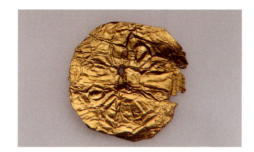

Small disk with rosette, BM 2004, BM 2045–66

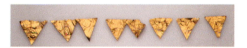

Triangular strips, BM 2038–43

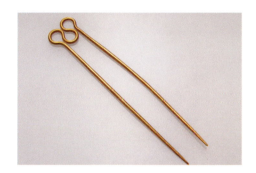

Gold double pin, BM 2020

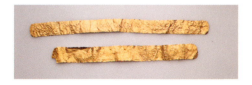

Gold strips, BM 2152, BM 2155–58

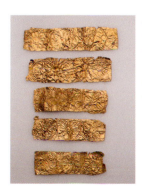

Small gold strips with repoussée rosettes, BM 2000–03, BM 2005–14, BM 2044

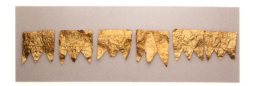

Gold strips, BM 2032–37

Similar strips (Museum of the Royal Tombs of Aigai [BM 2032–33]; length 7.1 cm and 6.5 cm, respectively) also existed in the bottom corners of the *epiblema* as well as on the noblewoman's shoes (Museum of the Royal Tombs of Aigai [BM 2035–36]; length 6 cm and 6.4 cm, respectively), the soles of which were covered with silver sheets (Museum of the Royal Tombs of Aigai [BM 2163–64]; max. length approx. 25 cm).

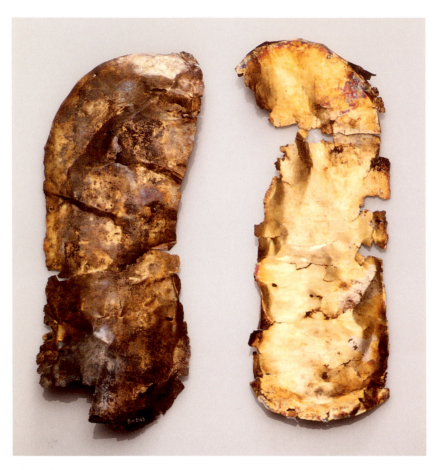

Silver sole covers, BM 2163–64

The Jewelry of the Lady of Aigai

In addition to the fibulae and pins, the Lady of Aigai was bedecked with other various pieces of gold jewelry, all of which were in vogue at the time. On her head was a gold strap diadem (Museum of the Royal Tombs of Aigai [BM 2153]; max. length 48.9 cm, max. width 3.6 cm]). As the rather close-set holes at the lower edge indicate, the relatively wide and thick gold sheet was stitched onto the textile, covering the wreath made of organic material that was used as its core.

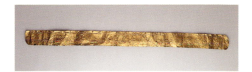

Gold strap diadem, BM 2153

The entire surface of the sheet is decorated with very interesting mold-embossed mythical representations. In eight rectangular plates (*metopes*), clearly defined by stippled lines, the following subjects (from left to right) can be identified: in the first, a pair of heraldic sphinxes and a pair of rampant heraldic lions framing palmettes; in the second, an entertaining version of the return of Hephaistos to Olympos, with Dionysos as guide; in the third, Herakles dressed in the lion skin, shooting arrows at two centaurs; in the fourth, two Gorgons—Sthenno and Euryale—running in *Knielaufschema* (arms and legs in pinwheel pose) after Perseus, the slayer of their sister, Medusa; in the fifth, Theseus struggling with the Minotaur and Herakles combating the Lion of Nemea in front of Athena; in the sixth, the blinding of the Cyclops Polyphemos by Odysseus and two of his companions; and in the last two scenes from athletics games, most likely the famous funerary games for King Pelias of Iolkos, one jumper, two contestants in throwing events, and one judge in one metope and two pairs of boxers in the other. Dispersed between the figures are irregular stippled rosettes, characteristic expressions of the Archaic craftsman's horror vacui.

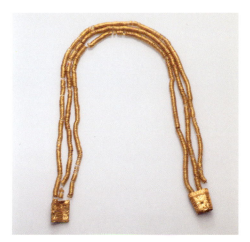

Gold fistulae, BM 1974–75, BM 1993

After the disintegration of its hard organic core, the gold sheet crumpled badly; as a result, some figures are not easily distinguished. Nevertheless, careful observation reveals that they are all rendered with considerable clarity, following forms and shapes that bring to mind the vibrant and voluptuous world of Eastern iconic iconography.

With the narrative flair characteristic of Archaic times, the unknown craftsman recounted on the gold adornments of the Lady of Aigai beasts and monsters and the feats of gods and heroes, thereby transforming the queen's attire into a true manual of mythology and giving us the unexpected opportunity to grapple with the stories that Macedonians were fond of hearing before their kingdom became the most important Greek state in the north.

The three gold fistulae (syringes) with conical finials (Museum of the Royal Tombs of Aigai [BM 1974–75, BM 1993]; max. width of finials 3 cm) undoubtedly adorned the head, as indicated from the position in which they were found—together with the diadem—behind and above the crushed skull, encircling the head like a halo to the top of the neck. Made of coiled

fine flat wire, the three fistulae, which closely resemble three tight curls of golden hair, were attached to the top of the head, probably to the hair, and fell freely at the sides, framing the face with their warm glow. Their ends were inserted in conical finials made of thick gold sheet with lavish filigree decoration on the front. These finials are quite large and it would be reasonable to assume that they would have pulled on the wire, stretching the tight coils and distorting the shape of the fistulae. That this did not happen indicates that a fine cord or thick thread must have passed through the spirals, holding them in place along their length. Perhaps the small (0.9 cm wide) biconical gold beads—four on each side—(Museum of the Royal Tombs of Aigai [BM 2024–31]), some of which were found right next to the finials of the fistulae, hung from the end of the cords.

Only two other examples of such pieces of jewelry are known. Both were found in the two most lavishly furnished female tombs at Sindos and were interpreted as necklaces that hung from the temples onto the bosom. These burials were in cist graves, and it is possible that some items on the deceased had shifted position due to the action of water or rodents. Nevertheless, it cannot be ruled out that there were variations in the way aristocratic ladies wore their fistulae.

What is certain is that this extremely rare, impressive, and somewhat glamorous adornment should be considered a direct descendant of the heavy bronze fistulae which, with the help of large bronze buttons, hung from the headdress of women in the Early Iron Age (eleventh–seventh century B.C.), falling freely on either side of the face, just like the gold ones of the Lady of Aigai. After all, bronze fistulae were a popular adornment in the tumulus cemetery of Aigai, and the heaviest and most spectacular of these were found in the tombs of the priestesses with the triple bronze double axes.

The gold strap earrings (Museum of the Royal Tombs of Aigai [BM 2018–19]; max. diameter approx. 3.4 cm, width of strap approx. 0.9 cm), two miniature masterpieces, are perhaps the most charming of all of Lady of Aigai's adornments. Of a general type quite common in Archaic times, these earrings are unique for the exceptional skill and imagination of their creator. The basic idea is a strap that gradually widens toward the front and forms a loop that is fixed with a very fine hook in the earlobe. Here, however, the strap is transformed into veritable gold lace that ends in a multipetaled blossom from which flowers a three-dimensional narcissus, like that adorning the heads of the pins. Two buds flank the blossom, enhancing the vividness of the ensemble. Granulation and filigree, two highly complicated techniques, are manipulated with unparalleled virtuosity and panache in order to capture the beauty of the flower within the magic of geometry, fashioning a delicate harmony animated by the play of light and shade.

From the queen's neck hung an elegant pyramidal pendant (Museum of the Royal Tombs of Aigai [BM 2022]; height 2.5 cm) lavishly decorated with granulation and a tiny narcissus at the apex, while a necklace (Museum of the Royal Tombs of Aigai [BM 2023]) adorned her décolleté. This simple but superb piece of jewelry consisted of sixty-one gold ribbed beads—similar

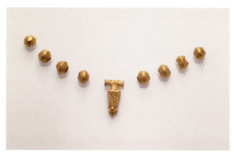

Gold strap earrings, BM 2018–19

Pendant, BM 2022, BM 2024–31

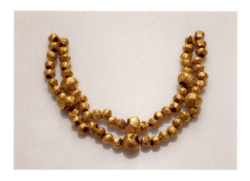

Necklace, BM 2023

to those on the fibulae and the pins—strung in two rows, their glister heightening the wearer's allure.

A long braided silver chain (Museum of the Royal Tombs of Aigai [BM 2165–66]; length 95 cm), a masterly example of the achievements of the silversmith's art though unfortunately not in good condition, hung from the lady's shoulders down the abdomen. The greater part of the chain, which is almost a centimeter thick, is formed from eight tightly knit, interlinked braids. Each end of the chain passes through two gold cones decorated with filigree and splits into paired terminals, which are inserted into tiny gold tubes that assume the form of snakes. With the scales of the skin and the features of the head rendered in filigree, the four snake heads hold in their mouth the gold loops with which the chain was affixed to the peplos, just below the fibulae.

Less elaborate are the pieces of jewelry for the hands and arms: a plain gold ring (Museum of the Royal Tombs of Aigai [BM 2021]; max. diameter 2.1 cm) was worn on the middle finger of the right hand, and a plain, open spiral bracelet (Museum of the Royal Tombs of Aigai [BM 1997–98]; diameter approx. 8 cm) was wound around each arm like a snake, as inferred from the convincing accuracy of their repoussé snake's-head finials. Wrought from thick gold sheet, these bracelets might have been placed just as they were found, but the pronounced hollow of the sheet is better explained if these "clad" a core of relatively pliable organic material (flexible wood or perhaps horn).

The form and technical details of the items in the Lady of Aigai's parure indicate that these are the creations of one and the same craftsman, whose workshop should be sought somewhere in the wider area, perhaps not far from the River Echedoros, which is rich in alluvial gold. Precious and impressive yet elegant and somewhat austere in comparison with other examples, all the pieces match each other down to the finest detail, forming a true set. It is a rare find and reveals not only the wealth and status of this unknown Macedonian queen who died a century and a half before the birth of Alexander the Great but also her exquisite taste.

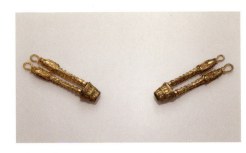

Silver chain, BM 2165–66

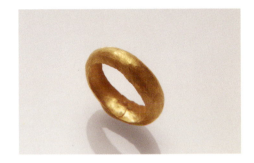

Gold ring, BM 2021

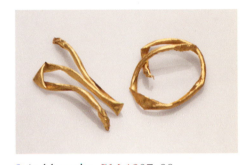

Spiral bracelet, BM 1997–98

BIBLIOGRAPHY

Andronikos, M. Το Αρχαιολογικό Έργο στη Μακεδονία και Θράκη 2 (1988), pp. 1–3.

Kottaridi, A. Το Αρχαιολογικό Έργο στη Μακεδονία και Θράκη 3 (1989), pp. 1–11.

———. Το Αρχαιολογικό Έργο στη Μακεδονία και Θράκη 10 (1996), pp. 79–92.

———. In Excavating Classical Culture (Oxford 2002), pp. 75–83.

THE MACEDONIAN TOMB AT AGHIOS ATHANASIOS, THESSALONIKI

Maria Tsimbidou-Avloniti

This impressive monument was revealed in summer 1994, after several months of excavation in the heart of the large tumulus dominating the area of Aghios Athanasios, a modern village twenty kilometers west of Thessaloniki. It is a small single-chamber tomb. Its façade is completely covered with mural paintings in remarkable condition and stands in its own right like the set of a silent drama. Predominant in its architectural articulation are features of the Doric order, well attuned to a vivid polychromy, though there are some purely Ionic details as well. The front is 4.60 meters wide and the same height, including the central akroterion, while the lateral akroteria and the pediment are inscribed in an imposing parapet. White flame-shaped palmettes project, as if three-dimensional, against the black ground of the akroteria, while supple acanthus stems and fleurs-de-lis (lilies) embellish the motifs of the lateral half-palmettes.

Dominating the center of the pediment is a large luminous disc flanked by two winged griffins that touch it cautiously with one foot. These demonic creatures are depicted with the head and body of a feline and golden wings curved forward, in accordance with the Oriental type of lion-griffin.

Below the painted pediment are deep blue triglyphs and white metopes, but the surprise waits lower down, on the narrow frieze above the doorway, where a symposium scene unfolds. A representation so familiar from descriptions in ancient texts and corresponding vase painting but unique in the thematic repertoire of funerary monuments in Greece.

The composition is developed on a surface 3.75 meters long and just 0.35 meters high and includes a total of twenty-five figures painted by a rapid but skilled hand so that they seem almost in relief, as the deep blue ground enhances the feast of color. At the center are six wreathed symposiasts reclining on three couches with covers in scarlet, violet, and light blue. Lazily resting on the colorful pillows, the men are deeply absorbed in the music of the kithara, which pulsates in the hands of the striking female kithara player, while the young female flautist stands and plays her aulos. Projected in front of the couches are three tables laden with fruits, eggs, and sweetmeats, essential desserts for wine drinking. The representation is completed by the nude, supple-bodied ephebe, the oinochoos, poised to respond with alacrity to the call of the men and to keep their cups brimming with wine.

This classical symposium synthesis, which seems to illustrate the lines of the lyric poet Alkaios and the loquacious pages of Athenaios, is framed by two other scenes that round off its narrative: from the left approaches a band of three men on horseback and their companions on foot, with vessels filled with wine, a contribution to the symposium to which they are invited. Nocturnal shadows flicker upon the faces of the youths and the robust bodies of the steeds, as four flaming torches illuminate the dark sky.

At the right edge of the frieze the atmosphere is calmer, even though the eight men depicted there are in military attire and fully armed. Leaning relaxed on their spears and shiny shields, they observe events, conversing in whispers. It is precisely the elements of their dress that transform this section of the frieze into a "prating symbol" (*type parlant*) of the locality in which the scene is set since, together with the well-known weaponry of Greek forces, the young men are clad in the traditional Macedonian uniform: leather boots (*krepides*), cloaks (*chlamydes*) fastened by a fibula on the right shoulder, and the Macedonian brimmed hat (*kausia*) that was proudly sported by Alexander the Great himself and his generals into the depths of Asia. They also wear brilliant helmets with high crests and fluttering white plumes,

and the famous Macedonian shields, with the characteristic starburst emblem, complete the wonderful composition.

This representation is without doubt of a symposium of Macedonians, a symposium probably held in the courtyard of the obviously luxurious residence of an eminent person in Macedonian society. Furthermore, the doorway of the façade is flanked by two male figures, slightly smaller than lifesize, with long spears (*sarissas*) in hand, who, wrapped in their cloaks and their sorrow, stand silently beside the entrance to the tomb, eternal custodians of the distinguished deceased. Depicted above their head are two large shields in vibrant colors and with impressive devices. Projected against the purple ground of the left shield is a gorgoneion, while described almost in relief on the scarlet ground of the right shield is the winged thunderbolt of Zeus. These male youths are similar in appearance to the men in the frieze, but what is astounding here is the rendering of their personal features and feelings. The figure at left is portrayed with serene brown eyes, overcast by sadness, and lips drawn into a barely perceptible smile. The features of his counterpart at right are shown with greater intensity, since his forehead furrows and his eyes narrow as he struggles to hold back the welling tears.

It is patently clear that this impressive tomb was the final resting place of a high-ranking Macedonian military officer, as indicated by the remains of the iron weaponry that had escaped looters and lay on the floor of the burial chamber. Despite the vandalism, propitious circumstances had still preserved the remnants of a luxurious wooden couch with ivory decoration as well as a gold quarter-stater of Philip II. Thus, the dating of this unique monument—documented in any case by the rest of the excavation data—to the last quarter of the fourth century B.C. is reinforced.

BIBLIOGRAPHY

Τσιμπίδου-Αυλωνίτη, Μ., Αγ. Αθανάσιος. "Το χρονικό μίας αποκάλυψης," *Το Αρχαιολογικό Έργο στη Μακεδονία και Θράκη* 8 (1994), pp. 231–40.

———. "Η ζωφόρος του νέου Μακεδονικού τάφου στον Αγιο Αθανάσιο Θεσσαλονίκης: εικονογραφικά στοιχεία.," *Αρχαία Μακεδονία* VI (1999), pp. 1247–59.

———. "Οι Μακεδονικοί τάφοι του Αγίου Αθανασίου και Φοίνικα Θεσσαλονίκης. Συμβολή στην εικονογραφία των ταφικών μνημείων της Μακεδονίας." Ph.d. diss. Thessaloniki, 2000.

Tsimbidou-Avloniti, M. "Revealing a Painted Macedonian Tomb." In A. Pontrandolfo, ed. *La pittura parietale in Macedonia e Magna Grecia. Atti del Convegno Internazionale di Studi in ricordo di Mario Napoli (Salerno-Paestum, 1996).* Paestum, 2002, pp. 37–42.

———. "Excavating a Painted Macedonian Tomb near Thessaloniki: An Astonishing Discovery." In M. Stamatopoulou and M. Yeroulanou, eds. *Excavating Classical Culture: Recent Archaeological Discoveries in Greece.* Studies in Classical Archaeology I, BAR International Series 1031 (2002), pp. 91–98.

Τσιμπίδου-Αυλωνίτη, Μ., and Χ. Μπεκρουλάκη. "Χρώμα και χρωστικές ουσίες, ύλη και εικόνα σε δύο ταφικά μνημεία της Μακεδονίας." In M. A. Tiverios and D. S. Tsiafakis, eds. *Color in Ancient Greece: The Role of Color in Ancient Greek Art and Architecture (700–731 B.C.). Proceedings of the Conference Held in Thessaloniki 12–18 April 2000.* Thessaloniki, 2002.

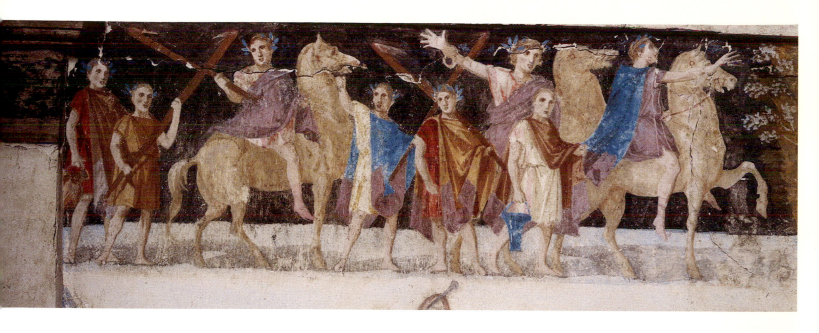

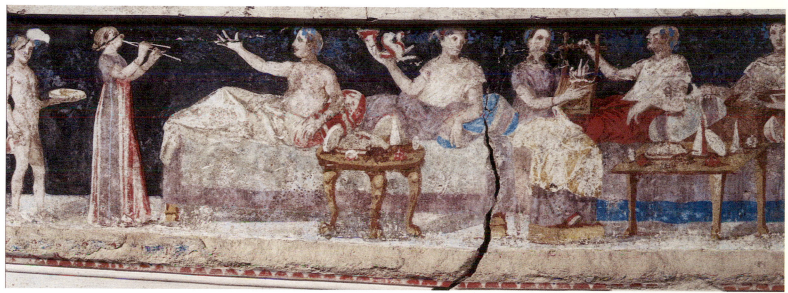

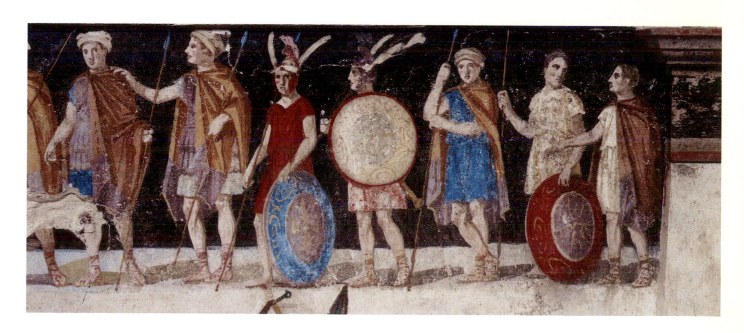